**What Artists**

Charlie Porter is a writer, fashion critic and art curator, and visiting lecturer in Fashion at the University of Westminster. He has contributed to titles such as the *Financial Times*, *Guardian*, *New York Times*, *GQ*, *Luncheon*, *i-D* and *Fantastic Man*, and has been described as one of the most influential fashion journalists of his time. He was a juror for the Turner Prize in 2019, and lives in London.

# What Artists Wear
# Charlie Porter

PENGUIN BOOKS

PENGUIN BOOKS

UK | USA | Canada | Ireland | Australia
India | New Zealand | South Africa

Penguin Books is part of the Penguin Random House
group of companies whose addresses can be found at
global.penguinrandomhouse.com.

First published in Penguin Books 2021
005

Set in Akkurat Std 9/13.8 pt
Printed in Italy by Printer Trento S.r.l.

The authorized representative in the EEA is
Penguin Random House Ireland,
Morrison Chambers, 32 Nassau Street, Dublin D02 YH68

A CIP catalogue record for this book is
available from the British Library

ISBN: 978–0–141–99125–2

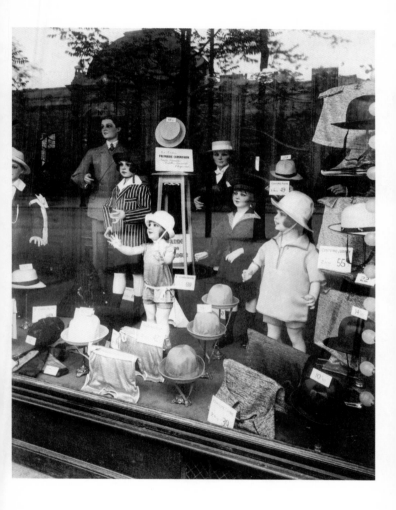

**On a Wednesday evening in May,** the Tate threw a cocktail party in Venice. It was the opening week of the Biennale, the festival of international art held in the city every other year. The gathering was at Scuola Grande di San Rocco, its walls and ceilings covered with vast paintings by the sixteenth-century artist Tintoretto. The invitation read: 'Dress code: Lounge suit'.

According to *Debrett's*, advisers on etiquette, a lounge suit is, for men, 'a suit worn with shirt and tie'. For women, 'a smart, or cocktail, dress (with sleeves or a jacket)'.

Down the front, there were formal speeches from the gallery's chairman and director. At the back of the hall stood Charlotte Prodger in a long-sleeved white T-shirt. Five months earlier, Prodger had won the Turner Prize. Organized by the Tate, it is one of the most prestigious prizes in art.

Nearby was Helen Marten, another previous winner. She wore a black trench coat, a white shirt and blue utility pants. Her partner, Magali Reus, a recent nominee for the Hepworth Prize for Sculpture, was wearing a silk shirt, jeans and sneakers.

The artist Anthea Hamilton, once a Turner nominee, arrived in a tiered and sequined dress that you would not call 'smart, or cocktail': she later described it as 'Edwardian'. She wore it with sneakers and, because it was pouring

with rain outside, an overcoat. Stood a few feet away was Helen Cammock, one of that year's Turner nominees. Cammock was wearing a grey T-shirt and trackpants. On her feet were sneakers.

These five women are among the most vital artists of our time. Most of them are queer. Each lives and makes work within a patriarchal society and art world. They are supposed to play along with its structures, even if their work pushes against them. Clothing makes this tension abundantly clear.

If we were to look back at the clothes artists have worn over past decades, what might we learn about the conditions in which they made their work? What might an artist's wardrobe say about their bravery and defiance, or indeed their compliance with the culture and ideology of their society? We might go a step further, look at our own wardrobe and ask: what might this then say about our own defiance or compliance?

Our clothing is an unspoken language that tells stories of our selves. What you are wearing right now is sending messages about who you are, what you think, and how you feel. This goes beyond the limitations of fashion: it is a daily, even hourly, signalling of our beliefs, emotions, intentions. Much of it is intuitive: we sharpen up to impress; cocoon ourselves when we're feeling blue; make an effort on a date. But when we put on our clothes, we don't fully acknowledge their loaded meaning. We just wear them.

Many of us make daily compromises when we get dressed to go to work. Our clothing then carries other social meanings: power and ambition or acquiescence, humility

or arrogance, repression and exploitation. For women, dressing for work presents a tougher challenge than it does for men.

Artists live a different way. The work of an artist is not office based. It breaks from the rhythm of 9 to 5, weekdays and weekends. It is a continual push for self-expression. Artists create their own circumstances, their studios becoming self-contained worlds. Their work can question, or it can reinforce, generally accepted ways of being. What artists wear can be a tool in their practice. Their clothing can tell of their desire for another mode of living or, sometimes, their conscious subscription to the status quo.

Artists are often revered for their style. I have friends who pin photographs of artists around their mirrors as inspiration – snapshots of Georgia O'Keeffe, Barbara Hepworth. Fashion houses regularly plunder these images, copying their outfits as part of the relentless fashion-season cycle. It seems logical that an artist should have an eye for clothing, connected with the visual creativity of their work. When we really look at images of artists, we realize it goes deeper than that. There is more to what artists wear than just an appreciable way with clothing.

To approach an artist just as a style icon can strip away the reality of their life and work. Art isn't easy. It can be a lonely pursuit. Countless artists are ignored, acknowledged late in lives, or even only after their death. For many, their work is necessarily more important than recognition. Evidence of this sense of purpose, despite it all, is also found in their clothing. What they wear is testament to this fearlessness, this focus.

Clothing has long been a prime subject in art. This cave painting was found at Tassili n'Ajjer, in Algeria. The walking figure with two spears has some form of skirted garment at their hips. Some of the paintings at the site are thought to be around 10,000 years old.

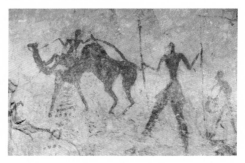

For millennia, painting and sculpture have depicted humans, nature, the actions of humans, and their garments. Clothing and fabric have always been central to what artists wanted to express. Here is *La Pietà* by Michelangelo, made for the Vatican in 1498–9, with its pointed symbolism of a mothering body that is extravagantly draped, the venerated male body mostly naked.

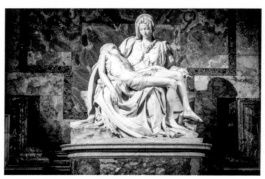

When you look at *Girl with a Pearl Earring* by Johannes Vermeer, what do you actually see? Much of the canvas is dedicated not to the girl, or the earring, but to the fabric of her garments.

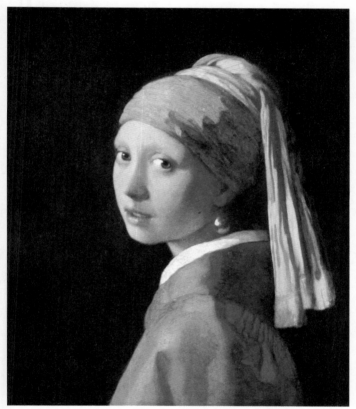

And what are we really looking at? A painting on canvas is really just a piece of fabric.

The twentieth century saw art travel beyond traditional

forms. In 1913, Sonia Delaunay made the *Simultaneous Dress*. Here it is, front and back.

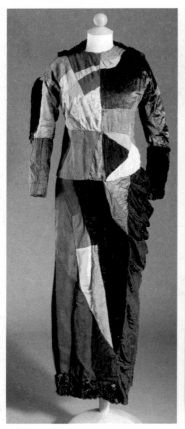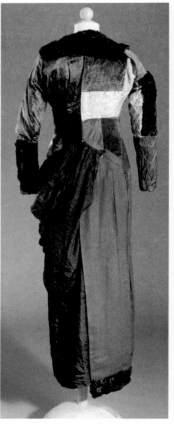

A garment could now be art.

In the decades since, art has become a lived experience. Artists regularly feature in their own work. What they wear is often crucial to their practice. Clothing can be used

in a performance or to express a concept. It can feature in sculpture or installation, video or a virtual world.

Over the same time period, our relationship with clothes has changed completely. Formal dress codes have begun to break down. The line between work and play is blurring. Advances in fabric technology have made garments lighter, warmer, easier to wear. Shopping is now a mass leisure activity. Fast fashion is cheap and manufactured in far-off lands. Meanwhile the industry as a whole blinkers its conscience, and consumers often ignore the hardship and injustices faced by those who make our clothes.

These changes in art and fashion seem to go hand in hand. Is this freedom?

The art industry is still dominated by male artists. In the first few months of 2019, just 2 per cent of art sold at auction was by women. At London's commercial galleries, 68 per cent of represented artists are male.

Fashion is condescendingly seen as a female pursuit. Look at the fashion pages of most newspapers and you'll see that fashion is really taken to mean womenswear, in the strictest gender-binary terms. Yet the owners of the two biggest luxury-label conglomerates are both men, both profiting from what women spend.

I've spent twenty years as a fashion journalist. Most of my writing has been about clothing up to the point of production. This meant writing about garments of which one version had been made, only worn once by one model in the unreal conditions of a catwalk show.

Many of those pieces in fashion shows are just for the

runway – they are never commercially produced. To write about wearing them is fantasy. The language of fashion is founded in conjecture.

Now I want to write about clothing after the point of production. That is, once it has been made, bought, worn and given meaning by its wearer. I would like to understand the language of clothes. Artists make an excellent first field of study, because of their freedom with style, their struggle for self-expression, and the power structures they work within, and often fight against.

This is not to deify artists: how boring, how false. How much do we miss of someone's complexities if we put them on a pedestal? This goes for their work, their lives, and also what they wear. It dehumanizes Frida Kahlo to treat her garments as sacred relics. To talk of her in platitudes limits our understanding.

Clothing can be much more useful if we are wily in our manner. I've often found that, when I ask someone about their clothes, they soon start talking about so much else: how they live, what they do, how they think, what they want. Clothing is a way in.

By studying the garments of artists, we are able to approach them as human beings. Once we break from the assumption that artists are god-like, we can disrupt the canon, an art-historical tradition dominated by white men. In the process, we can look again at the meaning we attach to our own clothes, and free ourselves from ways of being that seek to keep us in our place.

We'll start with Louise Bourgeois, an artist who was alive for much of the twentieth century and the beginning of the twenty-first. Her work was ignored for most of her life. Bourgeois had a pivotal relationship with clothing, in the century where clothing became a material in art.

We've got a lot to get through. But then when you visit an art gallery, how much time do you really spend in front of each work? According to research, it's 27 seconds. And yet in that short amount of time, the work can go in deep.

There are many artists to encounter. But as we look at them all together, patterns start to emerge. We'll see that, often, artists wear the same garments over and again, particularly while working. Theirs should be an example to all of us to only buy what we need, to buy what will last, and to wear it until it cannot be worn any more.

For this book, I had the pleasure to email with the artist Richard Tuttle, who you'll hear more from later on. Tuttle's work and words are beautifully, insightfully elusive. He mentioned an image by Eugène Atget, a photographer who documented Paris at the turn of the century, until his death in 1927.

Tuttle said: 'Your book could be like the photo of a hat-shop-window, where you can see *all* the hats, not just the one you would choose if you were in the same position as the camera, not just a moment, but eternalized in scope and in time *by* the photo?'

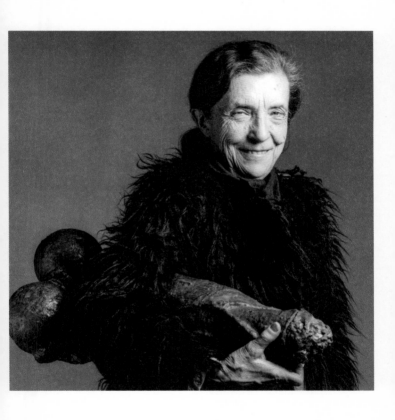

**Louise Bourgeois**

**Louise Bourgeois kept a rail of clothes** opposite her gas stove. You can find them there now: her home on West 22nd Street in New York has been preserved since her death in 2010. Her kitchen is a tiny galley between her front and back rooms, the stove two industrial kitchen burners, the white brick wall behind them greased. Much of the rail is occupied by white shirts and tops, her everyday layers. A sleeveless long white shirt has the label MOTHERHOOD.

There are also momentous pieces. Within pan-fat-spitting distance is a monkey-fur coat like the one from her famous portrait by Robert Mapplethorpe, a clasp at the neck, shirt collar attached. She apparently had two. The coat from the photograph is said to have been given by Bourgeois to the writer Gary Indiana. I emailed Indiana to check. Was the Mapplethorpe monkey-fur coat the one at her home?

'No. I do have it.'

How did he come to have it?

'One day Louise just said, I think you should wear this for a while, and arranged it on me.'

Indiana still has the coat. 'Someone threw it in the wash at some point, so it shrank a lot.'

Bourgeois was in tune with the emotion and trauma that we instil in our clothes, and the toll of letting them go. Fashion had been part of her life since she was a child, born in 1911 to an affluent Parisian family. Here's Bourgeois in 1913.

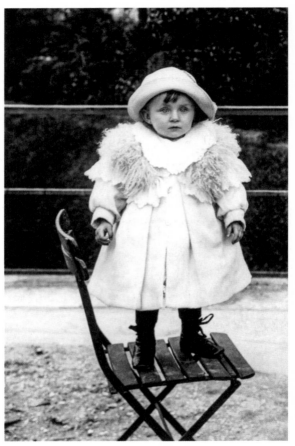

She was wearing Chanel aged thirteen.

That photo was taken in 1925, by which point her father, Louis Bourgeois, had started an affair with the family au pair, Sadie Gordon Richmond. Her father's emotional abandonment would have a powerful impact on her life, her work. Bourgeois would come to use clothing as a focus within the self-psychoanalysis that defined her artistic practice.

By the mid-1930s, Bourgeois was studying art and had begun exhibiting her work in group shows. In 1938, she met and married art curator Robert Goldwater, emigrating with him to New York. She made work, became part of the artist community, but was known more as Goldwater's wife rather than an artist in her own right. Here is Bourgeois at the opening of a show by Franz Kline in 1960 at the Sidney Janis Gallery.

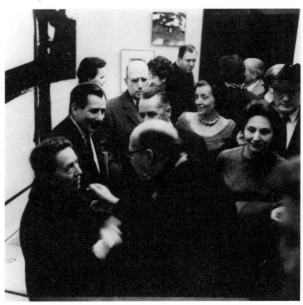

That's her, in the beaded necklace. In the crowd around her are Kline, Mark Rothko, Willem de Kooning: male artists benefiting from the full glow of critical attention not then given to their female contemporaries. When this photo was taken, Bourgeois had not had a solo show for seven years.

Clothes in her daily life were intrinsically linked to her grief, trauma, rage. On 2 January 1961, Bourgeois wrote about it in her notes. This is a translation, but I'll keep the pacing of the words as if by her hand:

*Like a dumbo I think*
*I am going to cry – my garments and*
*especially my under garments have always been a*
*source of intolerable suffering because they*
*hide an intolerable wound.*

Such was the significance she found in clothing. She held on to it all, as she describes in this note from around 1968 – the 'Alain' she refers to is her third son:

*It gives me great pleasure to keep my clo*
*thes my dresses, my stockings, I have never thrown*
*    away a pair*
*of shoes of mine in 20 years – I cannot separate*
*myself from my clothes nor Alain's – The pretext*
*is that they are still good – and it's my past and as*
*rotten as it was I would like to take it and*
*hold it tight in my arms*

Goldwater died in 1973. Bourgeois's work became more ambitious. It was as if she were unshackled. As part of performances, she created otherworldly garments,

a total contrast from the stifling correctness of her child-hood clothing.

Here is Bourgeois in 1975, stood outside her home, wearing her sculpture *Avenza*.

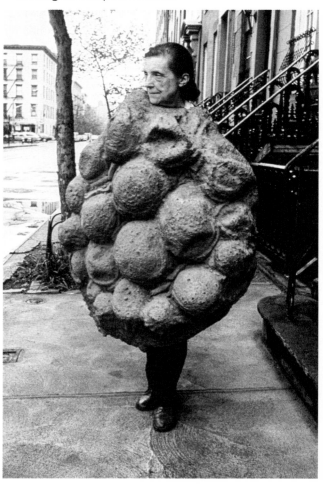

She continued to hoard her clothes. On a loose sheet, thought to be from 1986, she wrote:

*very very difficult to get rid of*
*all clothes that I do not use this year*
*what do they represent =*
*failures, rejects abandoned*

Something changed. In 1995, aged eighty-three, Bourgeois cleared her clothes from her home to her studio in Brooklyn. She wrote:

*The shock came when the truck appeared =*
*and a twenty year preserved wardrobe actively*
*left my sight – the cord was cut and I felt*
*dizzy –*
*The history of the wardrobe started –*

Suddenly, her clothes became a material in her own work. With their meaning made overt, they were no longer at risk of being discarded upon her death.

It was a liberation.

In 1996, she made *Cell (Clothes)*, a sculpture like a room set, hung with dresses, skirts and stockings, some filled out to evoke a body. On the back of a white coat, Bourgeois embroidered in red thread 'The cold of anxiety is very real'.

Wardrobe purged, her clothing in her last years could be of defiant glee, of pleasure and provocation. It was aided by a new friendship: in 1997, she met the Austrian artist and fashion designer Helmut Lang. He was forty-one at the time, a fast-rising name, just moved from Vienna to New

York. His designs were exacting and playful, utilitarian, clever and sexy. Bourgeois wrote about Lang in her diary.

SEPTEMBER **9** TUESDAY

1997  252nd day – 113 days follow

*La Memoire :* swatches are enough
*Colliers :* d'échantillons de tous
les effets portés, les vêtements eux mêmes
pendent disparaître
1000 vêtements sur cintres
voir dessins

*colliers*

Designer Helmut Lang from Vienna
curates a show of Holzer, Louise Bourgeois
and at the museum.

The H of Helmut is beautiful, extending over the lines, with little hooks on the tips. She was charmed.

How does Lang remember their meeting? He emailed

from his home in Long Island, where he has dedicated himself to his art practice since quitting fashion in 2005. 'When I came to see her for the first time,' he wrote, 'she stood on the steps outside of her townhouse expecting me and said, "Bonjour Helmut – welcome!" and kissed me.' Bourgeois would wear pieces by Lang for the rest of her life.

'I have a very strong emotional and unconditional bond with Louise,' he wrote, using the present tense, 'maybe because, as she once said herself, we are both runaways.'

For evidence of this friendship, let's flick through her rails. It is extraordinary to be in the presence of her clothing. It feels as alive as her home, the phone numbers she wrote on the wall, still there, the pile of cushions on her chair that gave her extra height.

In the basement, under the spiral stairs she had built, there was a second metal rail crammed with clothes on hangers. It was propped up on a shelf stacked with plastic crates filled with folded cloth, ready to be turned into fabric sculptures in the seamstress's studio at the back. She was making work right up until her death.

On one hanger, a padded knit shawl by Helmut Lang. It was essentially a doll-sized duvet turned horizontal, its wadding thick, with two thin knit straps through which the arms could be placed. It was exquisite and odd, the type of piece Lang designed that found ingenious fashion in what is essentially function. It must have propelled him, knowing he had an audience of alert thinkers, like Bourgeois, eager for his experimentation.

Back upstairs, on the rail opposite the gas stove, there was a Helmut Lang black tufted tuxedo coat. It was a sample – inside on the label someone had written 'look 62

Stephanie'. Afterwards, I searched through old Helmut Lang catwalk images. At his spring/summer 1999 show, held in Paris on 30 September 1998, look 62 was the exact same coat, worn by Stephanie Seymour. Lang must have given this rare piece to Bourgeois.

'As we were friends,' wrote Lang, 'we did give each other gifts on certain occasions. She even made for me a special sculpture which has the form of a house – the house symbolizes family – with the text "WE LOVE HELMUT" on it. From my side, I gave her rather extravagant pieces which she loved to wear when she had a photo shoot, on special occasions, or when she had company she cared about.'

Still on her rail is the oversized sheepskin coat by Helmut Lang which she wore often. Here is Bourgeois, in the coat, at home, in 2005, aged ninety-three.

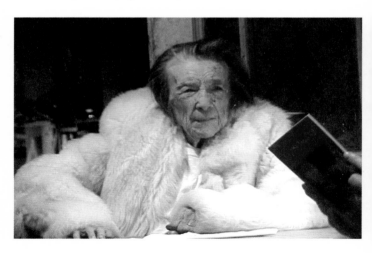

Clothes had carried the weight of her abandonment, grief, pain, sense of failure. Through her life, garments had first been decorative, then dutiful. At the end of her life, clothing was a release.

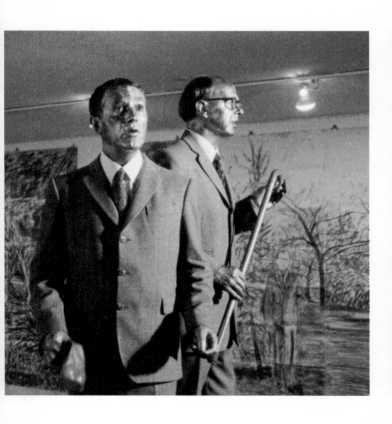

Tailoring

**One early summer evening,** I was sat on the top deck of the 67 bus coming down Kingsland High Street, looking out of the window. There were Gilbert & George! The artists were walking up the road, past queer bar Dalston Superstore, presumably on their way to the Turkish restaurant Mangal 2, one of their favourite places to dine. It was the first wave of summer, but the artists were in their heavy tweed suits.

It is the clothing they have worn since declaring themselves a collaborative art duo in the late 1960s. Even for men in their seventies, they stood out. No one of any age or gender nearby was dressed like them.

Tailoring is generally regarded as regular dress for men. So why do they look so weird?

To understand what artists wear, we must first unlock the hold that tailoring has on our psyche, and the role it plays in society.

On 9 March 1960, the French artist Yves Klein staged a performance in Paris titled *Anthropométrie de l'Époque Bleue*. He was thirty-one. It came to be seen as a landmark in twentieth-century art, an audacious use of the body in the act of painting. Klein died two years later, from a heart attack.

For *Anthropométrie*, Klein directed three naked female models to cover themselves with blue paint – his own colour, International Klein Blue. They then used their bodies as brushes on sheets of paper on the floor and wall.

Throughout the performance, Klein wore a tuxedo.

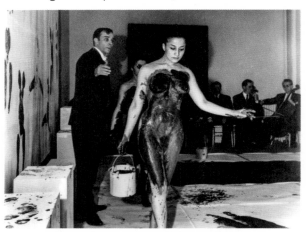

The audience was in formal eveningwear.

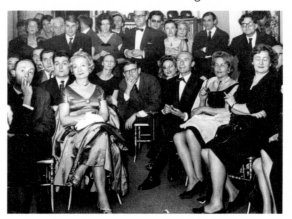

'In this way I stayed clean,' said Klein. 'I no longer dirtied myself with colour, not even the tips of my fingers. The work finished itself there in front of me, under my direction, in absolute collaboration with the model. And I could salute its birth into the tangible world in a dignified manner . . .'

His choice of outfit was not a one-off. A couple of months earlier, he had staged a version of the performance at his studio in Paris. Here's Klein, crouched on the floor with the work *Héléna*, the movement of a female body visible in the paint. Klein wears his tailored tux, cut sharp and neat. Underneath his white bow-tie hangs the Maltese Cross of his religious brotherhood. Klein's tux contrasts with the regular trousers of the unidentified figure stood behind.

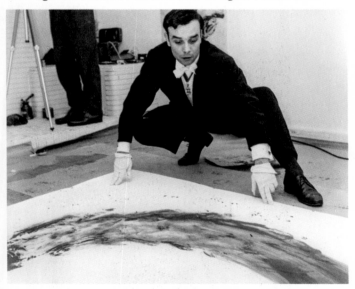

Elsewhere in mid-century Paris, tailored pieces were playing their role in another artist's taut psychology. Alberto Giacometti was totally dedicated to his work and the squalor in which he created it. The Swiss-born artist moved to the French capital in 1922. His stick-thin sculptures and intensely marked paintings brought him great success in his lifetime, yet he remained in the same dirty studio, shoving his francs under the bed. The squalor was also mental: he psychologically abused his wife, Annette, who frequently modelled for him. 'I've destroyed her, I've destroyed her, I've destroyed her,' he said. Through it all he was dressed in the clothing of male respectability: tweed jacket, flannel trousers.

'Alberto's apparel was so much a part of his personality as to seem almost a state of mind rather than an outfit of clothes,' wrote James Lord, who posed for Giacometti and, after the artist's death, became his biographer. Lord confirmed the rigidity of Giacometti's look: either a grey or brown tweed jacket, baggy grey flannel trousers that were usually too long.

This was not precision tailoring. Giacometti would be elbow-deep in clay, and still be wearing a tweed jacket. At work or rest, his tailoring was a permanent companion. A suit's power is often assumed to come from neatness. Giacometti had no need for tidiness to exert control.

If he took such little care of his clothes, couldn't we overlook his tailoring? It's just a crumpled old suit jacket, right? And yet it is not the sharpness of tailoring that matters.

Giacometti's wardrobe choices were as defined as the rules that guided his work. Men in his sculptures walked and pointed. They were granted movement, freedom. His women stood stock-still, arms tight at their sides, no movement, no freedom.

In France, women were not granted the right to vote until 1944. A bill for women's suffrage had been introduced in 1919, which the French Senate then repeatedly blocked for twenty-five years. French men had been granted universal suffrage in 1848, ninety-six years earlier.

Giacometti's mother, Annetta, was a frequent model in his paintings. Annetta lived in Stampa, Switzerland, where women would not gain suffrage until 1971. Annetta never

had the right to vote. She died in 1964, two years before her son.

A law forbidding women in Paris from wearing trousers was repealed in 2013. It had been introduced during the French Revolution to prevent women joining the 'sans-culotte' movement. The law was amended in 1909 to allow women to wear trousers if they were holding the handlebar of a bike or the reins of a horse. In any other circumstances, if women wanted to wear trousers, they had to ask permission from the police.

Tailoring is not neutral. We understand its meaning when worn by those in business, those of authority: the suit demarcates power over others – usually male power. Such is its ubiquity and hold on our psyche, its origins are rarely analysed. What do we want to hide?

Let's briefly glance back. The tailored suit evolved from male riding and military outfits of the seventeenth and eighteenth centuries. These were the garments worn by the British aristocracy, the ruling class that bolstered its wealth and power through the slave trade. By the late 1700s, the male aristocratic dress of George III's court had become frilled and frivolous. In London, at the beginning of the nineteenth century, society figure George Bryan 'Beau' Brummell began ordering plain yet elegant bespoke garments from the city's tailors, cutting away all the excess. Without Brummell, the modern-day suit would not exist.

In 1832, the Reform Act gave male property owners the right to vote. Here's a painting, by George Hayter, of the first sitting of the House of Commons after the act was passed.

Brummell's drab-coloured, sleek tailoring had become the new uniform of male power.

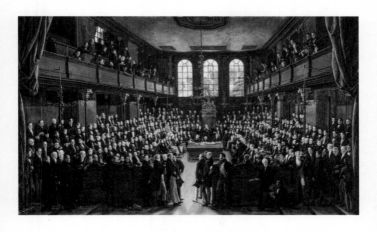

Can you see what's happening here? Claims of authority were locked into the tailored suit, the new signifier of power which presumed maleness, whiteness and the West as the imperial centre of the world.

We can say good things about suits, especially their ergonomic design. We can use these value judgements as a way of avoiding or ignoring the symbolism of the suit. But these value judgements do not wipe that symbolism away.

Giacometti's jackets have style from their spacious cut, the aged softness of the cloth, the wilful shambles that overrides any smartness, the relaxed balance of his baggy pants. He looked great. Here he is in the doorway of his studio in 1950.

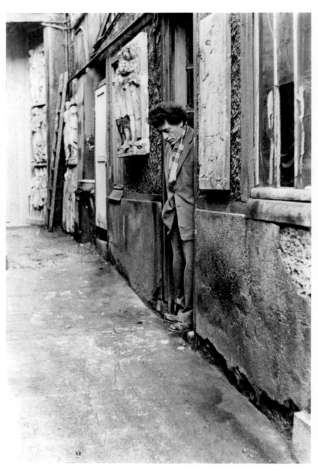

And there are instances in which the authority of tailoring has been wielded for good. In his early twenties, the artist Charles White was teaching a life-drawing class at the newly opened South Side Community Art Center in Chicago. The photograph is grainy, but it is an important document

of the city's burgeoning African American artist community. It was taken in either 1940 or 41.

That's him, stood at the front, wearing a jacket, shirt and tie to give him authority beyond his years.

White's mother, a domestic worker, had raised him alone, often leaving him at the Chicago Public Library during the day. He quickly showed an aptitude for study, and for drawing.

Aged fourteen, he became the youngest member of the city's Arts Craft Guild, a collective of African American artists and activists. In 1940, White helped found the South Side Community Art Center in Chicago, said to be the nation's most significant arts organization for African American artists of that era.

White is now recognized as an American artist of great importance. He created bold, compassionate, humane,

political portraits of African Americans. A teacher throughout his artistic career, he played a pivotal role in twentieth-century American art. He was both maker and educator.

After some years in New York, White moved to California in 1956, on the advice of doctors. He had contracted tuberculosis in the US Army during the Second World War. From 1965, White taught at the Otis Art Institute in Los Angeles. His pupils included artists David Hammons, Ulysses Jenkins and Kerry James Marshall. Marshall said of him, 'I saw in his example the way to greatness.'

With the move to the west coast, White's clothing had become more casual. This portrait by Kent Twitchell was drawn in 1977, two years before White's death. He's wearing a jacket like it's a cardigan.

What of women's tailoring?

During the 1940s, the American artist Georgia O'Keeffe started to wear suits. She was in her fifties, living between New York and New Mexico, where she would eventually settle. She ordered her suits bespoke, cut and fitted to her body, usually from men's tailors. These were her 'town clothes', worn when she visited major cities.

On 10 February 1944, O'Keeffe wrote to the First Lady, Eleanor Roosevelt, responding to a *New York Times* news story headlined 'First Lady Fights Equal Rights Plan'. Roosevelt had declared her opposition to the Equal Rights Amendment, which would guarantee equal rights regardless of sex, stating she feared the removal of laws protecting women in the workplace.

O'Keeffe strongly disagreed. 'The Equal Rights Amendment would write into the highest law of our country, legal equality for all,' she wrote to Roosevelt. 'At present women do not have it and I believe we are considered – half the people.'

She continued with her argument. 'Equal Rights and Responsibilities is a basic idea that would have very important psychological effects on women and men from the time they are born. It could very much change the girl child's idea of her place in the world. I would like each child to feel responsible for the country and that no door for any activity they may choose is closed on account of sex.'

Roosevelt would never support the Equal Rights Amendment. There has never been an Equal Rights Amendment in the United States.

O'Keeffe would order bespoke suits until three years

before her death. This is her last suit, bought in 1983 from men's tailors Emsley of New York. O'Keeffe was ninety-six.

The suit is of reduced design: there are no flaps over the pockets; the waistcoat beneath has a functional round neck; the cut is ample for bones living into their tenth decade.

It is glorious, an example of ergonomic tailoring that flatters the body. If only we could admire this tailoring without having to acknowledge its connotations.

As we have seen, suits come from male garments of power, from riding and military tailoring. There is no

equivalent female narrative. Women's riding jackets were derived from male dress. Women have no history of military tailoring, because, until the twentieth century, they had no history in the military. Female tailoring is derived from male tailoring.

Any artist who wears a suit, whatever their gender position, must contend with this encoded meaning of male power. There is no way to escape it. It is up to them how they use, exploit or challenge it.

Tailoring is prime to be subverted by artists willing to place themselves within their own work. As a teenager, Mexican artist Frida Kahlo wore suits with defiance. In this family portrait, she wears a three-piece suit, flanked by female relatives in dresses.

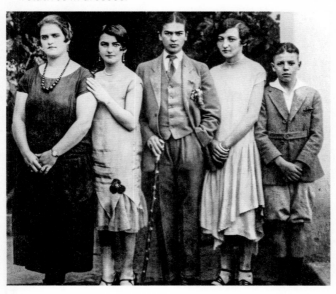

The photo was taken in 1926, a year after the crippling bus crash which fractured her ribs, legs, collar and pelvic bone. In 1928, Kahlo fell in love with the artist Diego Rivera. They married a year later.

Kahlo soon dropped the suit in favour of decorative Tehuana dress, an overt symbol of Mexican pride. Rivera liked Kahlo to wear this traditional dress. Rivera himself wore tailoring.

Theirs was a life of turmoil. The couple divorced in 1939 after affairs on both sides. In 1940, she painted *Self Portrait with Cropped Hair*. In the portrait, Kahlo wore what is assumed to be one of Rivera's suits, surrounded by her cut hair – Rivera had admired it long.

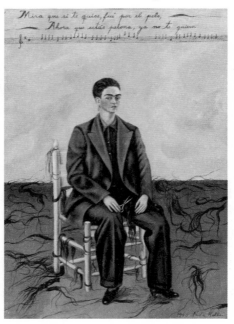

The male suit gives her power, but power over whom? She soon remarried Rivera, her wardrobe returning to traditional dress. Kahlo died in 1954, a year after Mexican women were granted the vote.

Two decades later, New York artist Laurie Anderson began using tailoring as part of her critique of power and control. Anderson's work encompasses music, performance, storytelling. She gained global fame from her songs, most notably 'O Superman'. This is the cover of her first album, *Big Science*, from 1982.

I emailed Anderson to ask when she began wearing suits. The timing of her replies made me think she was in New York, but her emails were signed 'Sent from somewhere'.

During the early 1970s, when she first started making performance work, Anderson went through what she called 'the all-white Maharaji era': long white smock tops, wide white pants. 'We wore white because we were Buddhists, doing drugs, part of a dance company, pacifists, the last of the hippies or all of the above.'

In 1978, Anderson wore tailoring on stage for the first time. She was performing at the Nova Convention in New York, a three-day celebration of the writer William Burroughs, who had returned to live in the United States after years in Tangiers and London. For the occasion, Anderson wore a tailcoat, cropped severely at the front and long at the back. Was wearing a suit connected to ideas of authority?

'It was a tailored man's suit, so yes,' wrote Anderson. Burroughs famously always wore tailoring. 'I had to be an MC and introduce William Burroughs. It had to do with making fun of authority like Burroughs did.'

The Nova Convention was an important moment for Anderson: it was the first time she used a Harmonizer to alter her voice, lowering the pitch so she could sound like a man. This character became known as 'The Voice of Authority'.

In 1986, Anderson wrote: 'It's only recently that I realized that this guy is based on my first idea of who men were.'

When she was a child, if she was feeling ill her father would cheer her up with songs and dances.

*I thought, How charming! Men are such a carefree species.*
*So light-hearted! So free!*
*The women, on the other hand, were authority figures*

44

*always saying things like, 'Read this book! Eat this dinner!'*
*and the men didn't seem to have a care in the world.*
*Now, it took me a long time to realize that this wasn't necessarily*
*the way things were in the real world.*

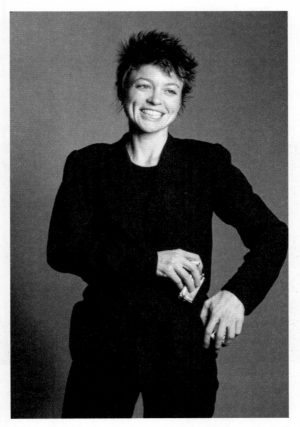

Nowadays, Anderson is most likely to be wearing what she calls 'farmer plaids'. The Voice of Authority still exists,

though he is now known as Fenway Bergamot, named by her late husband, Lou Reed. Her view on authority remains the same: 'Authority has always seemed bankrupt.'

Men have also worn tailoring as a means of subversion. In 1967, the American artist Paul Thek created an effigy of his corpse that has become known as the 'Hippie'.

The 'Hippie' was dressed in a suit, and laid to rest in a purpose-built tomb, housed in the Stable Gallery in New York.

Thek was friends, and sometimes lovers, with the American photographer Peter Hujar, who took this image.

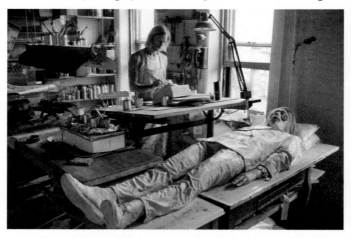

The photograph is important to our understanding of Thek. Barely anything of his work survives, much of it damaged, lost or destroyed in his lifetime. He had gained some recognition in the 1960s but found himself out of step with the contemporary art world, his work too emotional compared with what was then selling.

That sentence makes it seem like it was Thek's fault. In truth, the art world was unable to cope with such a queer, questioning, radical mind. Thek fell victim to the AIDS crisis, dying in 1988.

Look at the photograph in detail: Thek's effigy lies in memoriam, his garments painted pink. Any ceremonial reverence is undercut by the figure's tongue, half sticking out. The artist himself is stood nearby wearing a vest and apron, painting another cast of his own face.

Thek was immersed in ideas of life and death, the role of the artist, and how artists are treated by wider society. He was disobedient. It seems like the effigy is wearing a pink-painted suit but, if you look closely, he's actually matched the double-breasted tailored jacket with a pair of jeans. He's showing a disdain for the sanctity of dying, for the rituals and structures of power that hold humans from birth to death, the structures that venerate some and exclude others.

More male suit subversion: in London, 1969, Gilbert & George wrote their *Laws of Sculptors*, which have guided their lives and working practice since. Rule one is simple and clear. 'Always be smartly dressed, well-groomed relaxed and friendly polite and in complete control.'

From the very beginning, their appearance has been of primary importance in their work, pivotal to their existence as Living Sculptures. 'We step into the responsibility-suits of our art,' they wrote in their 1971 pamphlet *A Day in the Life of George & Gilbert*. 'We put on our shoes for the coming walk.'

Here they are, performing as the Singing Sculptures, in New York in 1991.

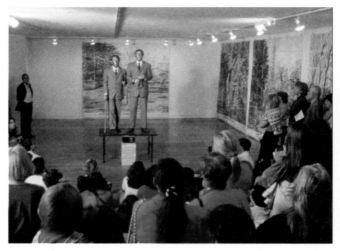

Their rule is one of both sincerity and subversion.

Sincerity first: 'We are both war babies, we both came out of a wrecked land,' said George in 2013, interviewed by the artist Slava Mogutin. Gilbert was born in the Dolomites, Italy; George in Devon, England. 'We felt that we were poor people and if it's an important occasion, if you try to get a job or if you go to a wedding or funeral, you dress up nicely.'

Then subversion: 'We realized that a lot of artists dressed in an eccentric way or had eccentric style to show that they were artists,' said George. 'We felt that alienated 90% of the world's population. You can't get into a restaurant – why be deliberately weird? We wanted to be normal, normal weird . . .'

Gilbert finished the sentence: '. . . so normal that we became strange!'

Their suits are not identical. George is taller and has a ticket pocket above the regular outer pocket on the right-hand side, a tailoring trick to visually lessen the length of his trunk. There are four pockets in total. Gilbert's suits have three outer pockets: two flap, one breast. The difference confirms their self-definition: 'two people but one artist' – they are not pretending to be the same person. Gilbert & George are absolute individuals choosing to work together for one goal.

The pair of them delight in the contradiction of their lives. George is said to vote for the right-wing Conservative Party in Britain. They have spoken adoringly of Margaret Thatcher. And yet their photomontage work has involved images of urination and faeces. They have posed in their suits among images of rent boys. They have taken off their suits completely, bent over and shown their assholes.

Their outfits are not made by establishment tailors on Savile Row but by outsiders. They have long lived on Fournier Street, in Spitalfields, East London, an area welcoming to successive waves of immigrants. Gilbert & George get their suits made by their neighbourhood tailors.

These immigrant tailors are found just outside the boundary of the City of London financial district, creating suits for those wanting to fit in. This is tailoring in which to ape normality.

The area where the artists live is one of flux. Rent rises are pushing out most locals. Are there any tailors left? I emailed Gilbert & George. This is their reply, just as they wrote it.

*1st, we had Jewish tailors.*
*then we had a Cyprus tailor.*
*Now we have a TIBETAN.*

Above all, tailoring signals the banality of power. It is a banality found in the single-breasted suit, mass-produced. This banality has been successfully wielded by artists.

In 1988, Jeff Koons named a whole series of sculptures *Banality*. It was the series that included a sculpture of Michael Jackson and his monkey Bubbles.

Koons studied art, then worked as a commodities broker on Wall Street. His day job funded his first art pieces, giving him independence from the art market. Tailoring was his everyday reality, and he played on the absurdity of being a sober-suited artist while making audacious art.

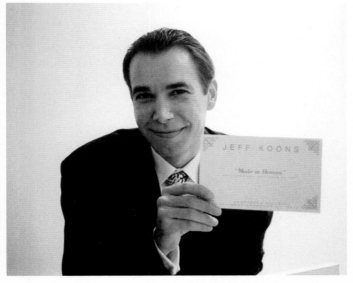

It is a familiar pose. To this day, Koons has a habit of posing in front of his works, mugging for the camera. He usually does so in the banal/expensive/banally expensive tailoring favoured by the blue-chip collectors who buy his work.

It is often at exhibition openings or art fairs that the language of tailoring is depressingly clear. Walk round, and you'll find most male gallery staff wearing suits. For all its overtures to radicalism, the art industry can be deeply conservative.

The same is true of the fashion industry, where catwalk creative freedom is a foil for the compromised mundanity of the mass-produced stuff that actually sells.

This is the context within which we must look at artists, and at clothing, and at those who attempt to find individuality and purpose with both.

**Jean-Michel Basquiat**

**Jean-Michel Basquiat is repeatedly cited** for his tailoring. It is often by white editors of men's magazines desperate to appear diverse. But Basquiat was not one to conform. His relationship with clothing was complex and intuitive, a jumble of thrift and high fashion, a mix of colour, texture, garment. In a photo shoot with his friend Andy Warhol, Basquiat had half his tie over his shirt collar.

Let's talk with one of his close friends, the stylist Karen Binns. Here she is with Basquiat and Warhol in 1984, at a dinner to celebrate the opening of a Basquiat show. Look at the difference between Warhol and Basquiat: Warhol in formal eveningwear, Basquiat in soft, pale tailoring.

How did they meet?

'I used to see Jean at poetry readings, on 9th Street and 3rd Avenue, on the diagonal,' Binns said. If you've been in the East Village, you'll know the spot – a rare diagonal street on an otherwise perfect grid.

'I would go there the Saturday afternoon, and I remember the first time I saw him because I remember looking at myself. Wow, he looks cool. What about me? That's what you did. I was like, Ohmygod I want my look to be strong too.'

What was he wearing?

'An orange woolly hat, tons and tons of dreaded hair underneath, two sweaters that were different colours, possibly lime green or blue-ish green and grey, old man's trousers, way too big, and a beautifully coloured sneaker. I think I even remember him reading something.

'I thought he was a rich kid. I thought, a black kid is not going to walk around looking like that, being as confident as he is, unless he's got loads of money. Meanwhile he was probably homeless.'

They first spoke at a club called The Roxy. 'He was wearing a coat falling off of him, and a beautiful sweater, and trousers that were falling off, maybe an old flip-flop or something. This was the fucking winter. I was like, really? He slapped me on the ass and I slapped him in the face. I said, "How dare you put your hands on me." He said, "Don't you know who I am?" I said, "Yeah, your name's Jean, you don't wear socks in winter." So I left it.'

There was soon a thaw. 'Next time I saw him again he had on some kind of two-tone beautiful sweater with holes in it, a random shirt beneath it, a very loose trouser, and the

biggest woolly multicoloured hat on. He came up to me in Area and said, "I want to buy you a glass of champagne."'

Basquiat had a singular approach to what he wore, whatever he was doing. 'He dressed in the most expensive clothes,' she said, 'with paint all over them. Constantly. Most of the time he wore Comme des Garçons, with loads and loads of paint, and also loads of joint burns. The slipper was part of his life, and they would be the beautiful slippers like your granddad had, paint all over them. I never saw such brilliance. It was always a look! The shirt would be twisted round, a scarf would be thrown from somewhere else. It was the most natural look that I've ever seen.'

Here's Basquiat in a hat she bought him for his birthday, made by Kazou. Next to him is artist Francisco Clemente.

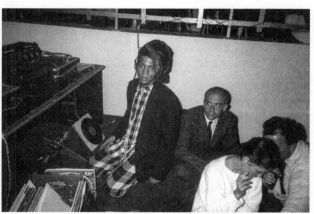

Again, look at the contrast between Basquiat and Clemente's clothes. Clemente is all stiff, buttoned-up. Basquiat has on a loosely constructed jacket, over a plaid shirt, with plaid trousers in broader check. It is tailoring from another

world. What was Basquiat wearing? 'Probably Comme des Garçons.'

Basquiat was living and working in a studio just off the Bowery. 'His style was eclectic out of necessity. He used to say to me, "I live where I live to remind myself where I'm from." I said, "But you're from Brooklyn, like me." He goes, "No, I used to live in the homeless shelter across the street." There's always that sense of homelessness.'

And then Binns mimicked his voice. '"Always dress just in case," he'd say. "I might have to sleep on the street, Karen, it takes one minute for us to be outside."'

Spontaneity, self-belief was all. 'I remember showing up at his house one day, and him putting on a beautiful new jacket from Comme. Underneath was the painting outfit he'd had on all day, and the slipper he had no intention of taking off. He said, "Great, I'm glad you're here, I just called a cab." I was like, "What do you mean?" He said, "We're going to the Met." I said, "I'm not going to the Met dressed like this."'

She was wearing a cap-sleeve trench three sizes too big, Adidas trackpants, brogues and a headwrap. 'He said, "No, you look cool, we look cool. We're bad. We're badass." I said, "You're taking me to the Met?" "Yeah, I gotta go for the dinner." I said, "Are you serious?" "Yeah." He takes me to the fucking Met dinner.'

Binns said Basquiat's art and what he wore were the same thing. 'When you look at his work, the way he put colours together, it's the way he got dressed. Completely.' So too the art on everything – tagging walls, doors becoming work, his ideas and intelligence uncontainable. Likewise

the paint all over his clothing. The language of what he wore was formed long before his sudden fame – oversized, off-kilter, chaos in control. Comme des Garçons was the place he found his language understood.

The label is the creation of Japanese designer Rei Kawakubo, whose ethos is a desire to create new forms. Its catwalk shows are held in Paris. In 1987, Kawakubo wanted Basquiat to model in her men's show. At the time, Binns's then husband, Harry, was working at Comme des Garçons in New York. Kawakubo asked Harry to ask Karen to ask Jean.

'I go to Jean's, I say, "Listen. You know Rei wants you to do her show?" He kept on painting,' said Binns. They talked about the terms, Basquiat smoking a joint, and agreed on a fee. 'He said, "Yeah, I spend a hundred grand a year in that shop anyway."' Basquiat also had other conditions. '"You know what else?"', said Binns, as Basquiat, '"You got to come, and they've got to put you guys in the same hotel as me. These are my terms."'

They flew to Paris. 'We get to the hotel, he's ringing my phone. "Karen, come upstairs."' She went upstairs, where Basquiat had received the payment, already made. 'I said to Jean, "You've got to show up for the show now, right?" He's like, "Don't worry about it." He's pulling out a joint in the hotel.'

Basquiat turned up for the show. He modelled a double-breasted suit, its multitude of buttons reaching back to tailoring's nineteenth-century origins, but its cut slick and modern. 'It was genius,' said Binns.

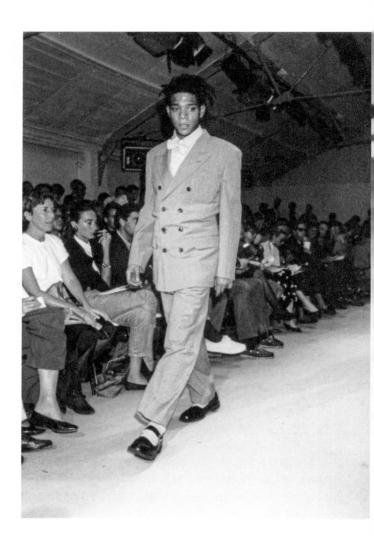

There were other looks, like this long zippered jacket, pushing the shape of a bomber into a more formal tailored line.

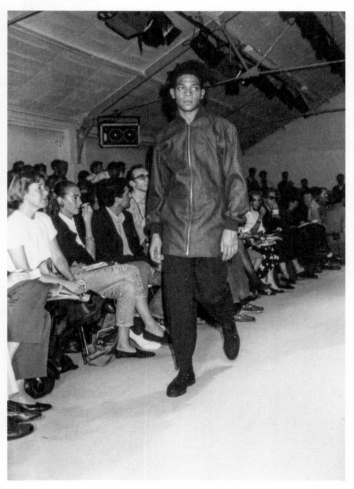

If only all tailoring had such sense of curiosity and purpose! If there had been innovation in its design, it could then have had a primary meaning other than as a garment worn to express power. The suit, and those that wear it, still rule, in ways that many artists have stood against. These artists have explored other forms of clothing, which we will consider next.

Workwear

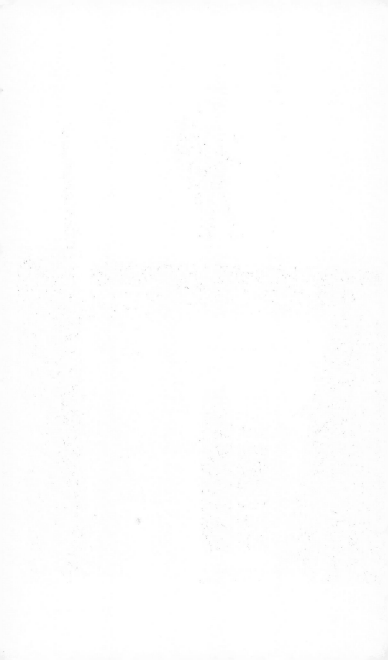

**This book started with a photograph** of Agnes Martin. It was taken in 1960 in her New York studio by Alexander Liberman. I am captivated by the image, by what Martin is doing, and the functional workwear keeping her warm.

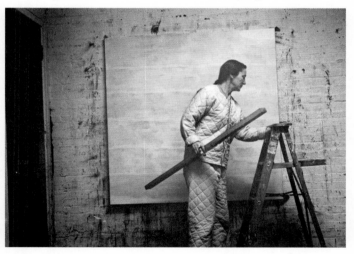

Functional clothing, or modern workwear, evolved from the garments of the working classes. During the nineteenth century, durable cotton ready-made clothing began to be cheaply mass-produced. Workers had previously dressed in wools and linens. Now wool was for tailoring, cotton for the labourer.

Industrialization increasingly required tough clothing that fitted close to the body, while allowing the worker full movement. The flounce and volume of rural dress faded away. In the 1920s and 30s, this distinction was articulated: the 'white collar' of tailoring worn with shirt and tie, the 'blue collar' of the worker.

Functional clothing is practical. The term has become part of fashion's lexicon, to describe garments that work hard: big pockets, durable fabrics. Why does functional clothing have such a charge? Why does the word 'functional' hit such an emotional spot?

Maybe artists can give us some clues. Because for many artists in the twentieth century, functional clothing was an alternative mode of dressing for a lifestyle that ran counter to society. Their lives can make us look at our own and ask: how do we function? What could we change?

Agnes Martin was born in 1912, in Canada, the daughter of farmers. Her father died when she was two. Her mother was neglectful. When Martin was six, she had tonsillitis. Her mother gave her money for the streetcar. She travelled to hospital, endured an operation, then travelled back home on the streetcar, alone.

Martin grew up in this era of newly available mass-produced functional clothing. She once listed the jobs she'd had before she could make money as an artist. They included working 'in a factory'; 'on a farm – milking'; 'three times at the wheat harvest'; 'as a waitress many times'; 'as a dishwasher three times'. In 1947, she built her own house. She was always a worker.

Martin was queer, schizophrenic, self-sufficient,

interested in Zen Buddhism: characteristics for women not celebrated in twentieth-century American society. Through her life and her work, Martin found her own ways outside societal structures to live with herself. Her life was about functionality: physical, mental, spiritual.

Until midlife, Martin existed in financial hardship. There was no excess: existence was basic. Here is Martin in her studio in Taos, New Mexico, in 1954.

A garment without fancy. And yet, contemporary eyes loom over it with desire. It's the line of the collar; the collar's width as it approaches the shoulder; the smocked line at the top of the chest; the slight drop shoulder; the low

pocket; the sturdiness of the cloth and the lived experiences it could sustain, hardy to use.

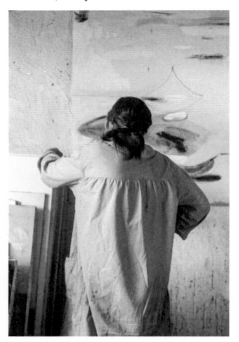

The hemline is long. On the left-hand side can be seen a large pocket. There is a strictness to that smocking, a clear field above, busy gathers of volume below.

At the time, Martin was too poor to live in New York. The city was fast becoming the focal point for global contemporary art, overtaking Paris. In 1957, Martin met the New York gallerist Betty Parsons in Taos. Parsons said she would show Martin's work if Martin agreed to move there. And so Martin spent the next ten years trying to work out how to function in New York City.

It was in New York that she first started painting with the grid of lines that guided her canvases. She lived and worked on Coenties Slip, an inlet of the East River on the southern tip of Manhattan, far removed from smart and sharp city life. Her loft was basic but full of light, in a community with other queer artists making their way: Jasper Johns, Ellsworth Kelly, Robert Indiana.

It was there, in 1960, that Liberman visited Martin to photograph her at work.

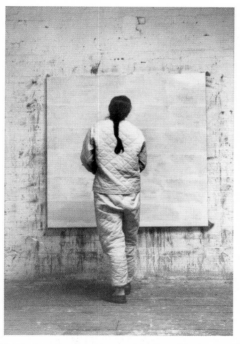

The jacket and pants are padded, quilted, worn for warmth. They are garments of supreme function and beauty. There is a simplicity to the collar, the buttoning, the shape.

The quilting makes a grid. Her hair is kept out of the way in a plait, which itself makes a grid. There is the grid of the bricks on the wall.

In an undated note, she wrote:

*The struggle of existence, non-existence is not my struggle.*
*The establishment of the perfect state not mine to do.*
*Being outside that struggle I turn to perfection as I see it*
*in my mind, as I also see it with my eyes even in the dust.*

When she was in New York, Martin's hair was long. In 1967, she cut it off and left town.

After eighteen months of travel, she settled back in New Mexico, where she lived alone for the rest of her life. She built her own adobe homes. Life was without frills. Her clothing was that of a human who laboured. Her labour was making art.

Today, the writer Olivia Laing has a pair of dungarees that belonged to Martin. In the States, they're called overalls.

How did she get them?

'Okay, so my friend Lauren's mum was a New Mexico desert lesbian,' Laing emailed, 'and she worked as Jane Fonda's animal wrangler/horse trainer and she became very close with Agnes via the NM dyke scene and when Lauren was pregnant she couldn't fit in her jeans but she couldn't find any American-style overalls in the UK and she complained about it to her mom, and she said oh I'll ask Agnes because Agnes always wore those Sears Roebuck farm worker ones. And so Agnes sent over one of her old pairs, all covered in paint.'

Sears Roebuck overalls used to be a common worker's garment in the United States. Sears have since stopped making them. At the time of writing, the company has only just escaped bankruptcy. If you want a pair, you'll have to get them vintage.

Martin's hard-working, utilitarian clothes reveal one of her great lessons: the connection between functionality and beauty. Towards the end of her life, she gave her paintings names like *Happiness*, *Lovely Life* and *I Love the Whole World*. 'An artist's life is an unconventional life,' she wrote in an unpublished manuscript titled 'Advice to young artists'. 'It leads away from the example of the past. It struggles painfully against its own conditioning. It appears to rebel but in reality it is an inspired way of life.'

Like Martin, the mid-century British artist Barbara Hepworth sought creative clarity away from cities.

Hepworth was a sculptor of monumental forms who strove for humanity in her carvings. She moved from London to Cornwall at the outbreak of the Second World

War and settled in St Ives in 1950, where she lived for the rest of her life.

On a Sunday in June 1944, a year before the war's end, she wrote a long letter about clothes to one of her closest friends, Margaret Gardiner. They corresponded often, but this is the only known letter where Hepworth talked about clothing. She was forty-one.

'The average older women's clothes are appalling at the same time there is nothing more painful than dressing in clothes too young, or too obvious in colour & form,' wrote Hepworth. 'We have to evolve some personal style that is an inspiration to <u>ourselves</u>. Inspiration is a necessity otherwise one is overcome by tiredness.'

On the next page, Hepworth shows some embarrassment in talking about clothing at all. She adds a note written vertically down the side of the page in tiny letters. 'This all sounds a bit silly (apropos of your remark about wanting new clothes) but evolving the personality in clothing is v. important & so difficult now.' At the end of the note she writes: 'See PS.'

The PS comes on the ninth page.

'I'm really keenly interested in the outward expression of social events as seen in clothing – it has always been most expressive & violently so before this war started. So its natural to think about it & as you say to want new clothes.'

The letter places Hepworth's choice of clothing within the wider context of her desire for change. It also reveals the self-ridicule that often goes with an interest in clothing: the next line, she mocks herself.

'You will have to put down all this nonsense to my general feverishness & excuse it. The 9pm news seems reassuring. B.'

P.S.

I can't imagine your hair ever being a difficulty — it will always be thick & shining. Mine is sheer hell. I'm looked through my residue of pre-war bits & pieces & realised that I can't really wear them again when war ends — they can't cut for Sarah & Rachel. One cannot face the post war world at over 40 yrs of age in pre-war frocks that one wore when 30! The trouble is that we are in danger of being out-of-date (not only in clothes) by being on the 'home front' & by being the age we are. I'm really keenly interested in the outward expression of social events as seen in clothing — it has always been most expressive & violently so before this war started. So it's natural to think about it & as you say to want new clothes. You will have to put down all this nonsense to my general feverishness & excuse it. The 9pm news seems reassuring. B.

D-Day had taken place on 6 June 1944.

Hepworth's work helped define a post-war optimism and idealism in British art and design. Her letter to Gardiner shows that she saw her clothing as part of the same drive. From her wardrobe after the war, it is clear that she found the 'outward expression of social events' in functional clothing.

Here is Hepworth at work four years later, body covered by a smock, her hair in a net to protect from dust.

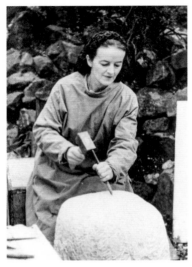

There was purpose to the functionality of her clothing. If she could, Hepworth preferred to carve in the open air, to connect with the nature that informed her work.

Roomy, practical, held secure, pockets that look well used. She wore the same clothes for years. Here's Hepworth in a similar jacket, worn with pants, by a prototype for *Single Form*, her sculpture which stands outside the UN in New York.

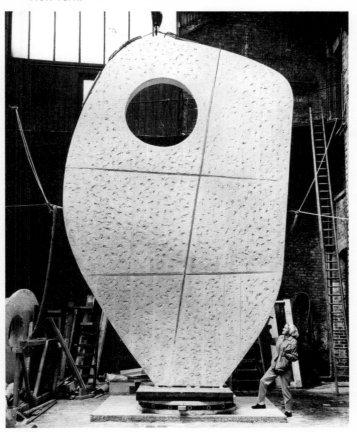

Hepworth was fond of zip-up technical jackets, often with elasticated waists.

Same style, different shade.

In 1965, aged sixty-two, Hepworth became a Dame, and, according to her granddaughter Sophie Bowness, felt she should begin dressing more like a dame. Two years later, she broke her femur. Bowness said it restricted her mobility, making her less able to carve. The change in her status and abilities led to a change in her wardrobe. Hepworth got into furs.

In the Hepworth archives is a note that lists her furs, and where they were worn.

*Long Russian Ermine white coat. BH to wear it to Tate*
  *on 15 Feb 67.*
*Squirrel Kaftan (for informal occasions)*
*Chilean fox jacket & hat (for working in)*

Hepworth at home, in her fur.

In a way, fur has function: it must have been warming to a body that was to live for over seventy years. In Hepworth's time, there were fur shops on British high streets. Attitudes have rightly changed.

When Hepworth is today cited as a style inspiration, it's not for her furs. More likely, it's for this sort of photograph. Here's Hepworth, aged thirty, in a striped jersey.

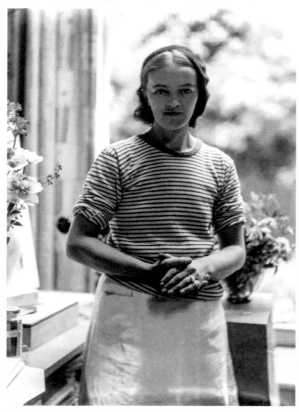

Striped jerseys originated as a functional garment for sailors. They became part of French naval uniform in 1858, their twenty-one stripes supposed to stand for Napoleon's victories against the British Navy. It was Coco Chanel who made them a fashion in the 1920s.

Pablo Picasso wore them when he moved to a house by the sea in the South of France after the Second World War.

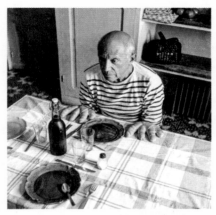

Breton stripes were a symbol of youth and rebellion through the 1950s and 60s. Here's Frank Bowling at work in London in 1965, three years after he graduated from the Royal College of Art.

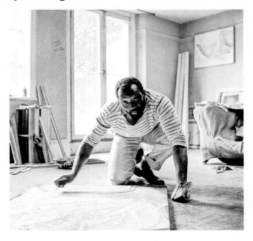

In the Breton jersey, there's that same formal attraction we found in Agnes Martin's grid. Perhaps it is this pleasing rigour that has made the garment endure beyond fashion.

The artist Derek Jarman would come to live out his life mostly in his workwear, both in London and at his cottage by the south-east English shore. He worked across painting, film-making, writing, set-design, gardening. Here he is, in a jumpsuit, tending to his garden at Prospect Cottage in Dungeness.

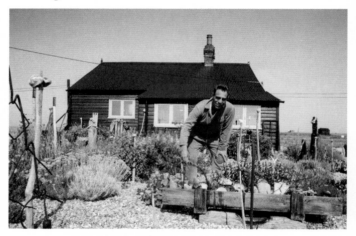

'Very distinctive,' said his friend and collaborator, the costume designer Sandy Powell. 'Always workwear, or it would be cords, baggy trousers with worn-out knees and a solid pair of shoes.'

Jarman lived with few clothes, few possessions. As well as the tiny place on the shingle of Dungeness, he lived out

of a small studio flat on the Charing Cross Road. He needed no more room.

'He didn't buy new things and I think he would look rather odd in a smart suit,' said Powell. 'The thought of him in a tuxedo would have been weird. His clothes were functional, but they looked good. Nothing to do with fashion. It was a definite look, and I thought it was always really attractive. He was a really attractive man.'

Jarman was diagnosed HIV positive in 1986. He bought the cottage in Dungeness the same year, spotted on a day-trip with his friend, actor Tilda Swinton. He died from AIDS-related illness in 1994, two years before the introduction of antiretroviral treatments, which have kept alive so many with HIV since.

The cottage is still there, preserved since Jarman's death. One Saturday afternoon, I was invited to visit. Prospect Cottage is so much larger inside than it looks from the outside! There's a central corridor, with rooms off either side. Each space has neatness and precision, a clarity that lets his chosen objects, his paintings, his stone and driftwood sculptures emit their alchemy.

At the back is Jarman's studio. When he worked there, he shut the door, and his partner, Keith Collins, was not allowed in. In that studio, spells were cast.

His painting area has been left as if he were about to pick up a brush. A long wooden table, caked with layers of paint. Three paint pots are left with the lid open: white, blue, red. At the end of the bench, under a dusty plate of glass, is a folded pile of Jarman's clothes.

I went closer. The straps suggest an apron.

The glass on top of the pile was likely ready to be used for etching. It was one of his favourite techniques. In his

bedroom was a canvas smeared with black paint with etched glass panels. One read:

*dear God,*
*if you insist on*
*reincarnation, please*
*promise me that I*
*will be queer tho I've heard*
*you don't approve*
*I'll go down on my*
*knees*
*yours faithfully*
*Derek Jarman*

A final look at the pile of cottons, woven into twills, denims.

Agnes Martin built houses. Barbara Hepworth chiselled away at stone. Derek Jarman gardened. It is important to remember the physicality of an artist's labour.

Lucie Rie was born and raised in Austria, fleeing to London in 1938. She was a ceramicist of eloquent finesse. Here is Rie, with an example of her work, in her potter's apron.

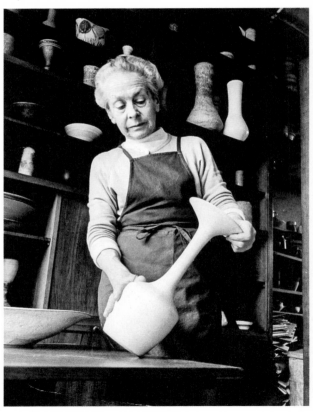

You can see footage of Rie at work on YouTube. There's a clip from 1987, a news report to coincide with her pottery appearing on a Royal Mail stamp. Rie was eighty-seven. Her control of the clay, the water, is precise. No mess spins off. Yet she has on two aprons for cover: one attached to her body, the other laid across her legs. Underneath, she's wearing a white shirt, sleeves rolled up.

Shirts were a favoured garment of hers. Here she is away from the wheel, sunbathing, sleeves up again.

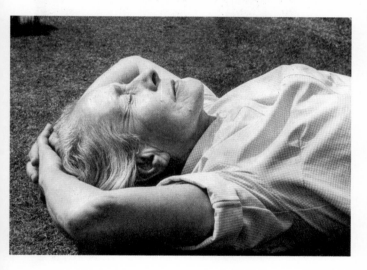

On the other side of the world lived the Japanese ceramicist Shoji Hamada. Unlike most ceramicists, he threw his pots using a hand wheel, sat cross-legged on the floor. It was hard, physical work, within which he found serenity.

In 1976, he was visited by the artist and ceramics

teacher Susan Peterson, who took this photograph of him glazing a bowl.

Such delicious clothes, widely cut, fully covering his body in this open-legged pose. Peterson described the look. 'He wears a treasured old kimono vest,' she wrote, 'woven years ago by a friend, which tops the traditional country style trousers, which are cut fully, tied at the waist, and tight at the ankles.'

At its extreme, functionality is safety. Before Ghanaian sculptor El Anatsui began making the draped found-metal curtains which have made him globally famous, he worked often with wood. In 1995, Anatsui exhibited at the October Gallery in London, and demonstrated his practice to staff.

He's wearing the kind of brute boot that could inspire some high-priced and decidedly non-functional sneaker hybrid today.

Anatsui's footwear was protection against injury. A few decades earlier, American painter Grace Hartigan wore functional clothing in order to stay alive. It was 1951,

she was penniless, no heating, just the need to survive.
Here she is, on the roof above her studio, in heavy
workwear boots.

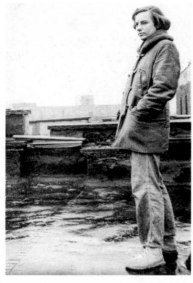

Of course, there are blinkers to my process. Instead
of Hartigan in functional clothing, I could have chosen
from many images of Hartigan, taken after she had found
success, prettified at openings, parties. But in 1950s
New York, the art world was dominated by men, the wider
American culture one of fixed gender roles. Within this
society, women were expected to be prettified. To con-
centrate on Hartigan at those openings and parties is to
acquiesce to those fixed gender roles.

I'd rather show artists at work.

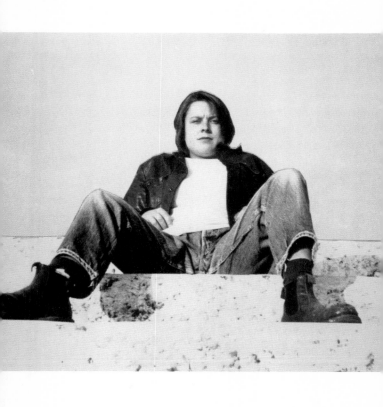

**Sarah Lucas**

**Winter.** A snowstorm was the main news in the United Kingdom. It was officially called Anticyclone Hartmut, but the media gave the storm a nickname: The Beast from the East.

'It is amazing here right now,' emailed the artist Sarah Lucas. She was born in 1962 in North London, but moved to the Suffolk countryside after the turn of the millennium. Her home was once owned by the composer Benjamin Britten. 'Bitter wind blowing dervishes of snow around the back field and whistling through the house.'

Lucas creates sculptures and photographs charged with personality and conviction. Her topics are life, death, sex, the body. She approaches them with fierce bluntness.

In the 1990s, Lucas made a series of twelve self-portraits. Over the page is one of her most celebrated, *Self Portrait with Fried Eggs*. It was made in 1996, but it looks as if it could have been taken today.

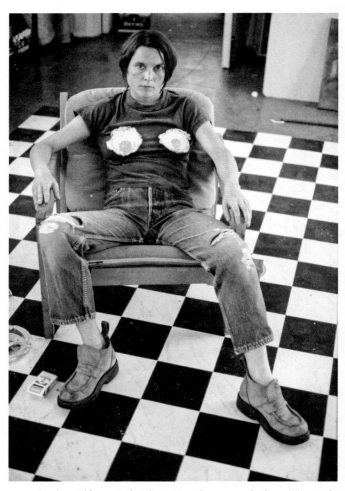

In the self-portrait, she wears her own clothes. We read her pose as masculine, her legs spread. Wait. Why should legs spread be masculine?

It's the same for her garments. Crew-neck T-shirts were introduced in the 1930s as an undergarment for American football players, i.e. men. The shoes Lucas wears are known as brothel creepers. The name says it all: sturdy-shaped footwear that's actually light, with a crêpe sole. The design is of military origin, then adopted by men who felt alpha while they crept around.

The two fried eggs on her chest puncture these gendered assumptions. It is a statement of female provocation, and male belittlement. It is sexy and funny.

From her earliest work after graduating in 1987, Lucas has used clothing in the language of her art. Often, she wears her own pieces in photographs. Other times, garments appear in sculptures, like the stuffed tights of the series *Bunny*. Clothing runs throughout.

So far, we've mostly considered artists no longer living. Lucas is crucial to our understanding of how clothing has become central within today's art. That day of the winter storm, we started a conversation. What were her memories of garments when she was a kid?

'When I was a little girl my mum made a lot of my clothes. Dresses and knit jumpers. I occasionally resort to this myself, not the knitting, although I do darn to great effect. I'm quite good at pyjama trousers, which is my preferred attire around the house. Plus giant cashmere jumpers.'

At college, she started wearing items that eventually became part of her work. 'I was wearing a lot of second-hand stuff through my college years, for reasons of economy.'

Lucas has talked openly about growing up with no money. 'So it was pot luck what I came across really. One leather jacket, which I still have, became a bit of a signature item and appears in many of the portraits. I did once make a copy of it in brown paper and had a chair made for it in MDF.'

The work is called *Auto-Erotic*. It was made in 1997, from her first show with her long-term London gallerist Sadie Coles.

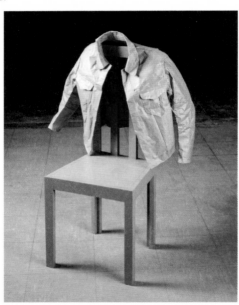

'Before that I'd used a pair of my own, very worn-in, Doc Martens. I put razor blades in the toe caps.'

That work is *1-123-123-12-12*, made in 1991. The boots are a size 7.

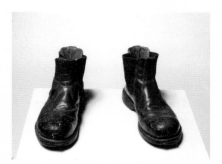

'Some items become special through wear. People can identify them with me. Some things have significance because they're universal, tights for instance.'

The work *Bunny Got Snookered* was shown alongside *Auto-Erotic* in 1997.

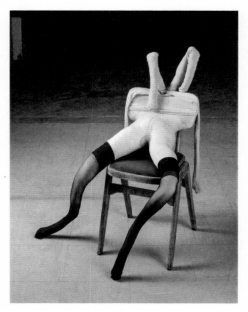

'They all have to lend themselves to being transformed into some other object.'

Clothing becomes art, transcending its original purpose.

'Everything is part of language,' said Lucas. 'Art/poetry is playing around with it.'

This symbolic language is within the garment itself: Doc Martens boots have a toughness that is readily visible in their design and materials. The rubber sole, the sturdy leather, the thick stitches that give them durability.

But the artist is saying more than that. By using her own scuffed and worn-in pair, by inserting the razor blades, she makes it personal. The work was created before she'd had her first solo show. The boots are like a marking of territory. Lucas is using our collective understanding of the language of clothing to say, don't mess with me.

Lucas in the 1996 work *Fighting Fire with Fire*.

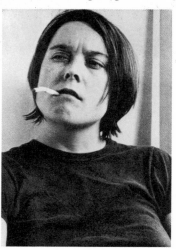

I'm sat writing this section in the café of the British Library. I should be up in the Reading Room, but I'm procrastinating. I've got my laptop open, though I'm looking up from my screen pretty much every other sentence. My mind is wandering, and it feels like I've got no focus. But right now, I am actively engaged in reading the clothes of people around me.

The reading is on many levels. Sometimes it's just processing information that barely registers as a thought: the jolt of a strong colour, or the thickness of a fabric that gives a hint of the weather conditions outside. Sometimes the read is judgemental. It is relentless. And it is not just because I have worked in fashion.

It is something in which we all engage. We all read each other's clothes, all the time. Think about when you walk down the street: you modify your behaviour depending on what those around you are wearing. It's like a primitive instinct that's warped from survival strategies of assessing imminent threats and dangers.

We share this visual language. We are unwitting experts at it. And yet we know so little about it. Lucas works with clothing on this primal level. 'I think clothes in the work can stand in for me – then again it all stands in for me really, I'm somehow implied. I imagine people looking at my work wondering what I think, what I'm trying to make them think.'

Summer. 'The weather's been a bit mixed,' Lucas wrote. 'Today, when the sun's out and it's hot, I'm wearing cut down jeans and a T-shirt, black because we've had a lot of pollen beetles about. Yesterday I went out to water the garden in a yellow T-shirt and got smothered in them.

'Evening times and first thing I wear Thai fisherman's trousers and a T-shirt and I keep a cashmere jumper handy and socks in case it turns chilly. If I'm going out into the world, LA or anywhere, I'm likely to wear a cotton shirt and long trousers, mainly jeans or combats. Shirts are better for keeping cool than T-shirts as they don't cling – they're breezier. I'm keen on massively large T-shirts.'

When she moved from London to Suffolk, did her wardrobe change?

'Well, there was a very good gentleman's clothes shop in Aldeburgh. Everything a chap might need. I had a notion I'd like to wear pink in the countryside, I never had up until then, so I bought a couple of pairs of pink pyjamas, Derek Rose. In London I had come across a couple of thick cashmere V-neck jumpers, one pink one grey – reduced to about a quarter of the price – enormous men's ones – that's how that habit got started.'

As we have seen with artists like Agnes Martin, there's a clear distinction between the clothing worn in a metropolis and that worn in the countryside. It is not just the garments, it is the speed with which they are changed or replaced.

In cities, we are immersed in often violently contrasting environments. We find ourselves wearing different outfits daily to keep pace with the change. In the countryside, the backdrop stays pretty much the same. We find we wear the same thing over and over.

'I'm always a bit perplexed when I do have to venture into the outside world, what the fuck to wear? It's always a relief to get back and get the old garb on,' Lucas wrote.

She lives with her partner, the artist Julian Simmons. 'I'm having coffee in the kitchen right now. Julian just walked in

in pyjamas and said, more or less to himself, "Have to get my old clothes on now." Case in point. Then he wondered why I laughed.'

In her work and life, Lucas holds a mirror up to gender, behaviour and identity. By using clothing as a tool, she gives her work abrupt clarity. This clarity comes from her use of archetypal garments that are so recognizable, so readable by us all. Next, we'll bring one of those archetypes into focus.

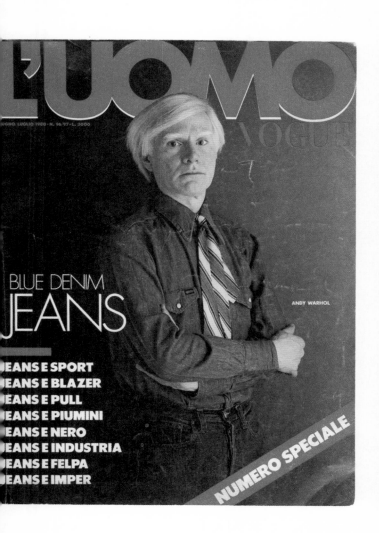

L'UOMO

VOGUE

GIUGNO, LUGLIO 1980 - N. 96/97 - L. 3000

BLUE DENIM
JEANS

ANDY WARHOL

JEANS E SPORT
JEANS E BLAZER
JEANS E PULL
JEANS E PIUMINI
JEANS E NERO
JEANS E INDUSTRIA
JEANS E FELPA
JEANS E IMPER

NUMERO SPECIALE

**Denim**

**Denim is a fabric of commonality.** It is clothing for an era in which the artist can be everybody. In jeans, an artist can disappear. Maybe this part of the book shouldn't be 'What Artists Wear', but 'What Artists Can Forget They Are Wearing'.

'Andy wore jeans every day,' said Bob Colacello. He was talking about Andy Warhol. Colacello was Executive Editor of *Interview* magazine from 1974 to 1983, which had offices in Warhol's New York studio, the Factory.

'Even when Andy was invited to the White House for a state dinner for the Shah of Iran. He wore his jeans under his tuxedo pants. He said tuxedo pants were too itchy.'

The dinner was on 15 May 1975. Colacello had travelled to Washington with Warhol and Warhol's partner, Jed Johnson. 'Jed and I were waiting for him at the Watergate Hotel. He took great pleasure to say he undid the button of his fly and showed the president's daughter, Susan Ford, his jeans.'

Here's Warhol, secretly wearing jeans under his tux, being greeted by President Ford. The Shah is stood to Ford's right. In 1976, a document by Amnesty International declared the Shah's regime as one of the worst violators of human rights in the world.

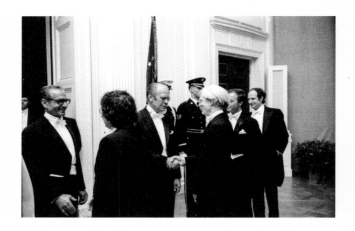

Warhol was born in 1928 to a working-class family from Pittsburgh, Pennsylvania. His father, Paul, worked away from home on construction sites. Warhol was part of the American generation that lived through the shift of denim from workwear to fashion.

Levi's jeans first appeared in 1873, just over a hundred years before Warhol wore them to the White House. Originally called 'waist overalls', they were cinch-backed and cut high, with fastenings for braces.

A rare early example is covered with bits of wax. 'They were worn in a mine,' said Tracey Panek, the historian at Levi Strauss & Co. 'The miners would have had a candle on a band on their head.' The jeans would have been shared between the miners, left in the mud room at the end of each shift. 'We think at least three people wore them,' said Panek of their oldest existing pair, 'because the knee marks are in different places.'

Over the years, the cut of jeans was modified closer to the fit we know today. They were adopted by ranchers. Dude ranches became popular vacation spots for city-dwellers, offering an experience of 'the wild west'. 'Levi's first appearance in Vogue was in 1935, for an article on dude ranching,' said Panek. It told readers to buy jeans for the 'dude rancher look'.

In 1934, Georgia O'Keeffe stayed for the first time at Ghost Ranch, a 21,000-acre holding just west of Taos in New Mexico. She would come to spend her summers there, buying a small isolated residence on the ranch in 1940.

Here she is hitching a ride to Abiquiu, a small town nearby. She is wearing Levi's.

The expression on her face says everything about how it must be to live and create within air and sky and land and horizon. Her jeans would have cost less than three bucks.

After the Second World War, jeans became a symbol of youth and freedom. On 20 August 1952, young American artists Cy Twombly and Robert Rauschenberg set sail for Europe. Rauschenberg was married at the time, with a son. He was twenty-six. Twombly was twenty-four. The pair fell for each other and spent eight months together away from the United States. During the trip, Rauschenberg took this photo of Twombly in Rome. He is stood with the right hand of the Colossus of Constantine.

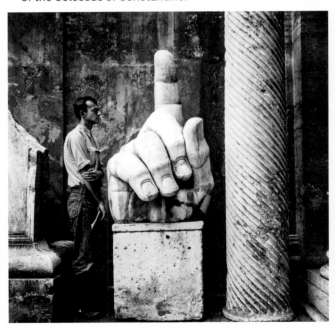

When Warhol moved to New York in 1949, aged twenty, jeans were not yet the wardrobe of those trying to make it in the city. He favoured chinos for his years as a successful commercial artist, drawing his beguiling illustrations for clients such as *Glamour*, *Harper's Bazaar* and department store Bonwit Teller.

In the early 1960s, Warhol managed to move beyond the word 'commercial'. He was now an artist. He painted comic-strip characters, bottles of Coca-Cola. He swapped his chinos for jeans. 'Andy always liked this idea of being demo-cratic,' said Colacello.

At first, Warhol wore black Levi's. 'In those days I didn't have a real fashion look yet,' he wrote in the book *POPism*. 'I just wore black stretch jeans, pointed black boots that were usually all splattered with paint, and button-down-oxford-cloth shirts under a Wagner College sweatshirt that Gerard gave me.'

Gerard was his assistant, Gerard Malanga. There's a pair of black jeans slung over a chair in this portrait of Warhol in bed with Malanga, taken in a hotel room in Paris in 1965.

When he wore blue jeans instead of black, it wasn't yet part of the 'Warhol' look. In December 1968, Warhol was photographed at the Factory in beat-up blue jeans, six months after Valerie Solanas shot him there, an incident that crippled him with physical and mental trauma.

It feels rare to see Warhol so off-guard. The image captures him wearing jeans as studio clothes, in line with their original purpose as a garment for workers. But Warhol's jeans would soon sharpen up.

Fred Hughes had just started working at the Factory. From Texas, Hughes became Warhol's business manager, bringing with him an uptown sensibility that would come to define Warhol's life in the post-shooting era. Hughes wore a blazer, a shirt and pressed blue jeans. It was an upper-class interpretation of a working-class denim wardrobe.

'It became the Factory uniform,' said Colacello. This was

a high-society take on the commonality idea – that the same design of jeans can be worn by many. Meanwhile Levi's had started using the word 'jeans' in their marketing. Bye-bye 'waist overalls' – the transition from workwear to high fashion was complete.

Warhol's change of look coincided with a change in his emotional life. Arriving at the Factory around the same time as Hughes was Jed Johnson, the handsome nineteen-year-old who would become Warhol's boyfriend. 'There was a store called DeNoyer on east 60th Street,' said Colacello. 'It was importing European men's clothes. Andy and Jed used to get corduroy jackets that were brown or blue, printed with a very subtle pattern on them.'

Here's Warhol, in a DeNoyer jacket with Levi's jeans, at the opening of an exhibition in Ferrara, Italy, in 1975. Note the Sony tape recorder in his lap: it was Warhol's constant companion, recording any conversation he could. Warhol called it his 'wife, Sony'.

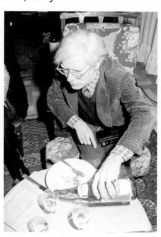

The look was practical. 'You could go to a dinner uptown and then go downtown to a loft after-party and sit on the floor,' said Colacello. 'He could get paint on his jeans, they were washable. You didn't have to bring them to the dry cleaner, like regular pants.'

Warhol wrote of his admiration for Levi's in his 1975 book, *The Philosophy of Andy Warhol*. 'I wish I could invent something like bluejeans. Something to be remembered for. Something mass.' It is possible Colacello was responsible for these words: he was the book's co-ghost writer.

In 1980, Warhol separated from Johnson. 'He became kind of anorexic in those years,' said Colacello. 'It was after Jed left him, which he pretended meant nothing.' Warhol had an idea: he'd become a male model. 'It was part of his dealing with the pain of losing Jed, which he refused to admit in any real way.'

Most of the time, models are booked to capture a mood other than their own, or channel a persona. When Warhol modelled, he was appearing as himself. Brands paid for the most recognizable version of the-world-famous-artist-Andy-Warhol. To be that, he wore blue jeans.

In his advertising images he is queer, radical: not what an artist is supposed to do, not what a fifty-something-year-old man is supposed to do. Warhol and his jeans had evolved into something both mass and also willfully individual at the same time.

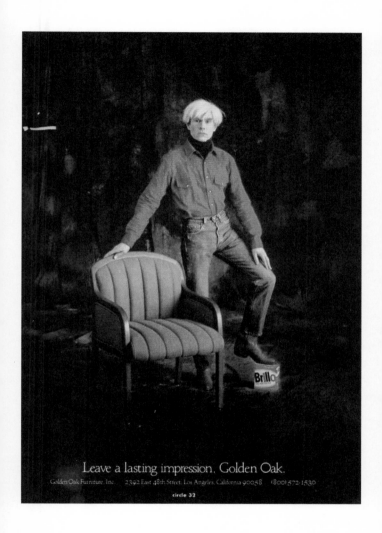

Leave a lasting impression. Golden Oak.

By the 1980s, Warhol's reputation within the art industry was laughable, tainted mainly by his portraits of society figures. 'Andy was certainly an outcast in the New York art world,' said Colacello.

Young artists felt otherwise. They admired and respected him. Here's Warhol with Keith Haring and Jean-Michel Basquiat, at the Factory in April 1984. Warhol kept youthful, wore his blue jeans.

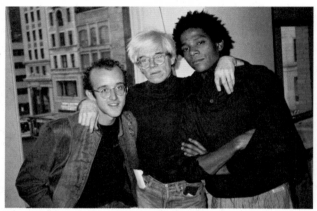

Look at all the stuff shoved in Warhol's pockets: a notebook, some dollars. Until the end of his life, three years later, Warhol would walk the streets, rucksack on his back, in his Levi's. He had become one of the most recognizable humans alive, yet his clothing was regular.

Jeans were a near-constant feature of Warhol's life. Let's now focus on denim's role in a specific moment for one of the most respected artists alive.

In 1968, David Hammons started to make body prints, using his own body, as well as those of others. He was

twenty-five, had moved to Los Angeles from Springfield, Illinois, in 1963 and studied art in the city.

The body prints would bring him his first wide attention. They set a benchmark for his work in the decades that followed, through which he would consistently question race, class, wealth, society and the presumptions of art.

'By doing body prints,' Hammons said, 'it's telling me exactly who I am and who we are.' The photographer Bruce Talamon visited him in his studio in 1974. Hammons was making a body print, wearing jeans.

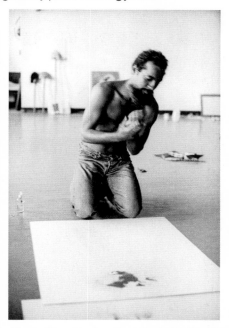

'Note the bottle of baby oil on the left side of the photograph,' emailed Talamon. 'He has just poured the oil on his hands and is rubbing them together. He would then rub his

oily hands on any part of his body and also onto his clothes and then press that body part onto the paper.' Hammons then poured pigment onto the image, to pick out the marks made.

In the work *Injustice Case*, made in 1970, Hammons made a print of a male figure gagged and bound to a chair, layered over the United States flag. The pose mimicks that of Black Panther co-founder Bobby Seale, who in 1969 was bound and gagged in a courtroom in Chicago. Seale had been charged with conspiracy and inciting a riot at the 1968 Democratic Convention.

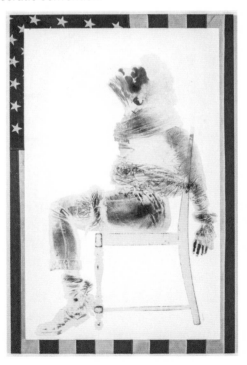

Hammons printed the figure wearing a pair of denim jeans, telling us the figure is an everyman in a state of oppression. 'Everyman' is such an easy word to use; as easy as reciting the values of the American flag. Hammons makes us acknowledge that 'everyman' includes those who live under racism, intolerance, injustice. It is a work of harrowing force.

Hammons made body prints until the late 1970s. Since then, his work has shifted, mutated. He has often used clothing as a material. In 1993, he cut the hood off a hoodie, threaded its rim with wire, placed it on the wall for the work *In the Hood*. In 2007, he collaborated with his wife, Chie, to slash, burn and daub with paint fur coats, which were then exhibited just off Park Avenue in New York, an upscale neighbourhood that is home to many fur-coat wearers.

Hammons is one of the most revered artists alive. He keeps himself to himself. He does not seek celebrity. Hammons is an artist who disappears, and the clothing he wears helps him do so. But his work has become public and permanent. His outdoor sculpture, *Day's End*, sits off Manhattan, jutting into the Hudson River, its metal frame tracing the exact dimensions of the long-since demolished Pier 52.

*Day's End* is a monument to another elusive artist, Gordon Matta-Clark. In 1975, Matta-Clark broke into the pier's abandoned warehouse and spent the next few months cutting storey-high crescents into its walls.

Matta-Clark made the cuts himself. To do so, he wore jeans.

'Gordon really didn't care about fashion,' said Jane Crawford, his widow. Matta-Clark died of cancer in 1978. He was thirty-five. 'He always wore work clothes, like jeans and a work shirt. A lot of the clothes, I don't know where they came from.'

Matta-Clark was part of the downtown scene in 1970s New York, which colonized the then-empty warehouses of SoHo. 'All of the factories had moved across the river to New Jersey,' said Crawford. 'Artists had no money, and they moved in.'

Today, I typed the words 'Loft Living SoHo New York' into a search engine. The first page had a loft listed at $18,000,000. The original loft-dwellers of the 1970s were essentially squatters. 'We weren't supposed to live there but everybody did,' said Crawford.

These were artists disconnected from a gallery system. 'Everyone had a profession they could do,' said Crawford, 'and then at night or on weekends they could make their art.' Matta-Clark had studied architecture at Cornell University. 'He would do dry-wall building and lofts, although he didn't do plumbing. Philip Glass did plumbing.'

It required a specific wardrobe. 'Practical clothes. Dressing for protection and warmth.'

Matta-Clark's art was concerned with fundamental issues such as home and housing, ownership and precariousness. Alongside his own work, he was a leading member of the Anarchitecture artists' group, which questioned the role played by property in American society. In 1974, he cut in half a house that was slated for demolition. Here, Matta-Clark is creating the work *Splitting*.

He was an artist of sincerity and commitment, whose practice went beyond individual works of art. Indeed, most of his work no longer exists. In 1971, he co-opened FOOD, a restaurant on the corner of Prince and Wooster Street in SoHo. It was artist-run, employing artists serving affordable and wholesome food to their fellow artists. Sometimes, artists were invited to create the menu for the night. One evening, Matta-Clark cooked an entire meal based on bones: marrow bones, oxtail soup.

Matta-Clark's interest in clothing was either practical or sociological. In his 1974 proposal for Anarchitecture's 'Endless City', he suggested wearable housing. Next to two stick-figure drawings with boxes on various parts of their anatomy, he wrote: 'THE KIND OF LIVING YOU CAN CARRY ALONG. ON THE HEAD/IN THE MOUTH/ON THE BACK/ IN THE ARMS/AROUND THE WAIST/ON THE FEET'.

These were recurring thoughts. On his Large Art Cards in 1973, he wrote 'WEAR HOUSES' and 'WEAR YOUR HOUSE

WELL'. On another card, 'WHERE' is written vertically down the side, by a list that reads:

It's like he wished clothing could be something other than what it was. 'Yes, probably,' said Crawford. 'He was concerned about migration and homelessness. Those issues were on his mind. He had so little time to work. His career was only eight years. Now it feels like five minutes.'

Wearing jeans can be a politicized act. They are the antithesis of the tailored suit. Certain restaurants, clubs, events have 'no jeans' policies, effectively stating that those in jeans are lower class. This is even though jeans produced by luxury goods conglomerates can easily cost four figures. On the day of writing these words, the most expensive pair of women's jeans on the luxury fashion site Net-a-Porter: £2,875, made by Balmain, a French fashion house now owned by a Qatari fund.

It is a long way from what denim once was.

In 1988, at a protest in Washington by AIDS activists ACT UP, the American artist David Wojnarowicz wore a denim jacket that he'd hand-painted. The protest was at the

Food and Drug Administration building, demanding equal rights to treatment during the AIDS crisis. It was a year since Wojnarowicz had discovered he was HIV positive. On the back of his jacket, he had painted the pink triangle of queer solidarity, and a stark declaration. 'IF I DIE OF AIDS – FORGET BURIAL – JUST DROP MY BODY ON THE STEPS OF THE FDA'.

Wojnarowicz was born in 1954 into a poor working-class family. In childhood he faced abuse, chaos and neglect. In his early teens, he was hustling in New York. By the age of fifteen, he was living on the streets. He made art that punctured the structures that shaped contemporary American society: wealth accumulation, high politics, warfare. Wojnarowicz lost his life to an AIDS-related illness in 1992.

Wojnarowicz was wild and he loved snakes. Here he is, photographed in 1981 by Peter Hujar, who we encountered earlier with Paul Thek. It was the year Wojnarowicz and Hujar met, briefly became lovers, and then deeply connected friends.

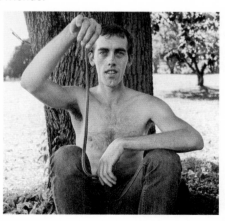

At the time, downtown New York was flooded with second-hand denim. Wojnarowicz once wrote in his journal of a dream about being in a thrift shop: 'I'm in what seems like a Goodwill store, looking over racks of coats trying to find a nice jacket – leather or denim – to trade for this big lumpy coat . . .'

He hated the fashion industry. In 1991, he turned down an offer to appear in an advert for The Gap, the chain that started as a denim retailer: 'Are you kidding? That's a sell-out. That's so commercial.'

Wojnarowicz's denim was not to be commodified, fetishized. Jeans were made for living: to be worn on the street and in the bars and at the piers on the Hudson River, where men cruised for sex. In his journals, clothing mostly featured as something that men take off. In August 1980, he wrote of the silence of the piers, 'something punctuated by breathing alone, and the rustle of shirts and pants sliding, being unbuttoned or folded back'.

Let's get some air. Here is the American artist Nancy Holt with her work *Sun Tunnels*, after the work's completion in 1976.

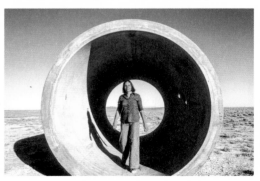

Holt bought 40 acres of land in the Utah desert on which to make the four concrete cylinders. They took four years to plan and construct. The artist spent a year in the desert, managing a build that was both intricate and physically tough. Holt wore denim.

Here is Nancy Holt, filming at the *Sun Tunnels* site in 1976.

Holt had been married to fellow land artist Robert Smithson. Smithson died aged thirty-five in a plane accident in 1973, the year Holt started the *Sun Tunnels*. Many of Smithson's works had a finite lifespan, like *Partially Buried Woodshed*, a structure at Kent State University partly covered by twenty truckloads of earth. It was purposefully left to rot: all that remains are the concrete foundations and a large mound of earth.

Smithson's most famous work is *Spiral Jetty*, a tendril path of rock and mud that extends out into the Great Salt Lake in Utah. Here is Robert Smithson at *Spiral Jetty* in 1970, the year it was completed. Smithson was wearing denim.

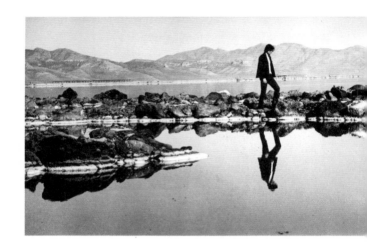

Back to the city. In a way, the American artist Jenny Holzer has made a form of urban land art throughout her career, such as displaying her *Truisms* in public spaces: on billboards, fly posters, projected on to buildings. In 1982, her *Truisms* scrolled on an electronic sign in Times Square, New York.

To make art like this requires stealth, reliable clothes that don't shout. Holzer regularly wears denim.

The German artist Blinky Palermo worked in colour and simple shape. He was a student of Joseph Beuys, and died young, aged thirty-three, in 1977. He lived a reckless life, chasing pleasure through sex and alcohol. Palermo, in front

of his work *Mirror Object*, wearing jeans with a detail of pure look-at-me fashion: front patch pockets.

The American artist John McCracken created smooth sculptures that are like finally being in the presence of alien totems. He wore denim for his labour. Here's

McCracken, in denim apron and jeans, alongside the finished sculpture *Hopi*.

The pride of Melvin Edwards, photographed with his 1970 outdoor sculpture *Double Circle*. You can still find it today, on the corner of Malcolm X Boulevard and West 143rd Street, in Harlem, New York.

Forty-six years later, Edwards was still wearing denim to weld his sculptures.

The glamour of British artist Richard Hamilton, said to have made the first work of Pop Art, with his 1956 collage *Just what is it that makes today's homes so different, so appealing?*. He loved denim, often combining different denims in the same outfit.

Here he is in 1970, long after the Pop Art bubble had burst, long after Hamilton had moved on to other concerns: politics and civil rights and interiors and industrial design.

Hamilton is in denim cap, shirt, jeans. Note the very purposeful appearance of white socks.

A similar mood, from Chris Ofili in 1999. It was the year after he won the Turner Prize, the year after his work *No Woman No Cry*, made in tribute to the murdered London teenager Stephen Lawrence.

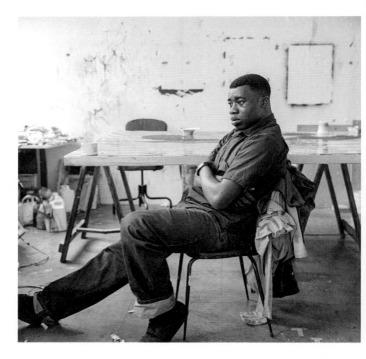

Denim travels with artists through their lives. Here's Robert Rauschenberg, who we met earlier – he took the photo of Cy Twombly in Rome. After making his name in

New York, Rauschenberg moved to Captiva, Florida, in 1970. He is in front of his property Fish House, wearing cut-off denim and the most glorious smile on his face.

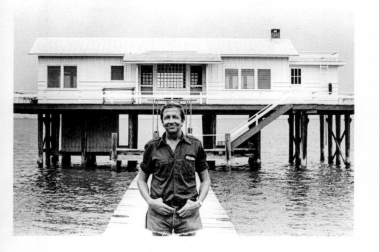

For all its humility, denim is a cloth of beauty.

We've previously seen images by Peter Hujar of his friends and sometime lovers Paul Thek and David Wojnarowicz. Hujar was active as a photographer and artist from the 1960s until the 80s. Early in his career, he shot stories for magazines like *GQ* and *Harper's Bazaar*. He understood the fashion image, how to frame and animate the body in clothes. The jeans in the self-portrait over the page have suppleness, spark, grace.

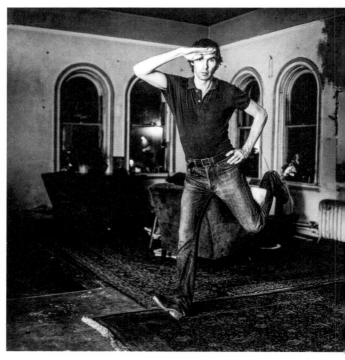

Hujar took the image in 1974. It was six years before the first reported case in the AIDS epidemic. He died from AIDS-related illness in 1987.

Hujar took great care in photographing fabric: the cloth wrapped and bound round skeletons in the catacombs of Palermo; the hospital sheet that covered Candy Darling on her deathbed; the remnants of some cut-off jeans worn by a man enjoying the queer liberation found on the New York piers.

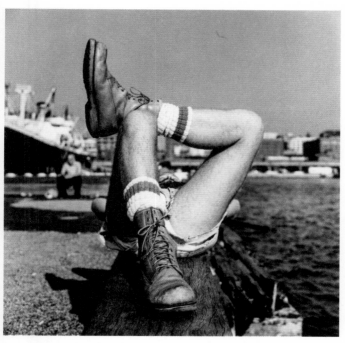

Even when barely there, torn, frayed and gleefully
abused, denim carries its narrative power.

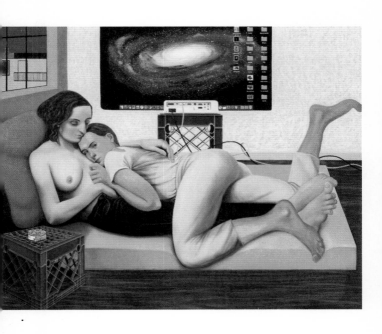

**Nicole Eisenman**

**Up until now, we've observed artists from afar** as we scrutinized the meaning of garments: their connection to power, labour and freedom. It's time to get closer, to get specific. Let's begin with a visit to the New York studio of Nicole Eisenman.

She's the perfect artist for this pivot, an artist whose work creates intimacy with her subjects. It is disarming. In her paintings – like those on the previous pages – there are familiar, present-day details: an Apple Mac desktop projected on the wall of *Morning Studio*; the noise-cancelling headphones of *Weeks on a Train*.

The familiarity also comes from the clothes: lovers entwined in jeans, T-shirt and sweats; the dumb humiliation of a slogan tee in *I'm with Stupid*, the traveller slumped in a zip-up jacket, sweater, shirt and jeans.

Eisenman's work speaks of queer love and life, the absurdities of technological progress, the conviviality of the shared experience.

I remember her first major show in a London public gallery so vividly. It was in 2012, at the not-for-profit Studio Voltaire. Eisenman made sculptures of human figures from plaster. A couple slouched against the wall. One lay on a mattress. Another had their butt up in the air. Eisenman

had put them together during a month's residency in the space. When the show was over, the works were destroyed.

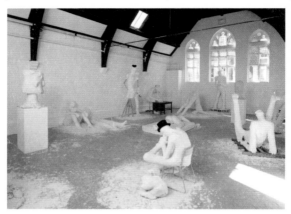

In 2019, Eisenman was one of the seventy-five artists selected for the Whitney Museum's Biennial, widely considered to be the foremost survey of American contemporary art. Her outdoor sculpture, *Procession*, was cited as a highlight.

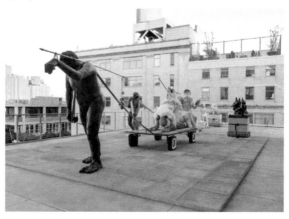

On 19 July, Eisenman joined three other artists to request their work be withdrawn from the show. They were protesting about Whitney board member Warren Kanders, CEO of Safariland, a company that had manufactured the tear gas used on migrants at the US-Mexico border. Five other artists joined the protest. Six days later, Warren Kanders quit the board.

When Eisenman is working, what does she wear? The artist Mary Manning spent some time with Eisenman at her studio in Williamsburg, Brooklyn, to give us a glimpse of her space and her clothes. Manning's work is about the emotion and poetry that can be caught through a lens, what we can see beyond what is said. Often, as on these pages, Manning collages the images to reveal more layers, more connections, more of the unspoken. They are alert to clothing. Here we see how Manning saw Eisenman.

**I'm a mess.** The cream sweater I'm wearing right now has so many stains and I have no memory of what caused them. I'm guessing coffee. There's a hole in the seam at the armpit that I've darned once but the hole won. I'm still wearing the jeans I gardened in three days ago, kneeling on damp soil. They're in a state. I've worn them every day since. My sneakers are covered in dirt from walking the dog.

This is normal for me.

Five years ago, I donated some clothes to the Victoria & Albert Museum in London. I didn't realize that, once a garment enters the collection, it cannot be cleaned. The institution preserves them as they are.

One of the pieces was a white knit by Sibling, printed with a blue *toile de Jouy* depicting the Hackney riots of 2011. When the knit was first exhibited, the mannequin's arms were folded. I couldn't work out why. Then I looked closer. On the front was an egg stain.

This is my way of being. I am suspicious of what is overtly clean. Clothing is there to be used. Garments are a testament to what has been done in them.

The first part of this book asked: what? We looked at distinct families of garments, and the artists who wear them. Following our visit to Eisenman's studio, let's now consider the different ways in which clothing is worn,

the role of garments and their effect. Like a cross-hatch, we'll change the direction of our approach in order to gain depth. Now we will ask: how?

The question matters because, particularly in the past fifty years, the line between artwork and artist has evaporated. It is especially true for artists who wear clothing as part of performance, and for those who make clothing as part of their practice. This mode of working is incredibly new, in the context of the millennia of mark-making. Many artists turned to performance because they could find no place for themselves within art histories, galleries or critical discussion, often excluded because of gender and/or race. Through performance, they mapped their own territory, claiming a space within which to make very public, very personal, forms of art.

But we also need to consider further the clothing of artists working in seemingly traditional forms, on canvas and with sculpture. Our first step will take us again behind the usually closed doors of artists' studios. As we saw with Nicole Eisenman, the paint on artists' clothes is an intimate, honest, physical manifestation of all it takes for their work to exist. What is left on their garments tells its own story.

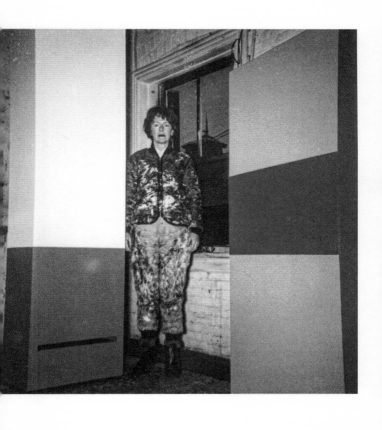

**Paint on Clothing**

**'She was an extremely messy painter,'** said Alexandra Truitt about her mother, the American artist Anne Truitt. Truitt's practice was an exploration of colour and the meaning it holds. Her breakthrough came in 1961, when she discovered simple sculptural forms – columns, boxes, planes – that could become fields to hold colour. These required immense physical and mental effort to create, yet she is still lumbered with that banal descriptor 'minimalist'.

On the previous page is Truitt with two of her works, *Camelot* and *Spanish Main*. The photograph was taken in 1964 at her studio in Twining Court, Washington DC.

Look at the clothes, look at the walls, and then look at the work. The clothes and walls are evidence of the labour, focus and rigour it took to give the pieces their own life.

'Everything was covered in paint, the clothes, the studio floor,' said Truitt, who was nine when the photo was taken. 'She would dip the paintbrush in the bowl. She would lift it up as it headed towards the sculpture: drip, drip, drip, drip, drip. And then she'd hit the sculpture with paint, and then paint over that again to smooth it down.'

Truitt used pigment to mix her own paint, in order to make her own colour. She was working in a world increasingly immersed in artificial colour – the synthetic dyes in

clothes, the still-novel tubes of acrylic paint, the codified logos of brands.

In 1963, New Jersey firm Pantone introduced its first Color Matching System, an annual guide detailing specific shades, allowing for standardization of industrialized colour across the planet. Today the effect is stark. We think we know red and yellow, because we know the red and yellow of McDonald's. The orange of the Penguin logo is Pantone 021C.

Truitt thought differently. To her, colour was alive, indefinable. Making colour became her life's work. 'I slowly came to realize that what I was actually trying to do,' she wrote, 'was to take painting off the wall, to set color free in three dimensions for its own sake. This was analogous to my feeling for the freedom of my own body and my own being, as if in some mysterious way I felt myself to *be* color.'

Truitt had started practising as an artist in 1948, mainly working in clay, plaster and stone. She lived in Washington, married to a journalist who worked in the city. They had three kids, Alexandra the oldest, born in 1955. 'She would wear these artist's smocks and blue jeans,' Alexandra said. 'Denim was strictly studio. She never wore her studio clothes out and about, ever.'

In 1961, Truitt took a weekend trip to New York, visiting galleries and museums for the first time in years. What she saw was a revelation. She returned a different artist. She was forty. Alexandra was six at the time. What can she remember?

'Her studio changed. Instead of going across the street to this small room, all of a sudden we were going to this

giant building where there were these giant sculptures. The whole tenor of everything changed. The studio was freezing cold. That's why she bought that quilted outfit.'

In 1968, Truitt was featured in the May issue of American *Vogue*. She wore the quilted zip-up jacket in that previous photo from 1964, the paint caked on. The photo is by Snowdon.

The article is a piece of posturing by a New York art critic called Clement Greenberg, who played a deadening role in locking twentieth-century art into a series of -isms. Greenberg doesn't even mention Truitt until the last line on this opening spread, after going on about minimal art, pop art, op art, assemblage, novelty art, Anthony Caro, Jasper Johns, David Smith . . .

The spread is a visual representation of what life was like for American female artists in the 1960s and 70s. While the critic ignores her and her work, Truitt stands there in her

paint-spattered jacket. It's like she's incredulous, waiting for someone not just to consider her in terms of others, but to really look and to really see.

Her daughter Alexandra now has the jacket.

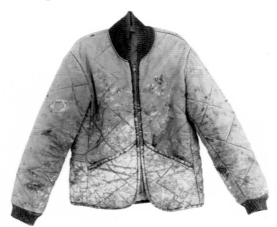

The curve of that front hem! Let's look at the back.

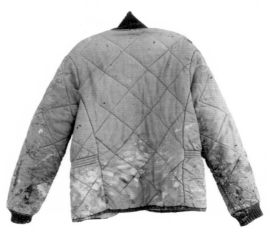

The jacket was from Sears, Roebuck & Co., the brand we encountered earlier with Agnes Martin's dungarees.

The label inside: Ted Williams was a retired baseball player, hired by Sears to give its work clothes some clout among 'ACTIVE AMERICANS'. Notice she also got paint on the inside of her clothes.

Truitt divorced her husband in 1971 and took custody of her children. She struggled to earn a living as an artist. There was recognition: in 1973, she had a mid-career show at the Whitney; in 1974 at the Corcoran Gallery of Art in Washington. There was also derision. In 1975, her paintings were displayed at the Baltimore Museum of Art. The canvases were painted white. The show was met with such

critical disdain, the mayor of Baltimore called the director of the Museum to reassure him of his support.

There was personal disappointment too. She was represented by the Emmerich Gallery in New York. In 1975, it held a show of her new work. Not one piece sold. She wrote that it was 'the most devastating defeat I have so far met. Devastating because I so need the money, not because I am unaccustomed to this kind of failure.'

Truitt grew increasingly focused. 'As time went on, she became more comfortable working on what she called her nerve,' said her daughter. 'What she was doing was authentic to herself. It was an investigation or an adventure.'

Did the plainness of Truitt's clothing allow for this vaulting off into colour? 'That was definitely a thing. Those studio clothes accumulated a kind of neutrality. You can't make the work my mother made without wearing some kind of comfortable clothing. You couldn't reach up to paint

if you were wearing a lady's blouse. It was necessary. It wasn't making a statement. She had to wear a men's large or a men's medium shirt because there were no women's clothes in the 1960s that she could wear.'

With Truitt, it is glorious to see how precision and certainty were arrived at through mess and freedom. For other artists, their clothing mirrors their work. Let's follow British artist Phyllida Barlow, in a short film directed by Cosima Spender. At the beginning of one November morning, Barlow turns on her studio lights.

She takes her drill to a sculpture . . .

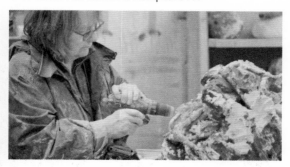

... then assesses the results.

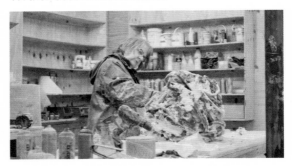

She marks shapes to be cut for a large work.

She lifts a beam, which she then smears with paint by dunking her hand in a pot.

She squirts insulation foam to create another sculpture.

Barlow has an ease and familiarity with her materials, built from a lifetime of making and breaking. She has been a practising artist for over fifty years. She represented Britain at the Venice Biennale in 2017. Yet barely any of her earlier work still exists.

Much of this is due to practicalities. Barlow has been active as an artist since the 1960s, but only received gallery representation in 2010. To subsidize her life as an artist, she taught at the Slade School of Art in London, eventually becoming Professor of Fine Art. Her students included Tacita Dean, Martin Creed, Rachel Whiteread.

She always made her own work, but hardly any of it sold. Her pieces were often so big, there was no way she could afford their storage. What she made was mostly destroyed, the materials reused.

Barlow had moral and political reasons for destroying and repurposing sculptures. For her, making work that was messy and short-lived was an act of resistance to hard capitalism, a refusal of the expectation that art should be neat, shiny and commodifiable.

Nothing is deified in her studio, even if now the finished works are preserved. More from Spender's film:

A close-up of that extraordinary jacket, crusted in material.

Barlow takes hold of a sculpture . . .

and tips it off . . .

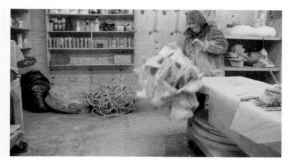

on to the floor.

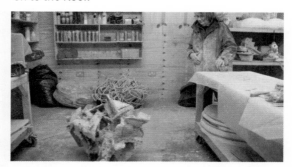

She pulls it apart in order to find something unexpected and therefore of interest.

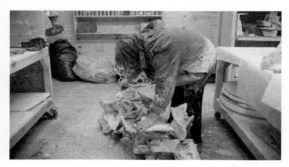

The work is done for now. Barlow sweeps up.

The American artist Jack Whitten got paint on his footwear every day. It was intentional. 'Dad wore his sneakers that he spray-painted silver on a daily basis,' emailed Whitten's daughter Mirsini Amidon, who answered some questions for me with her mother, Mary. 'He wouldn't leave the studio without stopping to re-spray his sneakers, so they were always fresh and shiny.'

The artist, outside his studio in Queens, New York, in 2007, wearing his silver-sprayed sneakers.

Whitten died in 2018, aged seventy-eight, just as his work was gaining wider international attention. In 2015,

he was awarded with the National Medal of Arts by President Barack Obama. Whitten explored abstraction and form, creating canvases that questioned the mode of painting itself.

An early work: *Homage to Malcolm* from 1970.

In the 1980s, Whitten innovated a technique by scraping off layers of acrylic paint, then re-laying them as if making a collage. He called the method 'tesserae', the ancient Greek word for the individual tiles that were used in mosaics.

In the studio, Amidon wrote, Whitten wore a white paint-er's jumpsuit over his clothes. 'The jumpsuit was encrusted with paint. I don't know how often they were replaced.' If guests visited, Whitten would change into a white lab coat, also covered in paint. 'The studio was his laboratory,' said Amidon. 'He was conducting experiments with paint and light. His clothing reflected the seriousness of his endeavor.'

Amidon wrote giving many glorious details of her father's clothing. 'He always wore a neckerchief. He usually wore some type of cap. For a while, when I was in college, he wore the purple W baseball cap of Williams college. Of course, we always contended the W stood for "Whitten".

Other years he wore a cap from a car dealership with their logo blacked out. He didn't like being a walking billboard for companies.'

Whitten was born in Alabama, growing up poor in a time of appalling racial segregation. He spoke of how, in his childhood, clothing was a point of pride. 'My mom,' he said in 1994, 'when we needed clothes and we didn't have any money, you know what she would do? She would go to the army surplus store and buy old clothing, bring them home,

take them apart seam by seam, and rebuild them. And when I hit the street . . . I had a new pair of pants on.'

The power of looking sharp stayed with Whitten. 'Outside of the studio,' said Amidon, 'he was quite natty, and slightly less covered in paint.' Whitten liked to dress up for openings. 'He collected brooches and would wear them calibrated to the audience: an enamelled octopus, a glittering spider, a red lizard, a Bakelite head of a scotty dog.' There were some constants. 'Always his silver flying fish necklace on a long thin chain. A hat. He loved his hats. He was always pulled together and expected the rest of us to look pulled together as well.'

Here is Whitten with one of his sculptures, *Quantum Man (The Sixth Portal)*, at the gallery Hauser & Wirth in New York in 2017. It was the gallery's first exhibition of Whitten's work. The photo was taken by the artist Alvaro Barrington, who we'll meet later on. The fish brooch!

One last image of Whitten, covered in paint, in the mid-1970s. The T-shirt is from his brother Bill's company. Bill Whitten designed the outfits for Michael Jackson in the *Thriller* era, including the glove.

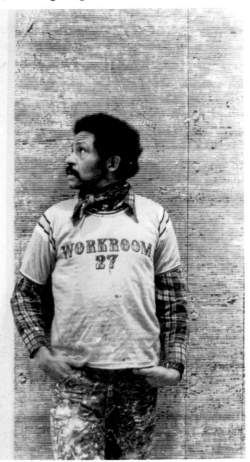

Jackson Pollock: he must have been messy, right? I found this photo on the Pollock Krasner House and Study Center website.

I emailed to ask: can I use that image of Pollock's footwear? The reply: they weren't his. They were his wife's – Lee Krasner's.

I couldn't have been more wrong. These clean brown loafers were Pollock's.

All the photography and footage I've found since shows Pollock flicking and dripping paint away from his body, on to canvases laid on the floor.

Because of Pollock's alcoholism and mental ill-health, Lee Krasner's work took a back seat. Recently, the importance of her art has been recognized. In her own lifetime,

she was largely ignored by a New York art industry enamoured with the male-genius-artist narrative.

I love filthy shoes. I emailed the British artist Chantal Joffe and asked if she'd send me a photo of the Crocs she wears when she's painting. Joffe chronicles her life in her work, in self-portraits and paintings of those she loves. I was sure one time she'd mentioned that she wore Crocs.

'Not when I paint!' she replied. 'I love Crocs, tragically, but paint goes through the holes. For painting I wear very old felt Birkenstock clogs.'

The next morning, she took a photo in her studio.

It's as if the Birkenstocks are disappearing into the floor.

'I've had this pair for about five years,' she wrote. 'It takes a long time to wear them out as they never go outside. It's always a bit shocking to get a new pair, all pristine and new grey felt. It feels wrong to get them messy and then I forget they were ever all new.'

Joffe said that she'd once painted a self-portrait wearing a silver pair of Birkenstock sandals. The painting is from 2016.

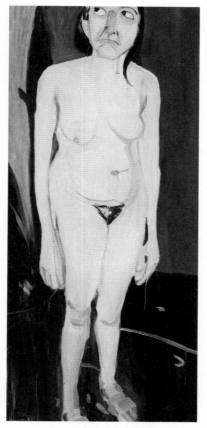

She paints constantly. The paint on her Birkenstocks is a result of her commitment to the work. Joffe is British, but was born in the US. 'I always think of a TV show I watched as a kid called *Mister Rogers' Neighborhood*,' she said.

I'd never heard of it before.

'At the beginning of each show he would arrive in a house and change his cardigan, and then his shoes. I'm like that. I arrive in the studio and change my shoes and put on my painting clothes.'

More artists' shoes. I was drinking one night with the British artist Kaye Donachie. She paints canvases full of narrative and longing, always of women. Donachie had talked about the trainers she wore to paint.

A few days later I emailed: did we talk about trainers? 'We did talk about trainers!!!!' Donachie replied. 'I can only paint in Nikes, although the ones I currently have are not as paint-splattered as my old ones, which disintegrated in turps.'

Turps means turpentine, an extremely toxic chemical used for thinning oil paints. She said, though, that she'd send me a photo of the painting T-shirt dress that she wore every day.

These paint-spattered clothes become part of an artist's toolbox, used day in, day out, a living history of their practice. The apron is the archetypal garment – here is one belonging to Matt Connors, on the back of his studio door in the East Village of New York. Alongside the image, a work he exhibited a month after sending the photo. It's called *Keyboard of Light*.

Connors is eloquent about how hard it is to paint in abstraction. The paint on the apron is a result of his specific way of working.

'My habits are kind of unformed and not very regular,' he wrote, 'because I have a lot going on in my brain.' Connors said he was always working on between six and twelve canvases at once. 'Paintings are almost always done flat on

sawhorses, because I use extremely liquid paint on mostly un-primed canvas, and there would be no control of the paint if it was not flat. Over the years of working this way, I have learned a lot about how such liquid paint will behave.'

You can see that liquidity here. The work is called *Pieta*.

The mess on Connors's apron reflects his choice of paints. Alongside this liquidized acrylic paint, Connors also uses oil paint. The former is synthetic, the latter natural. The two are not supposed to be used on the same canvas. Connors uses them together. This work is called *Repeat Clarice*, and it features oil, acrylic and crayon.

174

'The combination of the extremely liquid acrylic paint and the hastily prepared oil paint makes for a lot of mess,' he wrote, 'but also I have always used this as a way of making or finding marks. I will often grab some excess paint from a really overflowing puddle of paint on one canvas, oftentimes with my fingers even, and transfer it to another work. Similarly, with oil paint, I will typically end up with quite a bit on my hands and, before wiping it off on the apron, I will first check to see if it is needed elsewhere.'

Connors has had the apron for ten years. It's likely that some trace of every work I've loved is on that apron. 'I'm about to get a new one. The strings have ripped several

times.' Connors said he'd found a new apron he liked at a hardware store in New York.

Not all artists are so open about revealing their painting garments. I'm obsessed with photos of Francis Bacon in his studio not covered in paint. He lived and worked in chaos: emotional, physical, psychological. If all around was turmoil, why did he not show it in what he wore?

Bacon painted alone. His friend Michael Peppiatt once said that, when Bacon was working, he dressed in worn-out garments: an old dressing gown, an old pair of trousers, a sweater. When he finished work, he would change. Bacon headed out to Soho, ready to be gregarious and glamorous and drunk. When he invited photographers to his studio, that glamour was still on his mind. This portrait from 1960 is by Cecil Beaton.

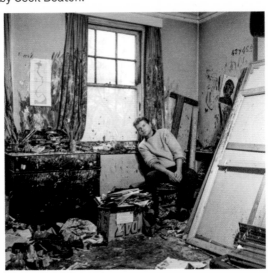

Look at the fabric on his body: spotless. Now look at the curtains. Bacon used them to wipe his hands. Those hand marks go so high! What would the clothes he painted in have looked like? Why doesn't he want us to see them?

Beaton photographed Bacon just before the artist moved to a mews house in South Kensington, where he lived and worked until his death. Here's a photograph of Bacon in that South Kensington studio in 1974. He'd already been there fourteen years.

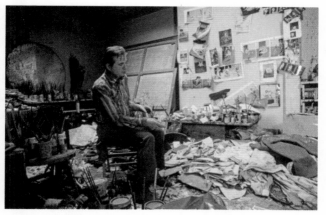

Once more, spotless clothing.

Bacon was an artist of unremitting control. In 1971, his lover George Dyer overdosed on barbiturates. He died in Paris, on the eve of the opening of a major Bacon retrospective. Bacon ensured Dyer's death was not announced for two days.

That control is here in these images. Bacon wanted the chaos of his studio to be seen. But he also wanted to present himself as in charge. He did so in clothing that was fresh, sexy, fashionable, clean. But look, what's that

there? On that pile of rags? It's a pair of trousers, slung with abandon, paint-smeared.

Bacon died in in 1992. In 1998, his entire studio, from the walls and ceiling to the dust in the room, was packed up and shipped to the Hugh Lane Gallery in Dublin. It took three years to put back over 7,000 items, recreating the space exactly as it had been.

In the door of the studio, the museum has built a Perspex nook. It means you can stand slightly inside the hermetically sealed space. There is so much to take in, so many clues to his work and his mind. It took me a few minutes to realize that there, the other side of the Perspex, were some clothes. On a chair, just like his friend Peppiatt had said, were a dressing gown, a pair of trousers and a sweater. I took this photo – the trousers are underneath the pile, just out of shot.

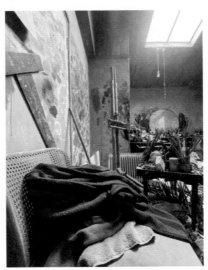

This was what Bacon really wore. I wondered: did they have a record of every item of clothing in his studio?

They sent me a detailed list of forty-five items. I'll describe them as well as I can.

Bacon had a 32" waist, inside leg of 31". Many of his trousers were from St Michael, a now-defunct clothing line of Marks & Spencer. Most were wool mix with polyester, though there was also a pair of St Michael blue denim jeans. These jeans, like the other trousers, were mucky, crumpled and covered in paint.

Three dressing gowns were found. The one visible in Dublin was the cleanest. A light blue St Michael dressing gown had a great smear of yellow on the back, patches of black near the armpit and hem. A blue towelling bathrobe was so covered in paint, it was as if it had taken on its own form.

Cashmere sweaters were spattered with paint. For some reason, one was listed with a hammer. Red-striped pyjama bottoms looked like a paint rag. There were nine pairs of lace-up shoes, mostly sneakers. Bacon took a shoe size 8.

For painting, it appears he wore fine leather slippers, the heels trodden down. Three were listed, though no pairs remained. One black leather slipper, left foot, was made by Church's of Northampton. Paint took to the leather gloriously. There they all were, the clothes that bore rare witness to his work.

They also archived clothing for his outer world. Item 15 was an olive-brown belted leather coat, its label read 'JAEGER LONDON PARIS NEW YORK MADE IN ITALY'. Beneath it was item 16, a pair of brown plastic wraparound shades. These garments he wore for the serious business

of drinking, of causing havoc, before he returned to the studio, reverted to his dirty clothes, the same old ones he knew no one would ever see him wear, and got down to business.

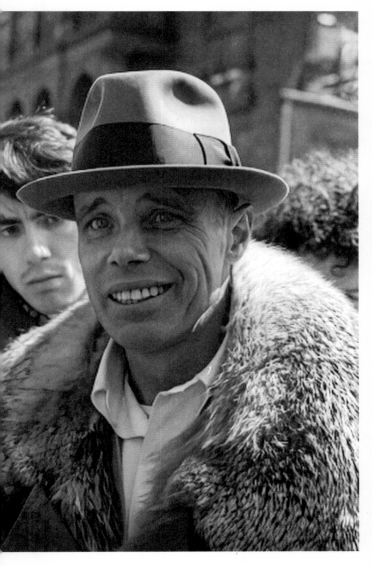

**Joseph Beuys**

**The German artist Joseph Beuys** spent the last twenty-five years of his life wearing the same look: felt hat, fisherman's jacket, white shirt, blue jeans. Combined, these clothes made him one of the most recognizable artists of the twentieth century.

Beuys said everybody was an artist, and that art 'is the only political power, the only revolutionary power, the only power to free humankind from all repression'. He was committed to dissent, activism, dialogue, peace. His work involved performances and happenings that he called 'actions', like his public lectures illustrated by copious chalkboard drawings. He also created monumental sculptures from materials such as fat and felt. For him, such materials carried symbolism. He travelled often and worked away from commercial galleries, resetting the boundaries of what art could be and where it could exist.

The photographs in this chapter were taken by Caroline Tisdall, who met Beuys in the early 1970s, while she was working as art critic at the *Guardian*. At the time, Tisdall was also writing extensively on conflict and human rights in Palestine and Beirut. The pair shared a common interest in politics, history and injustice.

Tisdall became Beuys's travelling companion and collaborator, a friend until his death in 1986, aged sixty-four. She is an expert on his life and work.

Today, Tisdall lives deep in Dorset. She is a successful racehorse owner. Her house dates from the early sixteenth century, an old timber-framed abbey dwelling. When I arrived for tea one Sunday afternoon, her door was open. I rang the bell anyway. It was an actual bell, with a curled metal pulley.

'Beuys completely believed in the power of materials,' said Tisdall. We were sat in her garden, the sun lowering behind her. 'Even in what you're talking about, his clothing and the materials of his dress.' He was raised a Catholic, with transubstantiation a core belief. 'Everything he used had meaning as a material. That was the basis of his art. And he used himself as an artwork, probably more than any other artist.'

As with so many of the artists we've encountered, Beuys's clothing was practical. It allowed him to get on with his art. 'What Beuys wore was a sort of uniform. It had expedience and efficiency, and it solved the problem of deciding what to wear. Good cotton shirt. Denims, and a fishing jacket that had lots of pockets for putting stuff in. With the hat. Makes a very distinctive outline. It solves a lot of problems. Once he put that together, he never had to think again.'

Beuys was in his early forties when he first gained attention as part of the Fluxus movement of the 1960s. Tisdall said his look came together then, bit by bit. Beuys had served in the German Air Force, and narrowly survived a plane crash in 1944, suffering an injury to his head. His felt

hat was from Lock & Co. Hatters of London. 'He wore the hat right from after the war because it protected him from the cold, the metal plate in the skull.'

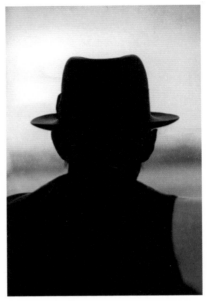

The plane crash became part of Beuys's own mythology, as did his clothes. He believed in shamanism. 'This hat,' he said, 'represents another kind of head and functions like another personality.' Beuys went on to say, 'When they describe it flatly as a trademark, this is because the meaning is not really clear to them. That's exactly what I meant when I talked of the shaman: it is impossible to decipher precisely the way it functions. A simple meaning would be that the hat alone can do the work and act as a vehicle – and I personally am not so important any more.'

Tisdall has one of his hats. 'He gave me one for him,

for next time,' she said, 'when he comes back.' Such was the duality of Beuys and his clothing. It was grounded in practicalities, but it was also like a space suit for vaulting spiritual realms.

Some more of the functionality: the fisherman's vest: 'You can buy them cheap. That's how they are. I fish a lot, and I wear them all the time. I have about four of them but they've all got flies and stuff in them. For him, it was ideal. All those pockets. Didn't need a handbag, darling.'

Note the camp. Tisdall said her nickname for Beuys was 'Josie'.

Here is Beuys, stirring a cauldron of fat, to create his 1977 work *Tallow*.

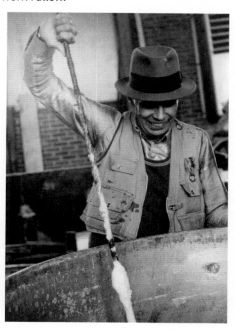

His denim jeans were by Levi's. Beuys was born in 1921, seven years before Andy Warhol, a fellow Levi's wearer. The two artists would collaborate in later life.

Tisdall said his shirts were German, 'very heavy cotton. As you know, a nice clean shirt makes you feel good. He was very particular.'

Beuys had two full-length coats. One was fur-lined, the other a full fur. Tisdall took this photo at the Giant's Causeway in Northern Ireland in 1974.

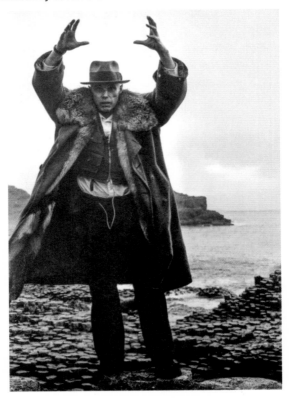

'He was recognizable,' said Tisdall. She then pointed to a paradox. The 'it' she talks about is his clothes. 'In a way it becomes invisible, or it stands instead of him.' It's both things: disappearing, so Beuys could get on with his work, yet so identifiable, it almost takes his place. 'Maybe the uniform could have gone on without him.'

Maybe it has, in ways other than Beuys intended. His look has been repeatedly copied by the fashion industry. In January 2015, *Dazed Digital* asked, 'What does Joseph Beuys have in common with the Paris menswear shows?' The answer: designers and stylists were taking inspiration from Beuys.

It is unlikely that he would have approved.

Beuys was against consumerist production. 'The more I consider the problem,' he said in 1969, 'the more I think that there's only a few things I need to make. I want to try to only do those that have some importance. I have no interest in production as such. I am neither interested in making works for commerce nor for the pure pleasure of seeing them.'

In 1979, he warned of 'a culture which is only interested and able to develop material conditions – only to exploit the material conditions, to exploit the resources of the earth, and along with this to exploit also the humankind ability for a kind of profit, you know. For a kind of profit for very few, very mighty personalities and institutions.'

Over forty years have passed since Beuys spoke those words. Today, the global luxury fashion industry is dominated by two conglomerates: Kering, owner of labels such as Gucci and Saint Laurent, and LVMH, owner of labels such as Dior and Louis Vuitton. The chairman and chief executive of Kering, François-Henri Pinault, has a net

worth of $43.4 billion. The chairman and chief executive of LVMH, Bernard Arnault, has a net worth of $155.4 billion. Arnault is the second-richest man in the world.

I'd arrived at Tisdall's with a theory, based on a work by Beuys from 1972.

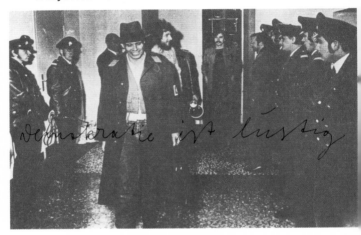

Beuys had been appointed Professor of Monumental Sculpture at Kunstakademie Düsseldorf in 1961. During his time there, he encouraged students to engage in political activism. In 1972, he was dismissed for over-enrolling his classes, an action contravening the school's policy of limited admission. On 11 October, Beuys staged a sit-in. Hundreds of students protested with him. After two days, he left the building, surrounded by police. The work captures that moment, the title written across the image: *Democracy is Merry.*

It is a stark photograph. Look at that grin. There is glee in dissent. At the time, Beuys was fifty-one. It is rare to see

acts of subversion carried out by men in their fifties. His clothing challenges the conventional idea of a man in mid-life: settled down, co-opted, establishment.

Didn't the power of his clothing come from this other-ness? In the image, it sets him apart from his police escorts as a figure capable of radicalism. Tisdall was reticent. 'I don't think it was *épater les bourgeois*, although I can see what you mean. I wouldn't say that was his main motivation.'

Although the garments were functional rather than tailored, Beuys still cared about his appearance. 'He was always well turned out,' said Tisdall. 'Well ironed and laun-dered, fresh and respectful.'

Maybe, I suggested, he wore a uniform of dress equiva-lent to the suits of his West German male contemporaries. 'That's a good thought,' she said. 'You should follow that up.' The norm among men of Beuys's generation – the genera-tion who had fought in the German Army, and then found a way to respectability after the war through economic productivity – was to look tailored, smart, modern, business like. 'Not like Nazis,' said Tisdall.

Beuys warned of the dangers of hiding from the past. He was honest about having been a member of the Hitler Youth as a child, about having fought in the war. 'Beuys always used to say, "Auschwitz is not over." All those impulses are still there in human beings. He was always very aware how society can slip into totalitarianism through convention.'

The clothes Beuys wore showed he stood for something other than the march of industry and capitalism. 'He grew up with all those uniforms and all those symbols. You were your uniform, weren't you? To take that and invert it, he was very bold like that.'

Tisdall and I had been talking for an hour. 'Your thing about clothing is interesting,' she said, 'because it makes him different from you and me. At a very basic level. Or a very profound level.'

**Clothing in Art**

**When we wear clothing,** we all adopt some form of persona, just like Beuys. This persona could be wildly different to what we see as our 'true' character. Or it could be a role we enjoy playing. We may be so used to the role, we forget we're playing it at all. In clothes, we are all performing, all the time.

This sense of personal performance has only intensified as dress codes have broken down over the past five decades. We have more choice in what we wear, the fashion industry thriving on selling us ideas of who we could be. Many are willing performers, though we may not like to admit it.

These behavioural changes are mirrored in the emergence of performance art. By the 1970s, it had become a practice for disobedient artists to define the parameters of their work outside of gallery and museum traditions, just like Beuys. They would transcend notions of what and where art should be, often having no terminology to describe what they were doing.

Performance artists have taken clothing and used it as a material within their work—but the use of clothing in art is not exclusive to performance. Other artists, such as Cindy Sherman, also make their own bodies, and the clothes they wear, the subject of their art. What can these artists tell us

about how we all wear clothes, all of us who try to pretend we're not performing, all of the time?

In 1973, the American artist Lynn Hershman Leeson arrived in San Francisco and checked into the Dante Hotel under the name Roberta Breitmore. She wasn't acting, it wasn't a role. Breitmore existed. She was an artwork.

It was the beginning of a five-year real-time private performance, near the beginning of Hershman Leeson's boundary-breaking career. This was site-specific perform-ance art in its nascent days. 'With Roberta, I don't even think I knew the term "performance",' she said. We were talking on Skype. 'For me it was an investigation of the blur of reality.'

Roberta had survived a childhood of abuse. She was a depressive. Roberta would come to have her own driving licence, credit card, bank account, even her own handwriting. She went on dates, attended therapy, tried to hold down jobs. For the whole time she existed, Roberta wore one dress, one cardigan, one wig. Here she is, meeting a date, Irwin, in Union Square Park in 1975.

'She got that outfit on sale for $5.99,' said Hershman Leeson. 'She kept the tag on it, on the outside, so people could see what she paid. It was part of her definition, for sure. It was part of the frame for how you see her.'

The colour of the dress was deliberate. She said that, according to believers in early alchemy, the stages of consciousness correspond to different colours. 'She wasn't quite conscious yet, but was starting towards becoming conscious,' said Hershman Leeson. 'She consistently wore that until she didn't exist, because she never really escaped the prison of her environment.'

Her wardrobe was limited. Isn't it sometimes cold in San Francisco? 'Oh, she had a jacket before it was stolen, a suede jacket in the same colour.'

Where was it stolen?

'I think at an EST meeting.'

EST stands for Erhard Seminars Training, a then-popular course held over two intensive weekends that 'brought to the forefront the ideas of transformation, personal responsibility, accountability and possibility'. Participants were forced to face and then free themselves from their pasts. Roberta attended.

In addition to her clothing, make-up was crucial to the creation of *Roberta Breitmore*.

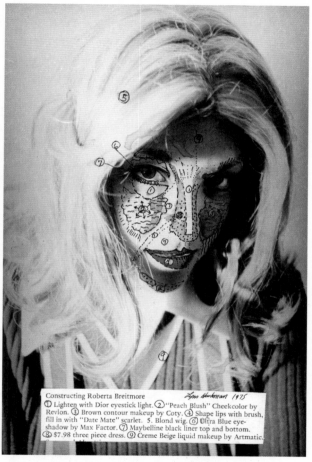

Constructing Roberta Breitmore          *Lynn Hershman 1975*
① Lighten with Dior eyestick light. ② "Peach Blush" Cheekcolor by Revlon. ③ Brown contour makeup by Coty. ④ Shape lips with brush, fill in with "Date Mate" scarlet. 5. Blond wig. ⑥ Ultra Blue eyeshadow by Max Factor. ⑦ Maybelline black liner top and bottom. ⑧ $7.98 three piece dress. ⑨ Creme Beige liquid makeup by Artmatic.

'It was a mask,' said Hershman Leeson. 'But make-up *was* a mask in those days.' She meant the products were thicker, clumpier. 'I took the chart from a lot of magazines

that were showing you how to use make-up. It was becoming what the media thought was the most attractive way to present yourself.'

By bringing Roberta into existence, she used performance to convey the trauma and trap of the female experience in 1970s America. 'For Roberta, it was a subconscious thing. She was trying to please the patriarchal standard of aesthetics, and yet define herself, which she wasn't able to do.'

As the performance continued Roberta became more depressed. Images from a therapy session were used to create *Roberta's Body Language Chart*.

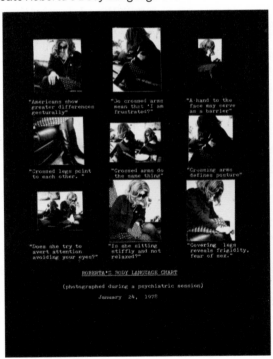

"Americans show
greater differences
gesturally"

"Jo crossed arms
mean that 'I am
frustrated?'"

"A hand to the
face may serve
as a barrier"

"Crossed legs point
to each other."

"Crossed arms do
the same thing"

"Crossing arms
defines posture"

"Does she try to
avert attention
avoiding your eyes?"

"Is she sitting
stiffly and not
relaxed?"

"Covering legs
reveals frigidity,
fear of sex."

ROBERTA'S BODY LANGUAGE CHART

(photographed during a psychiatric session)

January 24, 1978

'I went and saw her psychiatrist recently and he said he noticed that she never changed her clothes.'

Did the psychiatrist know at the time?

'That she was an artwork? No, not at all.'

When did you tell him?

'Only after she didn't exist any more.'

What did he say?

'He said he'd wished he'd written better letters to her. There were misspellings; he didn't know they were going to be part of the work. He had a good sense of humour.'

The therapy sessions had limited effect. Roberta's mental health declined. A photograph from 1978 is titled *Roberta Contemplating Suicide on the Golden Gate Bridge.*

'She couldn't escape her time, as much as she wanted to. She was part of that time, and she fed into the psychology

of imprisonment through her physical attributes, which included the clothing and the look.'

Roberta was eventually exorcized in 1978, on the grave of Lucrezia Borgia in Ferrara, Italy. *Roberta Breitmore* is now recognized by many academics and critics as one of the most significant acts of art in the twentieth century.

Throughout Roberta's existence, Hershman Leeson lived her own life. 'We were very separate,' she said. 'I had a lot of clothes, too many clothes. It was part of getting into the frame that she lived in, putting on the wig, putting on the costume. That was all her. It actually made it easier.'

A screenshot from the short film *Lynn Turning Into Roberta*.

Hershman Leeson has spent her life making work outside what's usually considered art. Recently, she's been looking at DNA, antibodies. 'Most things, people don't know what I'm doing,' she said, 'or they don't think I'll do it. So it's part of the subversion.'

Is the subversion also part of the pleasure of making work?

'Well, yeah,' she said. 'As a female in those days, in the seventies, you weren't given much leeway as to what you were able to do. So it was always a thrill to be able to do what people thought you were too constricted or weren't able to do, and then pave the way for the future.'

How does she define performance? 'I think performance is a state of mind,' she said. 'Often it doesn't matter if it's seen or not. The audience can come ten years later, it doesn't make it any less of a performance.'

So it goes today. One September, the Japanese artist Urara Tsuchiya travelled from her home in Glasgow to Dartmoor, a protected area of nearly 1,000 square kilometres in south-west England. She was with her regular collaborator, the photographer and filmmaker Ben Toms. They were making the film *Give Us a Meow*.

Tsuchiya works in ceramics, clothing and performance. For this trip, she'd made some outfits. One morning Tsuchiya did a 7.30 a.m. solo catwalk on a thirteenth-century bridge.

There was no need for an audience. The subversion comes from seeing Tsuchiya in those garments, on that bridge, out-of-time and alone.

When Hershman Leeson was midway through her *Roberta Breitmore* private performance, college student Cindy Sherman began taking images of herself. From the beginning, clothes were central to Sherman's work. In the 1975 work *Air Shutter Release Fashions*, she used an air shutter release cable to outline different garments on her naked body. Many of the garments she chose to convey compound the objectification of women, such as the *Playboy* bunny outfit.

bunny outfit

Sherman has since dedicated her practice to taking on the role of the multiple unnamed personas in her photographs, performing in front of her camera within the sets she creates. She dresses herself, dons wigs, applies make-up. What Sherman wears allows her to address gender stereotypes, societal archetypes and emotional states: fear, sadness, pride, horror.

'Clothes are very important in my work,' she emailed, 'because they play a major factor in giving clues to a character's personality. And I feel that's true for everyone, not just in my work.'

Sherman's images are usually presented as vast prints, bigger than life-size. Since the early 1980s, the works have had no official title, only a number. Here is one of her earliest, from a series that has become known as *Centrefolds*, from 1981.

Sometimes her subjects feel recognizable, like a series based on uptown society figures, dressed in their finest clothes and yet betraying discontent.

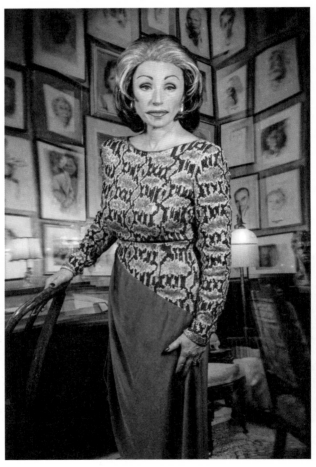

Other times, Sherman uses clothing and scenery for images that lurk on the edges of consciousness. In this work from the *Fairy Tales* series, she wears a gingham dress, a simple checked cotton associated with spring-time innocence. The character appears lost and afraid, in the dark of a forest. The wholesome connotations of the gingham heighten the fear.

Sherman doesn't fetishize the clothing that appears in her work. Garments are crucial to her art, but they are not the art itself. It's an important distinction: these clothes have never been displayed as artefacts. They are a means to an end, only appearing within the hermetically sealed world of each image. Sherman doesn't keep them, unless she can reuse them. By appearing in this clothing, it's like she's questioning it: why does this garment carry this meaning? Who is the person that would wear it? And what do we think of that person? Are we being fair?

The clothes often create the character. 'An interesting garment is more likely to inspire the character than anything else,' she wrote. 'A lot of what I do is trial and error, playing around and then just seeing what works.'

Sherman is constantly seeking new costumes. 'I am always on the lookout for interesting pieces, whether from a thrift store or flea market or even when just shopping for personal items (there are things I've bought that I know I'll never wear but might use). But occasionally I've looked for slightly more specific things on eBay or at a Salvation Army store.' She cited one of her series. 'For the *Clowns*, for example, I wanted bright, colourful, frilly things, but didn't want to buy actual clown costumes.'

One of Sherman's clowns, not in a costume but, if you look closely, wearing a pile up of detritus from consumerist culture.

Sherman can break the form of her garments. 'I've also mixed up the clothing in terms of purpose, using pant legs

for sleeves, wearing things upside down or backwards, if it worked better.'

In 1983, Sherman made a series that questioned fashion imagery. She was supplied with designer clothing by an American store, for a story in *Interview*. In this image, she wears a tailored dress by Jean Paul Gaultier, its exaggerated shoulder contrasted with the fitted waist, its length intentionally longer than a regular jacket.

In her notebook at the time, Sherman wrote: 'Attack clothes ... ugly person (face/body) vs fashionable clothes.'

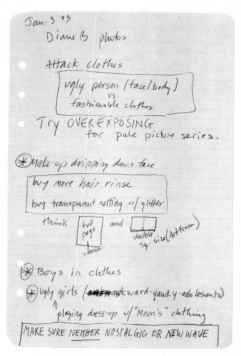

Jan. 3 '83
Diane B photos

- Attack clothes

    ugly person (face/body)
            vs.
    fashionable clothes

- Try OVEREXPOSING
        for pale picture series.

⊛ Make-up dripping down face

    buy more hair rinse

    buy transparent netting w/ glitter

    think [full page - internal] and [double sq. size (Artforum)]

⊛ Boys in clothes

⊛ ugly girls (~~some~~ awkward · gawky · adolescents)
          ↑
    playing dress-up w/ "Mom's" clothing

MAKE SURE NEITHER NOSTALGIC OR NEW WAVE

Sherman has since become closer to the fashion industry. She has appeared in campaigns and imagery for Comme des Garçons, Marc Jacobs. In September 2017, the Japanese designer Jun Takahashi of Undercover presented oversized T-shirts that used images of Sherman's work. Her name was printed in the font usually associated with the band Nirvana.

Here's a shot from the catwalk, where the models came out in twos – fashion shows are often a performance in

themselves. On the T-shirt is the work *Untitled A*, made while Sherman was still studying.

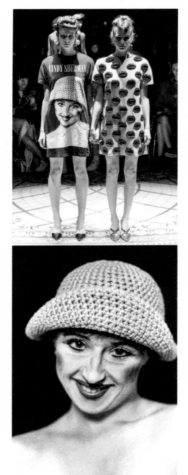

How did Sherman decide who she lets use her work? What did she like about Takahashi? 'I love his disregard for

what one would expect,' she wrote. 'Like normally I wouldn't let a museum reproduce my work the way he has. I thought what he did with the women's collection was brilliant.'

Anyone who bought the T-shirts is performing, like Sherman, whenever they wear it, whether they know it or not.

Sherman makes her work within an American society obsessed with overt, visual expressions of individual identity. What about artists working in societies that impose restrictions, under ideologies opposed to consumerist fashion?

Geta Brătescu, born in Romania in 1926, was aged twenty when the Communist Party came to power. Her studio became a place of escape from political oppression. She made collages, drawings, films.

In 2002, she created a series of nine self-portraits in her studio titled *Alteritate*. She was seventy-six, using clothes to cover up, yet revealing what is beneath. The images are simple and powerful. She conveys emotion and narrative through her body draped in coat, beret and gloves, the inherent ludicrousness of all these garments she's wearing, the ludicrousness of the garments we all wear. The series is pricked with humour by Brătescu wearing a thigh trimmer as a hat. In that image, none of her flesh is visible at all. By covering herself, she can scrutinize herself in a way separate from normal self-reflection.

'Before a portrait,' she said in 2004, 'is there anyone who thinks that the look he/she is gratified with by the framed face is actually the look the artist gave himself in the mirror, an introspective, intimate look?' She meant the difference

between looking at the surface and the willingness to see deeper. 'Disclosure, the testimony of an extreme act.'

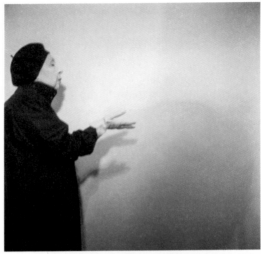

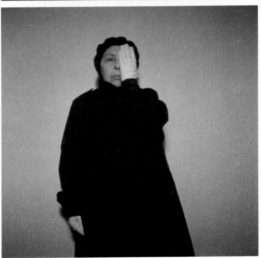

In the 1970s, the Taiwanese performance artist Tehching Hsieh had to leave his country to be able to make art. Hsieh had started as an artist at home, but he knew Taiwanese society was too conservative for his ideas. He joined the marines. When he made it to US soil, he jumped ship and headed to New York. It was 1974. He was twenty-four.

His first years in New York were spent cleaning restaurants. Hsieh was an undocumented immigrant. He was not making any art, his life stuck in a relentless and exploitative sleep/work labour cycle. Then he realized that this cycle could become his art.

Hsieh began a series of *One Year Performances*. The first, in 1978–9, was titled *Cage Piece*. For this work, Hsieh did not leave a wooden cage. The second was titled *Time Clock Piece*. From 11 April 1980 to 11 April 1981, Hsieh punched

a time clock every hour, on the hour. He did so wearing a grey work shirt, grey trousers, a belt, lace-up work footwear.

Where did the outfit come from? 'I bought it from a workers' uniform store,' Hsieh emailed. 'Punching the time clock is working, so I chose a worker's uniform.'

Look closely. Hsieh asked a friend to make a special label for him. 'I used my last name, the first date (April 11, 1980) of the performance and the last date (April 11, 1981) of the performance, as the logo of my company.'

Hsieh said he had four of the uniforms over the year, wearing each for a week before having it washed.

At the beginning of the performance, Hsieh was aware he could be accused of cheating. He arranged for a witness to sign each daily timecard, as well as signing and sealing the clock. Hsieh also installed a 16mm movie camera to shoot one frame each time he punched the clock. There was one more step. 'To help illustrate the time process,' he wrote, before the first punching of the clock, 'I shall begin the performance with my head shaved bald and allow my hair to grow back naturally.'

Here are the first three frames of Hsieh just as he started to punch the clock, and the last three frames taken a whole year later.

The tough, durable clothing looks the same on the first day as the last. It served its purpose: to illustrate the

relentless numbing of labour that degrades, seeing the human as just part of a machine.

The performance artist Marina Abramović once called Hsieh 'the master'. For *Rest Energy*, Abramović and her then partner Ulay dressed in office-wear. They then spent four minutes leaning back, Abramović holding a bow, Ulay holding an arrow pointed straight at her heart.

Note that Ulay's life was not in danger. Note too the language of the garments: skirt for her, trousers for him.

The normality of clothing worn in performance can be just as potent without the threat to life. From 2005 to 2009, Sharon Hayes used the street as the place of performance for her work *In the Near Future*. In various cities around the

world, she stood on a street corner for an hour holding a
sign, each slogan culled from a different historical protest.

Each time, she invited a group of people to document
the event, culminating in an overload of imagery. These she
showed all together, on thirty-five different slide projectors,
each one dedicated to a single action. Look at what Hayes
chose to wear: her zip-ups, her regular jeans.

She purposely dressed as if she were a passer-by. By doing so, she made a powerful point about the resonance of protest across time.

Activism is central to Hayes's work and life. She understands protest as a way of 'speaking with one's body'.

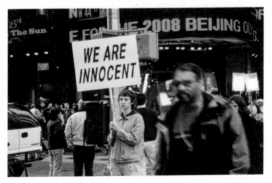

What about artists who have made their own forms of garments? The American artist Senga Nengudi began working with nylon tights in the mid-1970s. With them, she created wall sculptures that transcend their form. Nengudi activated these sculptures in performance, exploiting the inherent tension of the fabric.

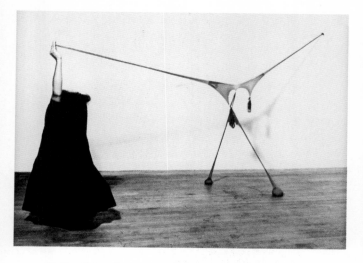

At the time, she was experimenting with garments that went far beyond recognizable clothing. In 1977, she was photographed wearing an outfit of paint-spattered brown paper, with a neckpiece of shredded paper. Her headpiece was made from tights. It's called *Study for Mesh Mirage*.

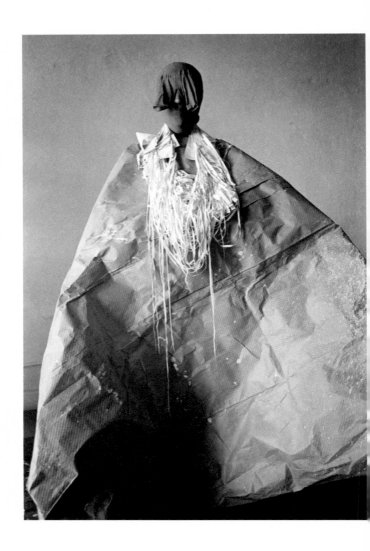

What a proud, powerful garment.

In 1978, Nengudi staged *Ceremony for Freeway Fets* under a freeway in Los Angeles. Tights were knotted and hung high from the columns. Musicians wore headpieces made by Nengudi. Her friend David Hammons performed with his own decorated staff. Nengudi appeared in a costume of yellow tarpaulin, vivacious and free against the desolation of the dirty concrete.

As with *Roberta Breitmore* by Lynn Hershman Leeson, Nengudi's *Ceremony for Freeway Fets* is an example of how performance does not need a vast audience. But then, in the 1970s, there was no major museum or institution that was giving African American artists equal access, or even any access, to an audience.

What is the effect on an artist when they make clothing as part of their work? In 1978, the American artist Richard Tuttle cut and silkscreened a pair of pants, then wore them for this photograph. Tuttle was thirty-seven at the time.

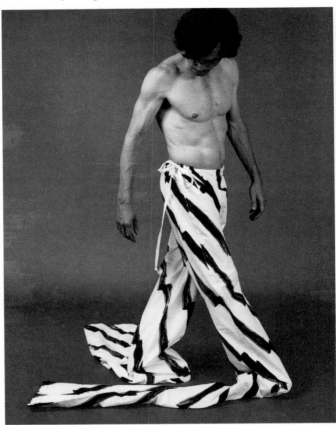

Tuttle believes in spirituality, mysticism, transcendence. He started his career in the 1960s and 70s, an era when the art industry felt it necessary to group artists in movements.

Tuttle was described by critics as a 'post-minimalist'. It means, 'we don't know how to talk about this artist'.

Before *Pants*, Tuttle was making works out of materials such as single bent stretches of wire, cut-outs of paper, a few centimetres of rope. He had already used fabric in his practice. His *Second Green Octagonal*, from 1967, is made with dyed canvas and thread.

*Pants* was created when Tuttle took part in a residency at the Fabric Workshop Museum in Philadelphia. There, he

made clothing for the first time: shirts, a jumper and a pair of pants. These pants were cut extravagantly long, with a silk screen of lightning-bolt flashes.

Here they are, not on Tuttle's body.

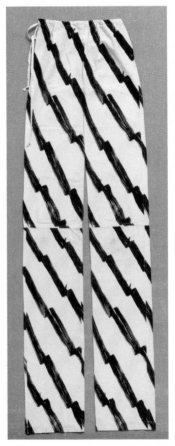

Tuttle has barely ever worn his art, before or since. His art has rarely ever taken the form of clothing. And yet this

art-garment appears as a liberating act, helping to further unlock him from an art-industry attempt to classify his work by movement or style.

We started emailing. He said that he was 'as ambiguous about dress as about everything else'. His words were indeed sometimes ambiguous and to me this is glorious.

'I never want to get so old as to not be able to fall in love with something to wear,' he wrote. 'I can remember 2, or 3, times in my life, when I felt I was well dressed. Yes it is an artist's art form. Today, with the body less important than the mind, I insist they are a seamless continuum. So it's a fight to dress, the way I see it, deadly serious, fun . . . "right" being perfect.'

Tuttle has a love of clothing, a love of materiality. 'We do not come with fur, scales, feathers,' he said. 'Clothes are these *and* what they are for us.'

He wrote about 'how' to dress himself. He said it wasn't a physical 'how', but a mental one. 'With artists, this can be creative. A friend once said, at the root of every good outfit is an idea.'

I asked him more about this 'how'.

'The how is, how am I going to clothe this body I only can have by naming. What do I have that can do the job that so obviously needs to be done, i.e. because of no feathers. Each person is answering that question. Each person must answer for themselves, isolating themselves, not only from other bodies, but the answers of others.'

Tuttle is saying something serious about how we all dress, whether we realize it or not. But he is also saying something about the nature of making art. It is in many ways an introspective act. It is not about spectacle and

entertainment, or how others view the work, although it may often appear otherwise. The profound resonance of Tuttle's work comes from this inner reckoning.

Tuttle has spoken of the importance of *Pants*, how this act of design helped him to question what is defined as art. I asked if he could say more. His answer wasn't an answer at all, and yet was much more.

'Sometimes we know something, how to do something, as if it comes from nowhere, and tells us. This telling is VERY interesting to me. It seems we need a philosophy to contribute to society, why something interesting to us may be interesting to others. Art can either lead or follow. *Pants* shows this transition. Also shows (socially) us, and in what way (artists) we do.'

Others have made the regular production of clothing central to their work. Since the 1990s, the American artist Andrea Zittel has worn a succession of hand-made uniforms. 'Much of my artwork, as well as my life, revolves around the contradictory nature of freedom,' she emailed from her compound A-Z West, just beside the Joshua Tree National Park in the Californian High Desert. Zittel has lived and worked there since 2000. Disclaimer: I am a Zittel super-fan. Her work makes my brain feel like it's suddenly secreting some strange new juice. Here's one of her *Wagon Station Encampments*, which can be slept in, located in the desert surrounding her house and studio.

'I've spent time living in the confines of prescribed spaces,' said Zittel, 'living without time for periods of time, eating and drinking only out of bowls or experimenting with things like living without running water.'

The uniforms began soon after she had graduated. 'I had just finished school,' she said, 'and was living in Brooklyn in a tiny storefront space.' It became an early work titled *Living Unit*, small at 54 square feet. There was no room for a closet, and, at the time, Zittel had a day job at a gallery, meaning she needed to look what was considered presentable.

'I started to think about social demand in our society for endless variety, and how this was in many ways so much more oppressive than uniformity.'

Zittel has often exhibited the uniforms. This display includes examples from the series *A-Z Personal Smocks* and *A-Z Single Strand Uniforms*. At the time, Zittel said, 'The *Uniform* project proposes that liberation may, in fact, also be possible through the creation of a set of personal restrictions or limitations.'

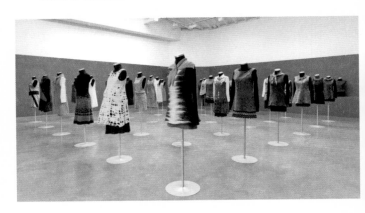

Zittel used to apply strict rules, committing to wear each particular uniform for a whole calendar season. Nowadays, she's more interested in finding an ultimate system of dressing that doesn't need to be reinvented: 'My uniform the past few years has been more constant. A long black skirt with a wool knit top for cold weather, a button-up shirt for warm weather, and a sleeveless cotton jersey top for hot weather.' Here's Zittel, photographed in cold weather, with her dog Owlette.

'I'm pretty content with this system right now and antici-
pate honing it into something that I can hopefully carry
through to the end of the decade.'

She's finding calm and creative satisfaction within these
constraints. 'These experiments question the definition
of freedom as it is framed by capitalist society,' she wrote,
'and propose that, in a world that sometimes quite literally
dictates almost every aspect of our lives, perhaps the only
way to truly be free is to make our own rules and criteria
that fit within the larger umbrella of the ones that are
already placed upon us.'

In the virtual world, it's not just clothes that are designed as
part of artworks. It's also bodies. In 2006, the Chinese artist
Cao Fei created the avatar China Tracy, who exists in the
online virtual world Second Life. At the time of writing, Fei
placed No.17 in *ArtReview*'s Power 100 list, up from 41 the

year before. There were only six artists above her, the rest being collectors, curators, gallery owners.

'Free clothing is available in the virtual world,' she emailed, her answers translated from Mandarin. 'Complex or special designs are more pricey.' She said there were many outfits in China Tracy's wardrobe: a *qipao*, Japanese schoolgirl uniforms, evening dresses, and then silver and white futuristic armour and fire-breathing flying boots, which are China Tracy's classic style.

Here's China Tracy in such futuristic armour.

But it's not just clothes. 'There are accessories, which include hair, skin, sex organs – they could be adjusted according to my own body shape. In the virtual world, I consider all things related to the body as a kind of dress code. For example, China Tracy bought some private parts. They come in a variety of colours, you can adjust the size as you wish, and it even has the ability to climax.'

It's practical. 'When you don't use it, you can store it in the inventory, then put it on when you need to,' she said. 'You have to dress for the occasion in the virtual world too. Whether you're attending a party or going to the beach, you've got various options to choose from. You might even

adjust the size of your body parts.' She explained further. 'When you wear a bikini, you can give your avatar a hip lift, or increase or decrease the size of her breasts.'

Other artists use clothing to seek parallel worlds within the physical realm. A few hours before that Tate cocktail in May, I was in the toilet queue at the Venice Biennale. The bathrooms were in an outside block, the queue long, down a side alley. This was a moment I wanted to make eye contact with nobody.

Suddenly a series of figures emerged, each in elaborate costume, with headpieces like the fin of a whale. They were led by a performer carrying a drum, squeezing past us in silent procession to get out into the fair.

There was immediate tension that set them apart, the contrast to the 'regular' clothing that I and everyone else was wearing.

It was the Canadian-Korean artist Zadie Xa, and her performers, staging the work *Grandmother Mago*.

My 'regular' clothes were suddenly put in stark relief. I visited Xa in her East London studio a few months later. 'Normal clothes are performative,' said Xa. 'I think about that all the time.'

Xa was wearing a black Nike running top, black track-pants. 'For example, if I was to wear this jacket here . . .'

She put it on over her running top and trackpants. 'This is some vintage Versace,' she said. She showed me the label: GIANNI VERSACE COUTURE – used by the fashion house until the murder of Gianni Versace in 1997. 'Now I've told you that, it makes a difference as well. If I'd greeted you this way and you noticed I was wearing this . . .'

She meant the impression her Versace would have made

'But if I came to you like this . . .' She took off the Versace and picked up another jacket. It was also zip-up, but of a cheaper, synthetic material and a baggier shape.

'This is just an H&M bomber.' She put it on over her running top and trackpants. 'It's a very different thing, yet underneath it's the exact same thing.'

In her art, Xa makes use of this messaging to create narratives. 'I use clothing as a vehicle to shapeshift, as a way to transcend present time, go into parallel time, and connect with a fictional idea of an abstract homeland.'

Xa is interested in matriarchy and Korean shamanism. She had recently been painting images of orca whales on denim in bleach, for use in her performances. 'Orcas are a matriarchal species,' she said. 'All the information they

learn about how to survive comes from their mothers and grandmothers. Orcas are one of the other animals to go through menopause. Afterwards, they become leaders.'

'A lot of the garments I'm making have to do with concealing the body,' said Xa. 'I don't imagine myself doing a performance where the clothing is sexy. It stems from this heteronormative gaze. I'm turning thirty-six. Whenever I think of bikinis or brassieres, I don't feel comfortable performing in that, being consumed in that way.'

She grew up in Vancouver, influenced by US hip hop, a culture of baggy, oversized silhouettes. 'For me, it was the idea of concealing your body all the time. I like the idea of being a shape.'

Xa and her fellow performers, backstage at the Tramway in Glasgow.

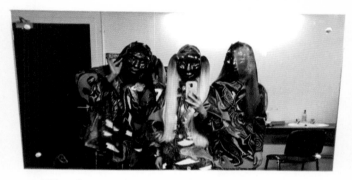

'When I put on the costume, I'm able to use it as a prism to understand the in-between spaces,' she said. 'Similarly the shaman is in between life and death, the gods and the living. That middle space in time, because I feel that's the real reality, where the boundaries that you have to fit within don't exist.

The costumes are crucial to reaching this state. 'When I put things on and I'm working with performance, that's the time I feel the door is most open to me, and all of the walls just collapse in that space and that time.'

**Martine Syms**

**Martine Syms was at the carwash.** 'I feel like I do all my calls in my car,' she said. I was in London. 'I'm like the most clichéd LA person – hey, talk to me. I'm driving.'

Syms makes videos, installations and performances that interrogate contemporary culture. She was born in 1988, part of the generation that grew up with the internet. She is an artist in the era of visual messaging – of branding, advertising and digital communication. Its language is part of her medium. Syms understands clothes: what they can do in her life, her work.

'I get a lot of joy from putting an outfit together,' she said. 'It just makes my day more exciting. Especially in Los Angeles. It's very casual here, so it's extra fun to dress up, because nobody's expecting it. I like to be, what's my look today, what's my vibe, are we going more femme or more masc, what shoe?'

I asked Syms if she could take some photos of her daily outfits but she had some already. 'You can choose. All are from the past month or so.'

Here's a few.

I was born fifteen years before Syms. My childhood was pre-internet, when clothing was the primary messenger of your taste or affiliation. Punks looked like punks. Goths looked like goths. Skate kids looked like skate kids. Hip-hop crews looked like hip-hop crews. Clothing was a crucial tool for communicating who you were, who you wanted to be.

Nowadays, communication itself has become a global youth obsession. Anyone with a phone can post about themselves to billions around the world. We can tell everyone immediately who we are, what we think, what we like, what we hate, what we stand for. Clothing has been denuded of its countercultural messaging.

A consequence: it can feel like anyone can wear anything.

'Take a *Thrasher* T-shirt,' said Syms. *Thrasher* is a skating magazine, its logo the name in graphic flames. 'When I was growing up in Southern California, it meant you skated, or you were a part of that scene. Obviously it doesn't have the same resonance any more.' *Thrasher* T-shirts have become ubiquitous. 'Someone might not even know at all what it meant, but might be wearing it because they've seen someone wearing it.'

Syms then referenced a queer classic: 'I love that book *Gay Semiotics*.' It was created by artist Hal Fischer, detailing the dress codes of gay men in late 1970s San Francisco. Here's one of the images from the book.

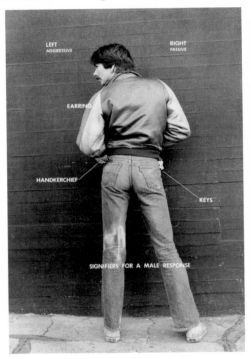

Fischer made the work eleven years before Syms was born. 'By the time I saw that book, those styles had already been adopted by many people,' she said. 'I was thinking about how you now have more private communication. You can message somebody and nobody knows who you're mes saging or what you're saying. I'm not sure what your style of dress signals any more.'

Syms is obsessed with bootlegs – clothes that appropriate images and logos, or designer fakes. She is a particular admirer and collector of Boot Boyz Biz, an anonymous label from Chicago that releases limited drops of bootlegs. Here's Syms in two Boot Boyz Biz hats. The first features the name of a 1981 track by the West German band Malaria!

The second is a cap featuring the title of a 1982 track by Laurie Anderson. It reads 'Born, Never Asked'.

Her interest in bootlegs crosses into the cultural and socio-political, the relationship between bootleg products and Asian and black communities. 'I was really obsessed with getting bootleg Balenciaga Speed trainers from China that season,' she said, talking about a sock-trainer style that had become a bestseller for the French luxury brand. 'I got the grade A replicas. There was a perverse pleasure to be like, no these are not real, they're fakes. I only paid $20 for it, and you're an idiot because you paid $600.

'Recently there's been what people call streetwear, which takes a lot from youth culture,' she said. It's true: for much of the twenty-first century, luxury fashion brands have been selling sneakers and hoodies in an attempt to stay relevant and also exploit a surge in youth spending power.

'It's often taken from youth of colour, from people who were really creative with their style of dress on limited means. It's copied and sold at ten times the price. The youth, they do have a power in terms of aesthetics, in terms of cultural capital,' she said. 'They don't have the same kind of power in terms of money. There's this obvious power imbalance.'

Many fashion designers have been called out over cultural appropriation: Gucci faced criticism for dressing a white model in a Sikh-like turban on the catwalk in 2018; Marc Jacobs apologized for putting white models in dread-locks in a 2016 fashion show. Syms believes the debate should go deeper: 'I think the conversation right now about cultural appropriation lacks nuance. It doesn't talk about military occupation, about colonialism or war, these ways that culture travels and then becomes something else.'

I've often found the word 'streetwear' to be racist. Why is it not called 'fashion'? 'What is the distinction?' said Syms. 'It's similar in films. If it's targeting a non-white audience, it's given a special designation, like "urban". Then there's always this surprise when, oh my god, people want to see this film. It just gets a little old. There are always these people of colour who are wearing things in an interesting way, and that gets adopted by a wider audience. Can we acknowledge there's a disparity in power? You can acknowledge a historical origin, and I think that's a more interesting way of talking about it. Being like, why is everyone into nail art, and why was it thought to be totally unacceptable and tasteless, and how has that changed?'

Syms uses clothing in her work, often in her installations. 'It's usually something pretty hard to replace,' she said. 'I had this piece and somebody stole the shirt.'

It was part of a work titled *SHE MAD: Laughing Gas*, first shown at the Hammer Museum in LA in 2016.

One side of the room.

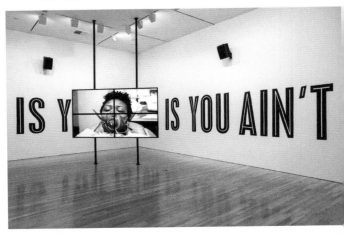

The other.

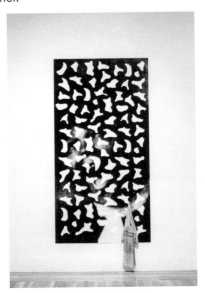

Close-up of the T-shirt.

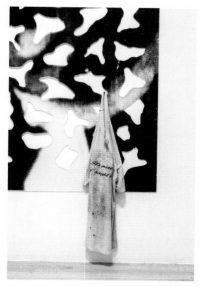

It was an extremely rare Chicago Bulls T-shirt given to her by her friend, artist Derek Chan. 'Some of those sculptures with clothes are like putting pieces of me in them,' she said. 'A little death. Sometimes it seems like that's all recorded media is really for and/or about.'

Syms embroidered the shirt. 'The embroidery says, "It's mine I bought it", which is directly about hair, but more specifically about weave memory, something my friend Steffani Jemison came up with when I first told her about prosthetic memory.'

It's gone. 'This high-school group visited and someone stole the shirt. That's the best-case scenario of it going back into the world, some rowdy teenager was like, I'm taking this.'

She also pays attention to the clothing worn by those in her films, or her avatars. 'I plan it. The clothes are so important for having the right tone. It's a personality thing. There could be a clothing item that I'll be like, that person's a total kitten heel, and you know what I mean.'

A total kitten heel: demure, but secretly racy.

It's the sort of social observation that can take place in the act of choosing what we wear. 'Getting ready, like that scene in *Hail the New Puritan*, that Charles Atlas film,' she said.

Ohmygod, it's the best film ever! It's about Michael Clark, his friends, his collaborators. One scene takes place in the East London flat of Leigh Bowery and Trojan, who are preparing for a night out with their friend Rachel Auburn. Deciding on their looks takes a glorious while.

'The getting-ready scene, it's so good,' said Syms. 'It's the best example of that pre-gaming with your friends,

like, "Should I wear this, are we feeling that?", which is an activity in itself.'

This pleasure extends to her everyday dressing. 'In the morning there's a point in which I'm like, yes, this is the outfit of today. It's like a click. Sometimes I just go to my studio and no one sees me, but I know.'

Syms has such ownership of how she dresses. She understands the layered meanings of garments, perceives clothing's context within her times, and uses this knowledge in both her work and her life.

For Syms, her choice of clothing is a conscious, creative act, of pleasure, of curiosity, of intelligence. Next, we'll consider artists who take a similarly empowering approach to fashion, and see how it can have genuine value for art, for artists, for all of us.

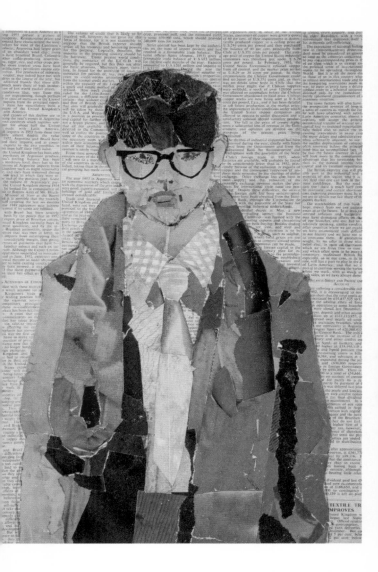

**Fashion and Art**

**Art and the work of artists exist separately** from the art industry. That should be obvious, yet the art industry makes so much noise about its openings, its sales, its art fairs, it can seem like it's the true heart of it all.

It is the same with fashion and the fashion industry. The fashion that we make in the daily act of dressing can exist without those who exploit it for commercial gain. We can talk about designers and labels if we want, but we don't need to frame the conversation about fashion around them.

Most of the time, when we talk about the relationship between fashion and art, what we're really talking about is two industries coming together in search of profit. This manifests most often in collaborations between artists and designers, hook-ups with a veil of creativity that are actually about selling product. It's fuelled by the perception that art is a commodity, a luxury good.

These collaborations can be exciting, dynamic. They can also be cynical, exploitative. Art is already seen as an elitist pursuit, especially with successive headlines about the millions paid for works at auction houses. When artists collaborate with the luxury fashion industry, they compound a view that art is for them, not for us.

Art and fashion are human experiences beyond these industries. Let's spend some time with artists for whom

dressing is a part of their creative expression, or a means of liberation, as well as those who engage in fashion design as part of their practice. Some inspire, or are inspired by, fashion, while others use it to question identity, the desire for clothes, and the way that we are seen.

At school, David Hockney was introduced to a poem by seventeenth-century poet Robert Herrick called 'Delight in Disorder'.

*A sweet disorder in the dress*
*Kindles in clothes a wantonness;*
*A lawn about the shoulders thrown*
*Into a fine distraction;*
*An erring lace, which here and there*
*Enthrals the crimson stomacher;*
*A cuff neglectful, and thereby*
*Ribands to flow confusedly;*
*A winning wave, deserving note,*
*In the tempestuous petticoat;*
*A careless shoe-string, in whose tie*
*I see a wild civility:*
*Do more bewitch me, than when art*
*Is too precise in every part.*

Hockney recognized himself in the words. He would still quote them sixty years later. Who cares about perfection? 'Sweet disorder' in clothing can lead to 'wild civility'. They encouraged him to a way of dressing that rises to a place of visual and intellectual satisfaction. Clothing could become a lifelong liberation.

Hockney was born in Bradford, West Yorkshire, into what he later described as a radical working-class family. His mother, Laura, was a vegetarian, rare in the first half of the twentieth century in England. His father, Kenneth, was a conscientious objector during the Second World War and later a member of the Campaign for Nuclear Disarmament. Kenneth was a regular sight on the streets of Bradford, dressed in a three-piece suit with a bow-tie, often decorated with paper dots to make them more lively. Of his father, Hockney said, 'He taught me not to care what the neighbours think.'

Hockney arrived in London in 1959, to study at the Royal College of Art. Homosexuality was still a criminal offence in the United Kingdom. Hockney was unashamedly out.

At that time, colour was scarce. Acrylic paint had yet to be commercially introduced in Europe, meaning swathes of vivid colour on canvas was still expensive. Hockney was friends with fellow RCA student artist Allen Jones. He remembers the reaction of a tutor, Ruskin Spear, to one of Jones's canvases: 'What's going on here? What's all this colour? This is a grey day, this is grey South Kensington, this is a grey model, she's got grey prospects, so what's all this red and green all over the place?'

Hockney's clothing grew increasingly vivid. 'One time he went shopping because he needed to buy some socks,' said his friend Mark Berger, 'and he bought a pair of socks which were in fact women's leggings and they were bright pink.'

His hair was black. In 1961, he visited New York for the first time. One evening, he saw an advert on television for

Lady Clairol hair colouring. 'Blondes have more fun. Doors open for a blonde.' Hockney became one.

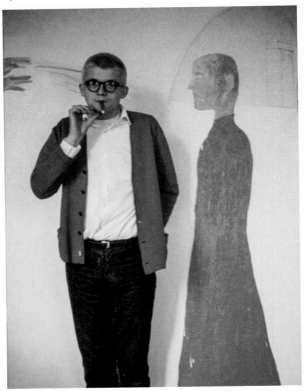

Hockney set a new template for the expression of queerness through clothing. He brought together bold blocks of colour in his outfits, exploiting what could be done by combining the separates of a newly casual wardrobe. It's a mode of dressing that has continued through his life: a green cardigan with a pale blue shirt and a red tie, say, or the bumble-bee stripes of a yellow-and-black rugby shirt

worn with wide mustard trousers. Here is Hockney, walking the streets of West London, in a gold jacket matched with a gold metallic bag.

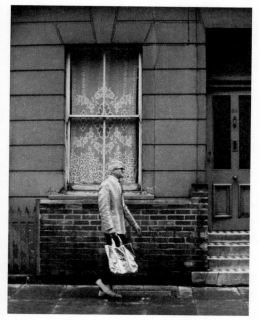

This was not about dressing for sex. Hockney found partners with ease, but was not driven by it. 'I can go a long time without sex,' he wrote in 1976. 'The trouble is, it doesn't dominate my life, sex, at all. For some people it does, but at times I'm very indifferent to it.'

It was about freedom. Hockney described himself as militant in his openness about being queer. It was a decision to live life blind to the law, as well as the homophobia of the times. His clothing was an unapologetic outward sign of his liberation.

As with Joseph Beuys, Hockney's wardrobe is repeatedly cited by menswear designers and magazines as inspiration. The result can be some nice clothes. But in co-opting Hockney's look, by connecting his style with luxury consumption, the fashion industry is masking something important. Before Hockney and his generation, the look of queer culture in Britain had been dominated by the upper and upper-middle classes. Queer male members of the aristocracy, or other privileged backgrounds, could find ways to live above society and defy the law. Working-class men were fetishized, their bodies toned by labour. Their jobs and their clothing became eroticized, fantasies that still continue today: the farm hand, the mechanic, the handyman.

In the first half of the twentieth century, the suave and elegant look of queer men was set by an international network of privileged friends: men such as Christopher Isherwood, Charles James, Cecil Beaton.

Hockney cut through class to peg out fresh territory. He was a young working-class man who was quick and clever, empowered and unafraid. He wore clothing with his own spin, with no deference to social class. It was a liberation soon embraced by many.

In 1957, the Japanese artist Yayoi Kusama arrived in the US. She was twenty-eight at the time, and soon found herself living in New York in abject poverty. She painted obsessively and in 1959 showed her polka-dot nets at her first solo show. It was met with a positive critical reaction. Through the early 1960s, Kusama became widely known in the city for her canvases, sculptural forms and installations.

Kusama has always been open about the reality of her

mental health. 'I fight pain, anxiety and fear every day, and the only method I have found that relieves my illness is to keep creating art,' she wrote in her autobiography. 'If I had not found that path, I am sure I would have committed suicide early on, unable to bear the situation in which I found myself.'

Her 'Psychosomatic Art', she said, was a means of 'creating a new self, overcoming the things I hate or find repulsive or fear by making them over and over and over again'.

Garments began to appear in her work. This suit is from 1962, the year she first started working in what became known as soft sculpture.

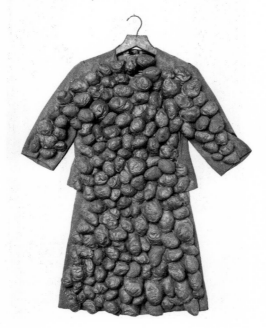

White male artists – Claes Oldenburg, Andy Warhol – appropriated aspects of Kusama's work, such as her soft sculptures and her repeated use of image. They were signed up to galleries. Kusama was not welcomed into the system. Her practice expanded beyond the confines of gallery walls. She began to stage happenings.

Her actions, often in public places, made a stand for gender equality and sexual freedom, against capitalism and war. She was soon making clothes to be worn at these happenings, using fashion as a way to find liberation. Here is Kusama in her boutique, in 1969.

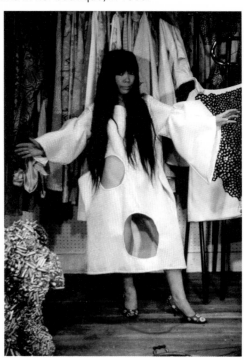

These garments were designed for orgies, playing on most people's fascination with, and fear of, exposure.

Kusama was traumatized by sex. 'I hated the shape of the male sexual organ, and I was repulsed by the female organ as well,' she wrote. Kusama was observer, not participant, wanting to overcome what repelled her.

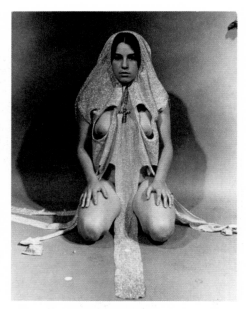

That garment is known as the *Silver Squid Dress*. This is Kusama's preparatory sketch.

A Kusama Fashion Show, on a New York rooftop, in 1968.

In 1969, Kusama went into production. She founded her own label. 'Walking the streets, I noticed many people who wore clothes which were very similar to my designs,' said Kusama, in an interview in 2000 with the Japanese poet and critic Akira Tatehata. 'After some investigation, I identified a company called Marcstrate Fashions Inc., which manufactured them.'

Kusama met with the president of the company, and they agreed to form a label together. 'He was Vice-President and I was President.'

The brand was called Yayoi Kusama Fashion Company. 'We did fashion shows and had a Kusama corner at department stores,' said Kusama. One such department store was Bloomingdales.

The collection included pieces made using Japanese tie-dye. In a press release, Kusama described it as abstract expressionist, or an existential approach, 'in which the action comes first and the solution to the design problem second, as one works'.

Kusama said that, as with most fashion labels, the stores only wanted to stock the most conservative pieces. 'The radical vanguard items that I poured my energy into sold little in the end.'

What happened to Kusama Fashion Company? The label was short-lived. Kusama moved back to Japan in 1973, because of her poor physical condition. Today, New Yorkers queue around the block whenever galleries exhibit one of her *Infinity Mirror Rooms*, placing the viewer in a seemingly endless realm of light and possibility.

Kusama now dresses in clothing resplendent with dots. She once used fashion to question, provoke and push boundaries within her work. Today, it has become a way of unifying her world.

For many, fashion is a creative act on its own terms. Here's the New York artist Tabboo!, in the stairwell of the East Village apartment block where he's lived for forty years. Tabboo!'s place is five storeys up, no elevator. His louche

tailoring – double-breasted, wide lapel, flared, verdant green velvet – connects with 1970s counterculture, when the artist was a teenager.

Throughout Tabboo!'s life, he has used clothing to push at gender identity. We can see this in the flair and vivacity of his suit, but it has also been part of his practice, through his earlier drag performance. Here is Tabboo! on stage at Wigstock in 1991, in front of a backdrop he'd painted.

Tabboo! grew up lower-middle to working class, with new garments only for school and Easter. 'For the most part, my parents picked out the clothes,' he said, on the phone from his apartment. 'When it was time for *me* to pick out the clothes, this was the mid-sixties, we're talking

psychedelia, little paisley shirts, striped pants, velour, I was like, *girl*, I was living for that shit.'

From a young age, Tabboo! recognized dressing could be part of culture. 'It was music, art and wild clothing. Always a combination with me. They always went together.'

Note that Tabboo! says clothing and not fashion. When he moved to New York, he had no money, and no awareness of designers or brands. 'I was dead broke,' he said. 'We would go to thrift shops and get the wackiest, most colourful things possible.' This cuts down the assumption that everybody in drag communities spends their life pouring over the pages of *Vogue*.

In the 1980s, Tabboo! performed drag at the Pyramid Club in New York, for which he also drew its psychedelic flyers. His art went international when he created trippy, acid-colour graphics for the first album by Deee-Lite, who grew out of the same East Village community. Their track 'Groove is in the Heart' became a global hit. I was sixteen at the time. Because of his graphics, I painted spirals over all my school folders.

Tabboo!'s work started to influence fashion, to which he was, then, still oblivious. 'Ingrid Sischy brought Gianni Versace over to my apartment.' Sischy was the editor of *Interview*. 'I had no idea who the fuck Gianni Versace was.'

He came to your apartment?

'In the middle of summer. He climbed five flights of stairs, to an un-air-conditioned apartment, with seven henchmen who were all dressed head to toe in black wool coats and bright gold buttons. At the time my whole apartment was dayglo lime green, my paintings were all that colour,

everything. And he comes over and buys half of it, and his next collection is all bright dayglo lime green.'

And yet, Tabboo! remained broke for a couple of decades. Now, his paintings are selling. 'Suddenly I had some money to buy real things,' he said. 'I could go to Gucci and say, ohmygod, look at this, can you believe they even make things like this, ohmygod. And they'll say, that'll be $2,600, and I'll be like, bag it up!'

Tabboo! has bought from Gucci, Comme des Garçons Homme Deux, Dries Van Noten, but he is not enslaved to brands. 'I buy it because I like it. I'm not into a particular label. I don't care. I've bought a vast array of gorgeous, colourful, glittery, well-made clothes. I love being older and sophisticated.'

I took this photo of Tabboo! in an Alpana Bawa suit at his 2019 exhibition opening at Herald St gallery in London.

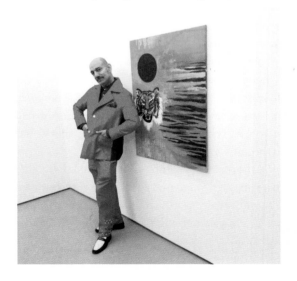

Wait! We want a detail shot.

His eye is drawn to pieces that can't be found anywhere else. 'People notice it. They're like, wow, what is that, that is gorgeous. Not only am I getting a thrill out of it, I light up the world with my outfits.'

Tabboo! has found a manifesto for life in dressing. 'Most part everybody now wears grey clothing or sweatshirts or gymwear, even to fancy events,' he said. 'I'm the one dressed to the nines. To the twelves! The fifteens! The number of times I walk out the door and they say, what are you all dressed up for? My answer is, today. This could be the last day of my life and this is how I'm living.'

He paints constantly, linking what he wears with what he paints, and then back to what he next buys. 'The clothes inspire the art that inspires the clothes. One seeds the next. To me clothing is a spiritual thing. I love the people that are

most spiritual. Even the Pope, *she's* got an outfit. Or you see Tibetan monks with their orange robes. Gorgeous!'

Such declarative dressing can be an act of defiance. Louise Nevelson was born in what's now the Ukraine, emigrating with her family to the United States in the early twentieth century. Her parents suffered from depression, her mother dressing extravagantly to retain a link to their homeland. Her influence on Nevelson's own dress is clear.

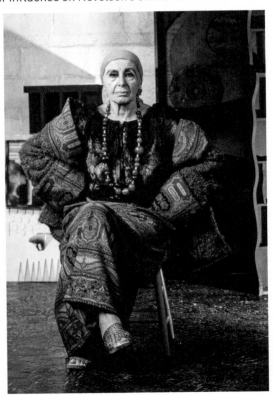

Nevelson was a single mother in New York with no secure income into her midlife. She made sculpture from wood she found on the street. The value of her work was only recognized when she was in her sixties. Throughout, Nevelson was engaged in elevated acts of dressing.

'I always had a flair for clothes and liked them because I have a whole feeling about appearance,' she said in 1972, 'and consequently in youth I had this kind of flamboyance and wore good clothes and wore attractive things.'

She recognized this meant some may question her seriousness. 'I think that because of their, not mine, their preconceived ideas that an artist had to look – that the older and the uglier they looked, the more they were convinced that there was a dedication. That's what I've been trying to break down all my life. And I still am.'

Benevolent connections between fashion and art often involve friendships between designers and artists, as we saw between Louise Bourgeois and Helmut Lang, supporting each other in their work rather than jockeying them for it.

The American artist Rachel Feinstein mostly makes sculptures and installations, creating romantic, gothic forms. She is ingrained in New York social life and is a lover of fashion: she cites Gucci, Tom Ford, Proenza Schouler and her good friend Marc Jacobs.

A few years ago, Feinstein hit a creative block. 'I was stuck in a rut.' She was talking on the phone from her summer cabin in Maine. In 2012, Jacobs asked if he could use one of her sculptures as the set for his next catwalk show. 'I said, that sounds cool, but I'd love to

make something for you instead of using an older piece. He said, OK, the show's in two weeks.'

Feinstein set to work, creating a sculptural backdrop of beguiling, dilapidated buildings.

'I had never worked on that scale before, in that short amount of time,' she said. 'I learned so much. It was incredible.'

The finished set during the show.

Feinstein's set had flourish and fantasy, with its looming follies, tumbledown steps and a tipsy fountain. It was an atmosphere of adult glee that was reflected in the mood of the collection. This was particularly so for the accessories: huge floppy hats created for Jacobs by the British milliner Stephen Jones; exaggerated-heel clompy shoes finished with a bedazzled take on the pilgrim buckle.

A couple of months later, Feinstein accompanied Jacobs to the Met Gala. She wore a hat and dress from the collection. Jacobs was wearing the shoes.

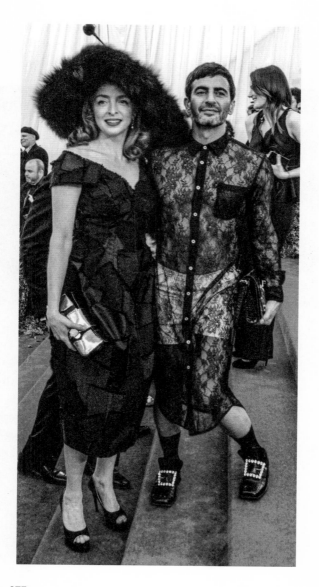

Collaborating with her friend got her out of that rut, pushing her towards larger forms, like a series of outdoor sculptures commissioned for Madison Square Park.

'I wouldn't have been able to do it if it hadn't been for that experience,' she said. Fashion unlocked her.

It was more than just the build. She was also struck by fashion's inherent disdain for permanence. 'I hate the hoighty-toighty shit that happens sometimes with the art world,' she said. 'There's this idea that because it's in a white-walled gallery, it's untouchable and it's very, very serious.' Fashion is different. 'You do it, it's done, it's over and you're on to the next thing.'

For Feinstein the experience was transformative. 'That was every day, every hour of my life for two weeks. I never found out how much the whole thing cost, and it was chainsawed up into pieces within thirty minutes. It was all gone. People ask me, don't you feel terrible, and I'm like, no, it was so liberating. I loved it.'

It led to Feinstein thinking deeply about her practice in general. 'I love the idea of chucking everything in the fire and saying none of this fucking matters, we're all going to be dust, don't leave a trace.' She questioned the assumption of permanence, and the implications for future generations of artists. 'Let all the other people coming have the room and the space. Why are you trying to put a monolith up? There's this huge part of me that thinks that's so phallic and aggressive and weird and I don't want to do that.' Through fashion, she found another way of being.

In 2007, the Scottish artist Lucy McKenzie was asked to model for her friend Beca Lipscombe's label. 'The moment that blew my mind was when I asked her one time, "Where do you get these made?" She said, "Oh, I make them myself in Scotland." It made me realize I had no idea how clothes ended up on my back.'

The two began to work together, forming the fashion label Atelier E.B. The initials stand for the cities they call home: Edinburgh for Lipscombe, Brussels for McKenzie.

An Atelier E.B tracksuit, from 2015.

Atelier E.B exists outside the fashion world. 'Artists are so seduced by the fashion industry and all the catwalk performance,' said McKenzie, 'but that never really appealed to us.' Instead, the pair focus on local production, working with Scottish and Belgian textile manufacturers.

Atelier E.B have no regular seasonal collections, no runway shows. No stores stock their garments. You can buy their clothes on their website, when they have them available. And yet they have staged exhibitions.

A storefront constructed inside their show at the Serpentine Gallery in London.

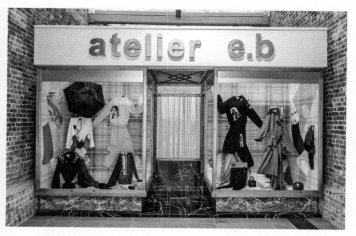

These are artists' fashion garments made to be worn. 'It's not just an idea. It's real clothes that people wear, and they really like them.' They also have no interest in acting like a regular fashion label. 'There are no rules, we don't have any employees,' said McKenzie. 'We can only do things exactly the way we want to do them.'

The British artist Anthea Hamilton was recalling a recent conversation she'd had with a friend about fashion. 'I said I didn't find a lot of art as urgent to look at,' she told me. We were sat in her studio in south London. 'We did both agree that we liked looking at fashion more.'

Remember that Venice cocktail party at the beginning of the book? Hamilton was one of those not following the dress code. She was nominated for the Turner Prize in 2016 for a show that included a giant sculpture of a golden

backside, the cheeks being pulled apart. In 2018, Hamilton created *The Squash*, a five-month performance installation at Tate Britain. Because it lasted so long, it was impossible for anyone to say they'd seen all of it.

Hamilton wore the same paisley dress for pretty much all of its installation.

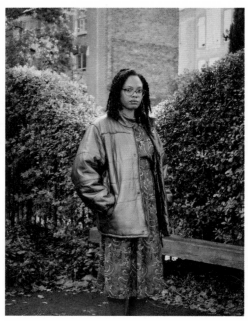

Hamilton said she wore it so much that the curator she worked with banned it for the opening party. After we'd talked, I kept thinking about the paisley dress. Why did she wear it so often?

She said the dress was really old, bought from what she considered Streatham's best charity shop about ten years ago. She said she had a limited wardrobe, that there were

only a few things she had that fitted, that weren't falling apart.

'There's a pressure for artists to have the right look,' she emailed, 'which is tied to all types of status, cool, youth and definitely wealth. I'm looking for things that get around those (what I view as) constrictions.'

Why *that* dress? 'I like this paisley dress because that pattern ties to another economy of wealth and class, so even though I do feel smart in it, there's a tinge of irony there. It's happily not sexy at all, kind of Christmassy, and it fits with my mum's regulations of what's decent. (She's a whole other bag . . .)' She now has a second red paisley dress. 'It's better than this one. TMI?'

Hamilton has long worked with fashion imagery. In 2012, she made *Karl Lagerfeld Bean Counter*.

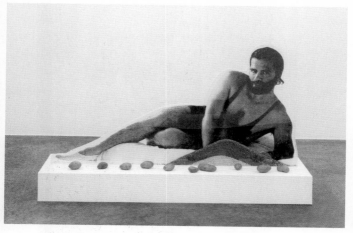

It's now in the Tate's permanent collection. For the work, Hamilton appropriated a photograph of the designer Karl Lagerfeld in his younger days, the look in his eyes one of

seduction and/or emptiness. A bean counter is slang for a tight-fisted bureaucrat. Hamilton's purpose: to question fashion's allure. Is this really the guy who had such control of perceived beauty and desire for so long?

Hamilton has continued to use fashion in her work, particularly with *The Squash*. She converted the grand central Duveen Galleries at Tate Britain into the white-tiled home of a character called The Squash, played on rotation by fourteen performers.

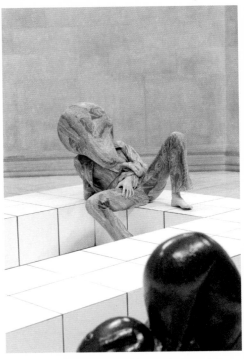

Each day, The Squash would prowl around the space, sometimes sitting, sometimes making movements. Other

times it would disappear. Gallery visitors walked freely in the same space. Throughout, The Squash wore costumes and squash-shaped helmets custom-made in collaboration with the luxury fashion house Loewe. It was like fashion from another world. One had a bodysuit based on lichen, with a bolero like a pumpkin.

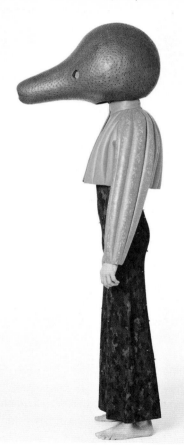

Another had a cod-piece inspired by ikebana woven baskets.

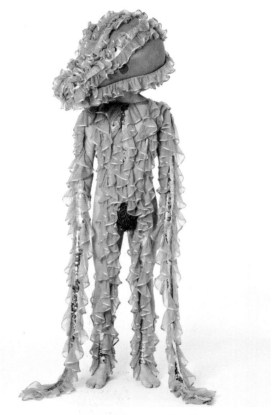

The helmets completely masked the face, elongating out like a butternut squash.

'The performers were subject to being stared at in maybe not very empathetic ways,' she said. 'I just wanted them to look really good, to just do my best for them.'

Much of the work was about who had the power. Hamilton said she had tiled the floor to wipe out the questionable pre-existing power of the Tate, founded by sugar tycoon Henry Tate. 'I wanted for the performers to be mostly non-white, because they would have a different sense of what it is to be looked at.' She said that the costumes acted to prevent an audience finding a narrative. 'The body refusing to offer up more detail, in a way.'

What did she mean? 'From my own experience, people aren't really listening properly anyway. They come to their own conclusions. Those conclusions might be right or wrong.'

She pointed to the example of the work she showed at the Venice Biennale in 2019. It included black mannequins wearing chef's clothes in a plaid wallpapered space.

'Because the mannequins are black, I've been asked if they are black men. I was like, you tell me. Why would you assume one way or the other? Why would you need that to be qualified? What's your reading of the whole situation, of an exhibition and an artist?'

She connected her thinking back to the Tate commission. 'With *The Squash*, people kept asking, how did you design the costumes? That's not the point. The point was, why did we need to design those costumes?'

Hamilton was in the gallery on the second-to-last day of its run. It was raining, so the space was busy with people seeking shelter. She watched *The Squash*. 'That day's performer, he was a ballet dancer. He was very handsome and used to being looked at. He was mixed race but with quite light skin, so when he put the kit on, I didn't know what people would see.'

As often happened on busy days, the performer was swarmed. 'People were really taking pictures on top of him,' she said, 'and I think he was like, "Oh no, sorry, we're done with that now. It's time to put an end to you thinking you can consume me." So he just climbed up to the point where he was taller than everyone else, and he just sat there for ages, and then he took his helmet off.'

It was a powerful moment. 'He stared everybody down. When they could see that they had been really staring at a person of colour, then they realized they really didn't know how to look at them. He wasn't smiling. He had this particular look on his face like, I saw you were looking at me, and now I'm looking back. After five minutes, the crowd had nearly all disappeared.'

Artists reveal how fashion is both intimate and political, blurring the boundaries between public and private. The British artist Prem Sahib uses clothing in sculpture and installations that look at queer spaces, and how they are inhabited. Sahib's work, exhibited at institutions such as the ICA and now part of the Tate collection, has helped me navigate those same spaces in London – clubs, bars, bathhouses.

Sahib usually dresses all in black. We met for coffee: he was in a black hoodie. Fashion garments, the kind you wear on a night out, have appeared in his work, such as the pressed-together padded jackets of *Rumble*.

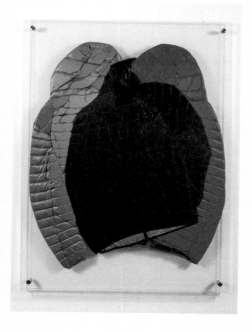

The jackets are warm yet light, cheap and dispensable, s
it doesn't matter if you throw them up a corner of a club. To
me, they stand for the freedom found in the intense connec
tion of sudden anonymous sex. 'It's funny that you're talkin
about liberation because I always think of them as being
really ambiguous,' he said, 'and also a type of restriction
to do with the forms we inhabit as bodies within capitalist
societies.'

Sahib grew up in Southall, West London, an area with a
majority South Asian population. As a teenager, he was a
cyberpunk. 'I think it was a way to deflect from having to
confront my sexual identity.' Sahib had a Saturday job at
the Kensington Market stall Children of Vision. He started
going out. 'My dad used to weld me outfits. I didn't tell him
I was going to Torture Garden.' It's a fetish night that was
then based in South London. 'When I was sixteen, I'd carry
metalwork with huge nails welded to the shoulders to
Brixton station, then get changed.'

Sahib soon came out and began going to mainstream
gay bars in Soho. 'I wanted to be really slick. I used to wear
a hell of a lot of make-up, to the extent that my friends
said to me, we literally can't see your eyebrows.' He was
wearing a particular style of fitted white shirt. 'This really
tightly tapered shirt called Basic Man by Zara. On one of
those nights I put on a little too much MAC Studio Fix,
and happened to meet someone in the bathroom. He was
wearing the same shirt as me and I delivered my first
body print.'

Sahib has memorialized the moment in the work *Basic Man*.

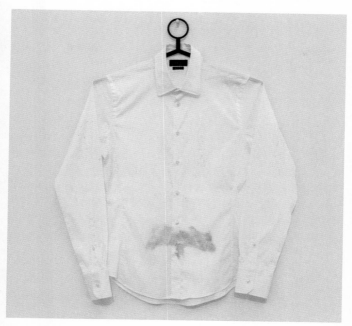

Sahib's work often tracks these spaces and the experiences within them. We'd sometimes go with friends to the gay men's bathhouse Chariots Roman Spa in Shoreditch and sit and chat in the jacuzzi. Chariots closed in 2016, the site bought by hotel developers. Before it was demolished, Sahib gained access, had the remains photographed, and

got hold of thirty of the lockers. He used them in the work *Do you care? We do.*

My clothes have likely been in one of those lockers at some point. Sahib's too. Sahib used to see this undressing a liberation. 'I've always thought about the idea of being naked as being democratic. In the past I'd thought that shedding clothes might make you shed societal constraints

Nakedness has been there throughout art history: just look at the bodies on show in ancient Greek sculpture. In the twentieth century, the body in art took on new significance, tracking the fashion of desire.

Finnish artist Touko Valio Laaksonen was better known by the name Tom of Finland. His drawings helped to define the fashion of gay men in the second half of the twentieth century, first appearing in the magazine *Physique Pictorial*

in 1957. Laaksonen dressed in the same butch leather jackets and tight-fitting pants that he drew. Here's Tom of Finland at the Eagle in San Francisco, in 1985, alongside one of his works.

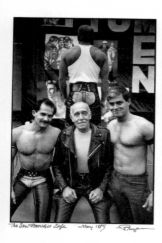

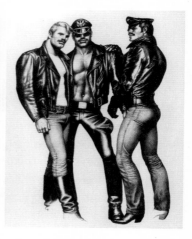

Tom of Finland became wildly popular, defining an ideal of the gay male body, clothed and unclothed. Over in New York, the artist Alvin Baltrop worked with stealth, documenting Manhattan's queer communities, particularly the cruising scene at the Piers during the 1970s and 80s.

While Tom of Finland's drawings are very much about proud display, whether of fetishized garments or naked flesh, Baltrop captured what was worn, or not worn, in hidden queer playgrounds.

Barely any images exist of Baltrop himself. Here is a self-portrait, at a dressing table.

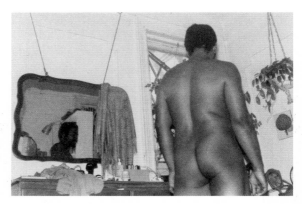

Baltrop's work shows us the style of the community that cruised for sex on the Piers, a look that saw nakedness as a way of dressing. The man facing us could step into the street and blend in. The figure walking away is following the codes of this queer microcosm, where all you needed was a leather vest and boots.

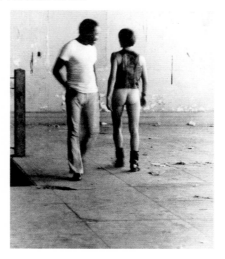

It seemed like a utopian idea of freedom. Is this idea still a utopia today?

Back to Sahib. He was now questioning the politics of nakedness in queer spaces. 'I've spoken to friends whose identity is expressed through their clothing,' he said. 'I realized how when they are taken away, you can feel vulnerable.'

Structural oppression exists in many gay male spaces. 'There is underlying misogyny and racism,' Sahib said. He has experienced such racism. 'These spaces are private. By making it public, we can talk about these things more openly.'

Here, the role of fashion, of clothing worn and removed, is to be part of a conversation about our understanding of ourselves.

'I'm fascinated by how material culture is used to express ideas of the immaterial,' he said. 'I've been reading how, in some religions, the material world is said to represent what is apparent, but not real. What is real is said to lie beyond the materiality of the world itself. But in order to express this, we use the material world. Clothing speaks of everything beyond it.'

Charlotte Prodger

**Charlotte Prodger messaged** from the Scottish island of Eigg, population: 86. 'I'm on a writing retreat with no internet. Borrowed a friend's now for 5 mins. Getting lots done! Very very stormy here.'

Prodger often seeks escape in her work, her life, yet she is utterly connected to the materials of today. She uses these materials to explore links between what is ancient and modern. She won the Turner Prize with her film *BRIDGIT*, named after a Neolithic deity, which was shot entirely on an iPhone.

Prodger wears casual clothing, and it often features in her work. In 2012, she made a film using ripped YouTube footage from the anonymous NikeClassics, who adored and destroyed his sneakers.

This is the opening shot of *BRIDGIT*. It is of Prodger lying on her sofa, filming on an iPhone that's resting on her chest. The camera moves with her breathing. She's listening to a pirate radio station. The view is of her sneakers.

Later in the film, there's a long shot of some birds at the seashore. The waves are calm. Another voice reads excerpt from Prodger's diary:

*November 14th. Bought two T-shirts, a pair of jogging pants and some socks at JD Sports. The checkout girl asked if it's my son I'm buying for. I said no it's me. She didn't say much after that.*

The film *Passing as a Great Grey Owl* has scenes of Prodger on hikes pissing in nature. The camera sees heathe some snow, Adidas trackpants, Prodger's hands, her piss. 'I feel very queer when I'm on my own in the middle of land-scape,' she told me once. 'Historically, the context of most

queer narratives has been urban. What does it mean when you're away from all those signifiers to be a queer body?'

Prodger says that, after years of making films, all she wants to do now is write. She offered to write a piece for this book. It's titled *Modern Studies*, connecting clothes, memory, emotion, identity, the presence of the past and a desire for something more. Casual clothes become like characters in themselves.

## Modern Studies
## by Charlotte Prodger

**1987**

*Erotic charge, electric jolt of looking down and seeing an upright Tampax, index of her, analogue of wanting, vertical in the inside pocket of her blue 501 denim jacket, hanging on the back of her black plastic chair, negative shape, index of outside her, in class. Modern Studies. On the outside pocket of her jacket, a red hammer and sickle badge. On mine, a gold baby Lenin.*

**1991**

*I'm standing behind the counter in Mace watching a boy across the road. He's standing outside Spar in a navy blue sweatshirt. Two figures of indeterminable gender sit in symmetry, back to back. Sitting on invisible ground. KAPPA, the sweatshirt says. Now the boy turns to go inside. The jeans say Pepe.*

*Our gayness was unspoken between us, me and K, as we pushed and pulled at either end of the tea trolley. We were care assistants at Inchmarlo House Nursing Home. He had ginger hair like me but slightly darker, and the same pale lashes. Our sky blue polyester uniforms hung stiffly on our bodies. Mine buttoned all the way up the middle. His, being the male uniform, buttoned at the side. The torso fastening doubled back on itself.*

**1993**

*These middle partings were exact. The line of the comb, splitting into two sections based on a grid like techno. Like the intensively farmed fields where I grew up. Crop rotations,*

divisions. Straight lines, precision. Austere like the minimalist techno. Except the techno had soul. The Presbyterians did not. Thank god for Detroit.

## 2010

I had a bit of a cataclysmic break-up. I had really fucked up and was caught between two things. I didn't know where to go, so I withdrew and rented this friend's static caravan near Balfron for a month, pretty much on my own, travelling on the bus into the city reluctantly only for my DJ shifts at night, then returning next morning to hide again. Splitting wood, watching The Wire, walking up and down the muddy track.

The caravan stood on the bank of a burn. It came with the name Nebraska. To get there you started down a sloping field that gradually narrowed like a funnel strung with pylons, then upstream the river on your right, then across one of four fields, depending on the bull. There was a 'school for naughty boys' nearby. Nothing much else around except for a thousand year old yew tree that's recorded in the Domesday Book. I never saw the boys from the school, but I know that some would escape from time to time because very occasionally two adults would come past the window asking had I seen any boys down here.

I got those A.P.C. jeans second hand somewhere. Or a friend gave them to me, I forget. They were faded, loose, a not very fashionable level of fade I guess, not like that heavy selvedge denim you get. I remember although it was a decade ago the hang of them on me, how they felt, getting looser on the waist while I was there. And the smell of me in them then, a break-up smell, a slight animal smell of adrenaline and uncertainty and abstract lust. Sometimes not wearing underwear because

maybe I didn't have enough with me, and it was that strange point of turning autumn where it feels like a tap running hot and cold at once and not fully mixing. I remember the feeling of my hand down that waistband in the forest, and of someone else's hand there in the city. I remember that in sharp focus.

One of the mornings, I washed my clothes and hung them on a line suspended between silver birches. A couple of days later I couldn't find the jeans, not anywhere. I asked the older dyke couple that lived in a caravan nearby, but I knew they didn't have them. I still wonder where they went because I would like to have them now. I think those boys took them.

### 2013

C lives in a flat with two friends on Woodlands Drive, back when people could afford to live west. She works in a coffee shop three streets away and comes home every evening smelling of milk, an invisible film of it. We're kissing inside her bed. It's winter, wet tenement windows. Dark a few hours and near dinner time. Tall windows and dark in the room too. By coincidence we're both wearing grey marl, also known as heather grey. Me a hoodie, both of us sweatpants. Hers Slazenger. A line of light is coming under the door from the hallway. And we're kissing with all this grey marl bunched up around us. Hands down each other's pants like boys.

Sound of a key in the door and the line of light bursts wide. G calls out THREE LIVE CRABS and C comes right on those words. Her coming is drowned out by the wet bustle in the hallway receding into the kitchen, where later we all congregate to peer at them. G was working a temp job, receptionist at the

*Chamber of Commerce. They help businesses fill in licensing forms. There was a new seafood place opening. The man had come in a lot, nervous and confused about the paperwork. After the job was finished he came in with a box of twenty live crabs as a gift. G was tasked with getting rid of them.*

## 2015

*Clothes are analogues of bodies. Not only because they are cut in the shape of a body but because they are next to it. Next to it for a day, for five years, a decade. The smell from this person's body, the person whose caravan it was, a person no longer in the world, stays on a grey wool herringbone scarf sealed inside a Ziploc bag for a few months, maybe a year. A recording of this person's voice, sound of spit and of breath (the engine of her) gets transferred from one format to another for preservation across decades, obsolescence snapping at its heels, while the smell on the scarf dissipates. And it came to me with moths. I took it to the alterations place on Victoria Road, said can you darn the hole. The woman looked at me, said have you gotten rid of them, because I don't want moths in my shop. I said yes. That turned out not to be true.*

Casual

**There are layers of meaning** to casualness, a mode of dress which has become predominant in society. 'Casual' refers to clothes that are designed for activity: sneakers, sweatshirts, tracksuits. Their comfortableness allows them to be worn with slouch. They are garments that cut across all social strata: for the extremely wealthy, the ability to lounge is a symbol of their luxurious life.

Then there is 'casual', which is seen in opposition to tailoring. It is a genre of clothing used as an embodiment of class, famously encapsulated in a 2006 speech by future prime minister David Cameron, in which he cited the hoodie as 'a vivid symbol of what has gone wrong with young people in Britain today'.

This kind of casual is the clothing that artists can weaponize, to infiltrate and subvert oppressive structures. This kind of casual is the uniform of unease, which is to say it is the clothing of our times.

Casual clothing has been around for at least a century: Adidas, for instance, debuted their sports shoes in 1924. These are clothes with heritage, though in archival imagery they can appear out of time.

One of the first artists I researched for this book was Duncan Grant. He was queer, British, a member of the

Bloomsbury Group in the early twentieth century. Grant had a child with the artist Vanessa Bell, and they lived together as non-sexual companions for over forty years. Their home, Charleston, in East Sussex, is now preserved and open to the public.

I had expected to find photographs of Grant dressed as you'd imagine for this bohemian collective: tailored, fey, foppy. There are many photographs of him like that.

Then I was sent this.

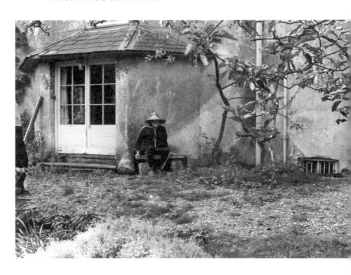

It's of Grant, sat outside Charleston, in a tracksuit. The photograph came to me via the son of Paul Roche, with whom he had a thirty-year relationship.

Here is another. Grant is holding a copy of Roche's poetry book *Enigma Variations And*. He had designed the cover. Th

book was published in 1974, four years before Grant died, aged ninety-three.

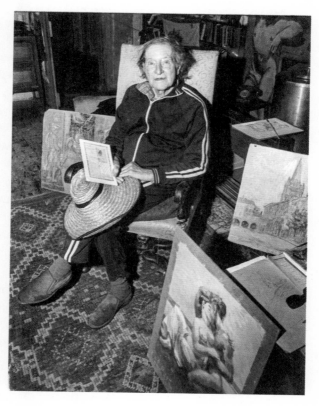

The images are startling. Then, casualwear was for young people, for the working class. When you were educated at private schools, you were meant to conform, to dress 'properly'. Grant went against the grain.

Attitudes to casual clothing cross-pollinated in the 1980s, fuelled by hip hop, rave culture and British football terraces. Since then, many who grew up wearing casual clothing have continued to wear casual clothing. It can now be a wardrobe of everyday midlife.

Much of this change is down to technology. It's the way working lives have been freed from offices due to laptops and Wi-Fi. It's the example set by tech CEOs who make billions dressed in a T-shirt and jeans.

It's also the way casualwear has become luxury fashion: on Gucci's website right now, there's a matching tracksuit jacket and pants for a total cost of £3,350. As Martine Syms showed us, these luxury casual garments plunder much of their inspiration from working-class people of colour, those whose options were and are financially limited. It's within this complex space that contemporary artists are wearing casual clothes, as well as featuring them in their work.

'I'm a fat person,' said the American artist Sondra Perry. We were talking on Skype: Perry was at home in Newark, New Jersey, wearing a T-shirt of the band Korn. 'Growing up, I was poor slash working class. Expressing myself through clothing was non-existent.'

Perry makes films, installations, digital renderings that address questions of race, exploitation, the body. This is a close likeness of Perry, in her 2016 work *Graft and Ash for a Three Monitor Workstation.* It's not an exact likeness because, as the avatar says in the film, 'We were rendered

to Sondra's fullest ability, but she could not replicate her fatness in the software that was used to make us.' Perry found that her body image was as ignored in tech as it was by fashion. The film was first shown on a monitor attached to an exercise station.

In 2018, Perry won the prestigious Nam Jun Paik Award for electronic and digital art, aged thirty-two.

When she was young, she said, there were two archetypes of garments available to her. 'It was auntie church lady clothing, or just non-descript anything.' Perry went for the latter, which is to say, casual.

'The hockey team here is the New Jersey Devils,' she said. Their stadium is just across the street from her apartment. 'I had a sweater that was a little too snug around my breasts, so all you could see was DEVIL.' Perry graduated from Columbia University in 2015, and soon gained

attention. She was asked to take part in talks, and this casual piece became her go-to.

At the time, Perry was making work inspired by the composer, poet and philosopher Sun Ra. Perry had been listening to a lecture he gave at UC Berkeley in 1971. 'Someone asked him, "How do black people stay righteous in this turbulent time?" He said, "We don't. That's not possible. I'll use anything I need to liberate black people, including evil." He was really flipping these ideas around respectability politics, around what is necessary for liberation to happen. At the end he was like, "Well, I'm an evil person, that's what white people call me, and they're evil too, so now we have something in common."'

Perry saw a connection to her New Jersey Devils sweatshirt. 'I thought, for me right now, this is it. The devil. I am the devil. I am here to disrupt.'

In 2017, Perry made a film, *It's in the Game*, about the

relentless exploitation of people of colour. Her twin brother, Sandy, had played basketball in college. Unbeknownst to him, the games developer and publisher EA Sports had acquired his physical likeness and statistics to use in a video game. Who owns our bodies? Alongside footage from the game, Perry filmed her twin at the Metropolitan Museum in New York among the institution's exhibits. She also filmed herself on a solo trip to the British Museum in London. Perry and her brother were both wearing casual clothing.

'The casualness of it is huge,' said Perry. They wore casual clothing for comfort and for concept. 'It's not a unique experience. Having a trip to New York, trying to get to this location, having on your comfy shoes, then you go into that space and then having a realization: how did these objects get here? It's the completely mundane and the almost sublime, intense understanding of what imperialism and colonialism is.'

Sandy in front of the Temple of Dendur, built c. 15 BC in Egypt, now in the Sackler Wing of the Met.

...just tore this shit down brick by brick,

'In your daily being, you're in your sweatpants, being comfortable because we're going to be out all day, you go to these places and then you realize the weight of them, in that moment. And isn't that how power works, all the time? It's rarely theatrical, it's always mundane. Bureaucracy is mundane, all these layers that power commodifies, it's just very plain as day but also very built into the fabric of life.'

Who is art for? And who is excluded? 'I grew up a 45-minute train ride from New York,' Perry said. 'I never went to galleries, I never went to museums until I started going to art school. It was a discomfort. I didn't know what that world was. I couldn't imagine going in with my ill-fitting jeans and ill-fitting bra, and just a T-shirt and a dusty-ass sweater that had holes in it and going into a gallery in Chelsea?' She was talking of the neighbourhood in New York that's home to the most monied commercial galleries.

'This world revolves so much around class and money and status and access.'

By contrast, Perry has her work available to view for free on her website.

The word 'casual' prickles. The British artist Mark Leckey makes films that use casual clothing as part of their visual language. He was born in 1964, a working-class teenager at the beginning of the 1980s, at the vanguard of the cultural shift which would eventually see casual clothing become acceptable for adults. 'I can only ever talk about this via class,' said Leckey. 'Otherwise, it's meaningless.'

This is Leckey, performing at PS1 in New York, during a retrospective of his work held in 2017.

His breakthrough film, *Fiorucci Made Me Hardcore*, debuted in 1999, used found footage to track British youth subcultures from the 1970s to the early 90s. Each movement is identified by its specific tribal clothing:

ultra-wide trousers for Northern Soul, bucket hats and T-shirts for acid house. This shot is taken from a pivotal moment, where dancers twist and spin in wide pants and skirts, cut with the sped-up vocal of Loleatta Holloway singing 'The Greatest Performance of My Life'.

The film is captivating, vivid, energized and revelatory. It connects the instincts behind successive youth cults: change the clothing and the music, and it's the same human desires being played out, the desire for community, for rebellion and connection. It is the desire for adolescents to claim space as adults. As the film progresses, the clothing

becomes increasingly casual. It shows how casual clothing has heritage, meaning, magic and power.

As with Perry, Leckey makes art as an open and generous act: the film is free for anyone to view on his YouTube channel.

When we met to talk, Leckey had just debuted a new film, *Under Under In,* on five digital screens as part of a major show of his work at Tate Britain. Hooded kids in streetwear were filmed at night under the motorway bridge where Leckey had played as a child. The characters flash their branding throughout: Nike, Adidas, The North Face. It's clothing that could cast the kids as trouble. Leckey wants

us to look beyond this stereotype. These brands become part of a narrative of belonging.

Leckey grew up in Birkenhead, the other side of the Mersey River from Liverpool. 'My early life is defined by fashion and being beaten up,' he said. 'That's the two things I remember mostly.' His interest in fashion was always analytical. 'From very early on I was very aware of the language of clothes. I've always been obsessed with what clothes mean, and what they're doing.'

Leckey moved to London in 1990, in his twenties. 'The people who I got to know were reading clothes on the same level,' he said. 'They'd have looks. I'd have looks. You'd look for people on the street who had looks. It's the reason why I came to London. I had no money and no work, and I'd be just drifting. I'd occupy my time by analysing what people were wearing. It was something that kept me from sinking into the quagmire.'

This reading of garments eventually became part of his work. '*Fiorucci Made Me Hardcore*, it's what that's about in a way.'

As a teenager, Leckey had been a Casual. It's the name for an initially underground movement of football supporters who brought a sharp eye for fashion, branding and looks to the terraces. 'I always wanted to pull that Casual movement out of the idea that it was full of racist hooligans and idiots, because in the early days it wasn't.'

Here I'd like to insert an image. I can't. 'There are no pictures of the early Casual stuff,' said Leckey. 'That's what's interesting about them.' The first Casuals dressed stealthily, adopting unexpected looks to avoid police harassment. 'One of the early ones I remember was looking like a geography teacher,' he said, 'corduroy jacket, patches on the sleeves. As a group it looked incredibly strange and uncanny.'

This was before the hive mind of the social media age. How many would be dressed the same way? 'There could be a thousand all wearing that,' he said. 'You could go round the back of the police and not get hassled.'

He said Casuals used clothing to look other than expected, and to disorientate those who would typecast them. 'I remember coming down to London in the early 1980s, all little scallies from Ellesmere Port. It was a little crew of us, all going to Burberry, admittedly to try and nick stuff, but also to buy a scarf or whatever. And just the absolute confusion that caused. Burberry was this high-end

brand and there's all these little herberts in there trying to nick their scarves. They didn't understand it at all.'

There was something serious going on. 'It's part of that realization of class, of where you're from,' said Leckey. 'You realize that through clothes. You realize that at a young age.'

Fiorucci was an Italian brand founded in 1967 that helped propel denim jeans from functional garment into one of fashion. Its jeans were hard to find in the UK and a status symbol in the Casual movement. Leckey explained their appeal. 'Jeans are a symbol of consumerism. That stuff is being sold to you in a very cynical way, with you merely as the consumer. The idea that you take that, you buy those jeans and you invest in it, to such a degree that it becomes like a faith, an agreed upon thing that's determining not just your life but people around you. This becomes a symbol, a totem of something that represents you. That was the idea

that I was always fascinated about, in Casual culture, and in subcultures, still with Adidas, with Nike, with North Face.'

That word 'totem' is important. During his new film *Under Under In*, the camera suddenly pans beneath the earth, into ancient realms under the bridge. Here's a still from that scene across four of the screens, the other showing the characters hiding up the ramp of the bridge.

Leckey is showing how human behaviours and desires connect across time, that sportswear and casual clothing is just a contemporary iteration of this need for communality.

'It's power,' he said. 'It's an act usually performed by people with very little power. It's an attempt to find some agency, some energy returning their way. It's still there now with streetwear, these brands getting co-opted. It's because that group have managed to find something meaningful, have created meaning themselves out of something that might be essentially meaningless or crass.'

Mark Leckey reveals the belonging and identity that can be found in casual clothing. The American artist Ryan Trecartin

queers it. He listed for me some of the ways his clothing ha[s] been described:

- *a stay at home dad*
- *lesbian*
- *F2M passing*
- *gay activist from the 90s*
- *tourist*
- *very ohio*
- *country*
- *high school drama teacher*
- *an extra*
- *quasi crisis actor*

Trecartin's films are a universe parallel to today's world, terrifying and hilarious and invigorating and familiar. His characters trash things and screech at each other, voices often sped up, mobile phones in their hand, their words lik[e] a warped version of the snatched conversations you hear on the bus.

His characters are often in hoodies or T-shirts or prairie dresses or some trash mix of cheap glamour most likely from a discount rail.

This is Trecartin in the film *CENTER JENNY*, in a 'WITNESS' sweatshirt to show he's a character on the periphery, both crew and participant.

There are wigs, nails, handbags, coloured contact lenses, make-up. He calls this an 'essential language layer'. The selection of this clothing is all part of his intensely researched depiction of chaos, a depiction of living today, oversaturated with images and anxiety and stimuli.

Trecartin sent me eight pages of his thinking about clothes. I'll keep his grammar as he typed it.

*in my mind, clothes & words can operate in a similar way;*
*wardrobe & language can operate in a similar way;*
*style & dialect or accent can operate in a similar way;*
*dressing & speaking can operate in a similar way.*

Here's Trecartin, in a scene from *Whether Line*, a film he made with his long-time collaborator Lizzie Fitch.

Trecartin was messaging from Athens, Ohio, in his home state. He was born in 1981, and spent the first years of the twenty-first century living in major cosmopolitan cities like Miami, Los Angeles. In 2016, he bought a 32-acre plot in rural Ohio with Fitch. They built a home with more doors than necessary, as well as a 55-foot-high watchtower, and a lazy river water-park ride, all of which now appear as the setting for their films. The detritus of construction is left all around: these sets are purposefully unlovely.

When he emailed me, he apologized for the delay – they'd had a gas leak.

'my relationship to clothing personally often involves tons of avoidance and acts of being off but passing.'

By 'passing', he means appearing as who you choose to be – consciously projecting a certain image. For Trecartin,

that includes actively choosing to make a life as a queer artist in a swing state which, in the 2016 presidential election, voted 51.69 per cent for Donald Trump.

He explained further. 'i love when things provide everything needed to generate assumptions and enough context for the brain to forgo examining further but then a vibe is left that just doesn't add up with the conclusion and so the brain senses something is off and then the general area code feels bent.'

He buys from places like Walmart, a chain of hypermarkets and discount stores across the United States. It's where Americans shop, the reality of clothing for most, far from catwalk or city-focused ideas of fashion. I just searched 'new arrivals' on Walmart's website: it brought up hoodies, sweat tops, trackpants, fanny packs. It's the casual clothing of the United States, including voters who elected Trump to be President.

*i think i'm always trying to retreat to some outfit that represents my version of a generalized notion of a default factory setting notion of 'easy-to-overlook' middle class, middle american, culture-lacking average man and neutral in masculinity ... like whatever type or stereotype i fall into when seen at a distance by someone who doesn't know me, i sort of go for the neutral version of that.*

Trecartin had some shopping tips. 'at walmart or target, find the clothes that are "average" height and most easily dismissed. if you overlook it, it's probably the right costume.'

For the garments in his work, Trecartin is inspired by his

friends, who 'push the potential of clothing and its ability to contain or channel culture to some very expansive places, using it to shape and twist reality and pervert context in complexly living and queering ways'.

It is a way that many radical queer humans have expressed themselves throughout decades of activism in the fight for equality: playing with the language and context of heteronormative clothing. This queering is crucial to his films.

Trecartin mentioned his 2009 film *K-CoreaINC.K*, which looks at the corporatization of culture. It featured the New York designer Telfar Clemens, a friend and regular collaborator, as the character Global Korea.

The scene below was shot in a tiny room crammed with five rows of aeroplane seats. 'telfar wore earrings that were

French tip nails,' Trecartin wrote. 'they defined and dif-
ferentiated his character as having "leveled up", i.e. to be a
marker of the idea of CEO.'

'i am not sure how I could have conveyed in a script what
the earrings conveyed so economically just simply hanging
in telfars ears.'

Clemens's clothes in the film are a classic example of
queer appropriation, creating something casual from a
formal idea of female propriety: a flouncy blouse, skirt and
headband. He wore no underwear and, in another scene
set in a campervan, he rolled around, flashing his penis
while holding the box of an Apple MacBook Pro. Execu-
tive dressing was being deployed chaotically, its surface
meaning a thin veil.

I'd asked Trecartin how clothing had helped him to play with reality and unreality. His response bounced close to th glorious freedom of words that comes in his films.

*auto renewal subscriptions you don't know how to cancel.*
*clothing is a fault of consensus.*
*clothing is easily weaponized.*

Casual clothing is inextricably linked to film and video art. The two have matured over the same period, coming to full fruition in the twenty-first century. Some filmmakers, like Trecartin, dress their characters in casual clothing. Others do the opposite.

When the British artist Hilary Lloyd makes film, she want her subjects to be themselves, wear their normal clothing. This clothing also tends to be casual.

A still from her projection *Car Wash.*

Lloyd herself is always wearing Adidas.

I can't remember a time when I've seen her not wearing Adidas. 'I really like uniforms,' she said.

We spent time together at Lismore Castle in Ireland. Here's Lloyd, on a tyre swing, down in the tree fern playground. She was wearing an Adidas jacket.

Her trackpants are men's, by Ronhill. Lloyd said that she shops for casual clothing twice a year. 'Nothing really changes that much. I get whatever new things there are and then leave. I can do anything I want to do in it, and I like that anyone can get it.' It doesn't mark her out as an artist.

There are other benefits. 'It doesn't have an age restriction,' she said. Lloyd was born in 1964. 'Let's face it, I've always been wearing it. But I haven't quite worked out how to do another sort of look.'

Why would she want to do another look?

'Variety. To be a different person, maybe?'

Does she like to disappear? Her eyes sharpened when I said that word.

'No, I don't like disappearing. Maybe merging.'

Her films are often very personal, filmed usually without script, narrative or traditional direction. She described her process with strangers. 'I have to ask you if you'll be in my film. I have to go and film you, and I don't want to give too much away and make you behave for the camera in a particular way. I want to seem approachable and not like I'm going to kill you.'

She thought further about uniforms, her definition seeming to mean a way of dressing rather than everyone in the same clothes. 'The people I'm filming are in uniform,' she said. 'Princess Julia was in uniform.'

In 1997, Lloyd made a slide projection with images of Princess Julia, a DJ, artist and counterculture figurehead, travelling to and from work.

This idea of uniforms continued in *Car Wash*.

Not long after we talked, Lloyd opened her new show *Car Park*. As part of the installation of structures, films and paintings, Lloyd showed a new film called *Moscow*. It's of a Polish man named Moscow.

I emailed: was Moscow wearing a uniform? 'Yes!' she replied. 'In fact that's how I explained it. No, don't dress up for this, wear normal uniform.'

By seeing her own sportswear as uniform, Lloyd links casualwear with functional clothing. As we saw earlier, such utilitarianism helps artists in the flow of their day to day work. Sportswear has become the functional clothing of today. What is it Lloyd likes about these new functional uniforms?

'I like the idea of someone doing something that they're very good at. They have an eroticness about them. So I'm probably just copying the people I like to film, creating my own uniform.'

She continued: 'Uniform has got drama. It's pretty sexy.'

Uniform doesn't have to mean sameness. Let's boil this all down to one garment, seen in a variety of ways: the T-shirt, which has its origins in underwear. T-shirts first emerged in the late nineteenth century, when, during the summer, labourers began to cut their all-in-one underwear in two. The first manufactured T-shirts came at the turn of the twentieth century. In 1904, the Cooper Underwear company advertised a product called a 'bachelor undershirt', with no need for buttons to keep it in place.

Here is the American artist Mary Manning, who took those photographs for us of Nicole Eisenman. Manning took this image using a self-timer in 1994. They were twenty-two.

T-shirts are the garments of everyday studio life, especially in warmer climes. The American artist Paul Mpagi Sepuya is based in Los Angeles, working every day with his camera and his mirror. 'Because I'm in the studio alone most of the time,' he emailed, 'I become the subject of a lot of pictures.'

In his art, he's often naked. He also regularly takes calibration shots, self-portrait tests he doesn't consider artworks in themselves, but which record his daily clothing. He's nearly always in a T-shirt.

'I wear what's practical in the studio, and most all my clothes are earth tones, browns, blacks and denim.'

'Intentionally or coincidentally, my clothing and my artwork have the same palette and aesthetic.'

Not all T-shirts – not all casual clothes – are for merging into the background. Since the late 1940s, T-shirts have been a prime vehicle for printed slogans or images – one of the first printed T-shirts was thought to have been created for the 1948 presidential candidate Thomas Dewey.

The Canadian artist Marc Hundley screenprints T-shirts with lyrics and song titles as part of his practice, an act of memory-making he also applies to print and canvas. Here's Hundley in his work *It's Up To You.*

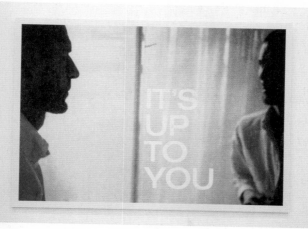

With his T-shirts, Hundley is evoking the emotional connection found in tour merch. Band T-shirts have a particularly sensitive place in the psyche of those who were adolescents in the late twentieth century, trying to find identity and belonging by going to gigs. Part of the ritual was buying the T-shirt that says to everyone after: I was there.

By screenprinting his choice of lyrics or song titles on to T-shirts, Hundley continues into adult life the connection

between memory, emotion and clothing. He sent me some images of a few of his T-shirts from his studio in New York.

Hundley's T-shirts speak of community. It is the community of those who love the songs, but it is also the community of queer humans now entering midlife, who use the emotional nourishment of the lyrics as fuel for going forward, when so many in the generation before them perished in the AIDS crisis, during which time most of these songs were originally released.

T-shirts can console, and they can affirm. In August 2019, the artist Alvaro Barrington organized a float at the Notting Hill Carnival, an annual celebration of Caribbean culture that's Europe's biggest street party.

Barrington was born in Venezuela in 1983, moved to Grenada when he was one, then to New York when he was

eight. He said that he wears T-shirts on rotation, like an 'Immigrant' T-shirt from Rihanna's label Fenty, 'Cause I believe in migration and open borders and the Caribbean's impact on the world.'

Barrington makes gestural paintings of life and colour and emotion. Around the time we emailed, he posted on Instagram the handwritten note 'I am a Black Artist', captioning it: 'I am a BLACK ARTIST because being black in all its complexities has shaped my imagination and my art responds to that always.'

For the Notting Hill Carnival, he silkscreened a T-shirt with the image of a hibiscus flower.

Barrington in the middle of the crowd with his gallerist, Sadie Coles.

Barrington still wears the T-shirt. 'I got all these colours from wearing it during the Notting Hill Carnival,' he said.

'That outfit is kind of my uniform. A lot of times I'm used to being in the studio for like 4/6 days straight in the same clothes. I like that when I go out at least the clothes on me have sentimental meaning, even though I smell like ass.'

The T-shirt is a garment of simplicity, made up of a bare minimum of pattern pieces. It is elemental, just like the work of Scottish artist David Robilliard.

In 1987, Robilliard painted a canvas called *Safe Sex*.

It was made a year after the British government launched a nationwide public health campaign with the slogan 'AIDS: Don't Die of Ignorance'.

Robilliard chronicled the traumatic landscape of gay life in 1980s London, navigating desire, oppression and epidemic. He started as a poet, encouraged by his friends Gilbert & George to draw images alongside his words. They would later describe him as 'the sweetest, kindest, most infuriating, artistic, foul-mouthed, witty, sexy, charming, handsome, thoughtful, unhappy, loving and friendly person we ever met'.

Robilliard wore T-shirts and he sometimes painted on

them. Here he is at a gallery opening in 1985. It was a pivotal point in his career, just before he began the large-scale canvases that brought his words and images together. On the wall to the left is the cover of his poetry collection, *Inevitable*. On the other wall is one of his watercolours.

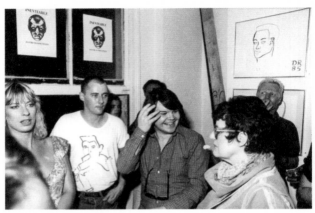

In his paintings, he captured the T-shirts worn by his figures with his elegant, spare and yet definite line.

NOBODY FINDS
A DREAM MAN
TILL THEY'RE ASLEEP

David Robilliard 1987

He shows us that T-shirt with eight lines of paint. In doing so, he gives it the same sexual charge as the one he wore at the Colony Club in Soho, the private drinking club that had Francis Bacon as a founding member.

Robilliard used humour as a weapon, mocking the aesthetics of male idealism.

I ASKED FOR ADONIS

NOT A DOUGHNUT

DAVID 1987
I ASKED FOR ADONIS ROBILLIARD

Robilliard shows this alleged 'adonis' is wearing a T-shirt via three painted lines.

He continued to release books of poetry alongside his work. To celebrate the launch of his book *Swallowing Helmets*, Robilliard wore a T-shirt.

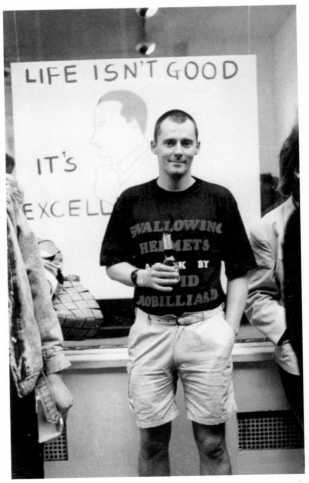

The same year he painted *Disposable Boyfriends*. The figure with the beer, in T-shirt and shorts, with his left hand in his pocket, looks just like him.

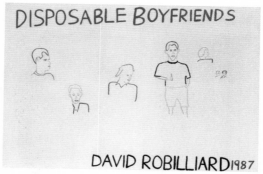

The T-shirt is defined by five painted lines. That's all there is. A year later Robilliard would be dead, a victim of the AIDS pandemic.

While writing this book, I've also been a judge for the Turner Prize. Both have changed the way I experience art. I have learned how to look.

Members of the prize jury were asked to agree upon a shortlist of four British or British-based artists, picked from a year of seeing as much art as possible. We were unanimous in our decision: Lawrence Abu Hamdan. Helen Cammock. Oscar Murillo. Tai Shani.

The artists got their work ready for the Turner Prize show at the Turner Contemporary in Margate, which opened a few months later. Whenever I saw them, the artists were always casually dressed. On the opening weekend of the exhibition, I took this photo of Cammock, who performed in front

of one of her prints. She was also showing her film *The Long Note*, about the role of women in the civil rights movement in Derry.

Cammock performs in both a sung and spoken voice. She does so in the clothing she always wears: T-shirts, sweatshirts, trackpants, sneakers.

The four artists had met for the first time in May, four months before the opening of the show. They soon

realized they shared common ground, working in different ways against distinct, but ultimately interrelated, power structures.

It was during a year of increasing division in the United Kingdom, fuelled by fallout from a referendum on the country's membership of the European Union. The prize was to be awarded nine days before a bitterly fought general election. The nominated artists joined together and wrote a letter to the jury.

'After a number of discussions,' the letter read, 'we have come to a collective view that we would like to be considered together for this year's award.'

They wrote that each of them made art about social and political issues. 'The politics we deal with differ greatly, and for us it would feel problematic if they were pitted against each other, with the implication that one was more important, significant or more worthy of attention than the others.'

A few hours before the prize ceremony, the jury met to formally read the nominees' letter. We agreed to their request.

The decision was still a secret. That evening, the award ceremony went ahead as usual. There were drinks, a sit-down dinner. Many guests had come dressed as might be expected: tailoring for men, dresses for women.

Just before the prize was given, the BBC began broadcasting the ceremony live. The announcement was made by the editor of British *Vogue*, Edward Enninful. As he revealed the news, there was an immediate standing ovation.

The collective Abu Hamdan / Cammock / Murillo / Shani took to the stage, the audience still on their feet.

Murillo was in a white T-shirt. Shani wore a look by

designer Craig Green that he described as a 'sacrificial picnic blanket'. She also wore a large Perspex necklace that read 'TORIES OUT'. Abu Hamdan was in a buttoned-up shirt. Cammock approached the podium to read a statement on behalf of her fellow collective members. She wore a bomber jacket and a rollneck sweater. In her ear, her customary single large hoop.

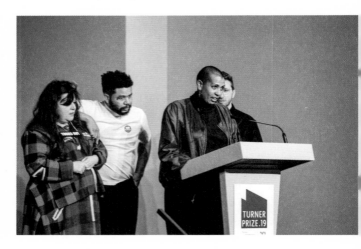

'The issues we each deal with are as inseparable as climate chaos is from capitalism,' she said. 'We each seek to use art to push the edges of issues, mapping the bleed of one into another, across time, across sectionalities, across the realm of the real and the imagined and through walls and borders.'

It was remarkable to witness. Cammock spoke with clarity and conviction. These were the statement's closing words.

'When there is already so much that divides people, we

feel strongly motivated to use the occasion of the prize to make a collective statement in the name of commonality, multiplicity and solidarity, in art as in society.'

She turned to the rest of the collective, and they hugged.

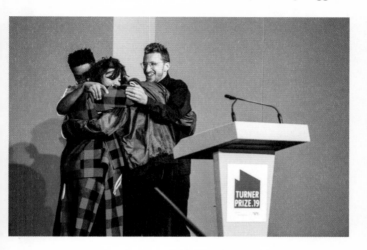

It felt like a beginning. Here were artists defining their own space: not a prize, not an institution.

I come to the end of this book changed, a change completed by their action. It is how I engage with what I once took for granted: the language of clothing, an artist's work. This change has affected how I view much else. The social, cultural, psychological barriers that once seemed so impermeable are now starting to dissipate.

Repeatedly, we've met artists whose clothing runs counter to the norm. These artists subvert, rework or reject what is expected of them. By their example, we should

account for ourselves: why are we so constricted, both in what we wear, and in our ideas?

What artists wear shows us how our lives can be broadened if we set out on our own intuitive paths. The invitation is open: for us to dismantle the structures of power, wealth, class, race and gender that control what we all wear. It is urgent, vital, full of possibility. This is the work we face next

# Sources

## LOUISE BOURGEOIS

**19.** 'Like a dumbo I think . . .': LB-0053
© The Easton Foundation;

**19.** 'It gives me great pleasure . . .':
Louise Bourgeois, c. 1963. , LB-0202
© The Easton Foundation;

**21.** 'very very difficult . . .':
LB-0049 © The Easton Foundation;

**21.** 'The shock came . . .':
LB-0826 © The Easton Foundation.

## TAILORING

**31.** 'In this way I stayed clean . . .':
Yves Klein, 'Le vrai devient réalité',
reprinted in *Zero* (1973);

**32.** 'I've destroyed her . . .': James Lord,
*Giacometti: A Biography* (1985), p. 364;

**33.** 'Alberto's apparel was so much a part . . .':
Lord, *Giacometti*, p. 362;

**38.** 'I saw in his example . . .': *Charles White:
A Retrospective* (2018), Sarah Kelly Oehler
and Esther Adler (eds), p. 23;

**39.** 'The Equal Rights Amendment...' Georgia
O'Keeffe, *Art and Letters* (1987), p235;

**44.** 'It's only recently that I realized . . .':
Laurie Anderson, *Stories from the Nerve Bible*
(1994), p. 150;

**47.** 'We step into the responsibility-suits . . .':
Gilbert & George, *A Day in the Life of George
& Gilbert* (1971), p. 3;

**48.** 'We are both war babies . . .': Interview by
Slava Mogutin, *Whitewall Magazine*, 2013.

## WORKWEAR

**66.** Agnes Martin's many jobs: 'in a factory';
'on a farm – milking' . . . : Arne Glimcher, *Agnes
Martin: Paintings, Writings, Remembrances*
(2012), p. 242;

**70.** 'The struggle of existence, non-existence
is not my struggle . . .': Glimcher, *Agnes Martin*,
p. 32;

**71.** 'An artist's life is an unconventional life . . .':
Glimcher, *Agnes Martin*, p. 123;

**77.** 'Long Russian Ermine...' Tate Archive, TGA
965/2/12;

**86.** 'He wears a treasured old kimono vest . . .':
Susan Peterson, *Shoji Hamada* (1974), p. 26.

## DENIM

**107.** 'In those days I didn't have a real fashion
look . . .': Andy Warhol and Pat Hackett, *POPism:
The Warhol Sixties* (1980), p. 28;

**110.** 'I wish I could invent something like
bluejeans . . .': Andy Warhol, *The Philosophy
of Andy Warhol: From A to B and Back Again*
(1975), p. 21;

**113.** 'By doing body prints, it's telling me . . .':
Ulysses Jenkins, *King David* (1978), https://
vimeo.com/15201499;

**119.** 'THE KIND OF . . .' *Anarchitecture* (1974)
Estate of Gordon Matta-Clark © ARS, NY and
DACS, London 2021;

**122.** 'I'm in what seems like a Goodwill
store . . .': David Wojnarowicz, *In the Shadow
of the American Dream: The Diaries of David
Wojnarowicz* (1996), p. 108;

**122.** 'Are you kidding? That's a sell-out . . .':
Cynthia Carr, *Fire in the Belly* (2012); p. 525;

**122.** 'something punctuated by breathing
alone . . .': *In the Shadow of the American
Dream*, p. 169.

## PAINT ON CLOTHING

**152.** 'I slowly came to realize . . .': Anne Truitt,
*Daybook* (1984), p. 178;

**156.** 'the most devastating defeat . . .'
*Daybook*, p.172;

**166.** 'My mom, when we needed clothes . . .': Interview by Kenneth Goldsmith, *Bomb Magazine*, 1 July 1994, https://bombmagazine.org/articles/jack-whitten/;

**176.** 'His friend Michael Peppiatt...' Francis Bacon: In The Studio by Lucy Davies https://www.telegraph.co.uk/art/artists/francis-bacon-in-the-studio/.

## JOSEPH BEUYS

**183.** '[Art] is the only political power': *Joseph Beuys's Public Dialogue*, recorded at the New School for Social Research, New York, 11 January 1974, https://www.eai.org/user_files/supporting_documents/beuys_dialogue.pdf;

**186.** 'This hat represents another kind of head . . .': Beuys quoted by Caroline Tisdall, in the catalogue for his exhibition at the Guggenheim Museum, New York, in 1980;

**189.** 'The more I consider the problem...': Interview with Louwrien Wijers in Joseph Beuys and Carin Kuoni, *Energy Plan for the Western Man* (1991), p244;

**189.** 'a culture which is only . . .': Interview with Willoughby Sharp, p. 92.

## CLOTHING IN ART

**213.** 'Before a portrait, is there anyone who thinks . . .': Geta Brătescu, 'Day and Night' (2004), in *The Studio* (2013), p. 294;

**220.** 'speaking with one's body': 'Sharon Hayes. In the Near Future', interview for CAG Vancouver, https://vimeo.com/23971715;

**230.** The *Uniform* project proposes...': Andrea Zittel exhibition press release, 2011, https://www.regenprojects.com/exhibitions/andrea-zittel5/press-release.

## FASHION AND ART

**257.** 'he taught me not to care . . .': Peter Webb, *Portrait of David Hockney* (1988), p. 5;

**257.** 'What's going on here? . . .': Christopher Simon Sykes, *Hockney: The Biography* (2011), vol. 1, p. 72;

**257.** 'One time he went shopping . . .': Sykes, *Hockney*, vol. 1, p. 75;

**259.** 'I can go a long time without sex . . .': *David Hockney by David Hockney* (1977), p. 68;

**261.** 'I fight pain, anxiety and fear . . .': Yayoi Kusama, *Infinity Net: The Autobiography of Yayoi Kusama* (2003), p. 93;

**261.** '"Psychosomatic Art" [was a means of] creating a new self . . .': Kusama, *Infinity Net*, p. 111;

**263.** 'I hated the shape of the male sexual organ . . .': Kusama, *Infinity Net*, p. 111;

**265.** 'Walking the streets, I noticed . . .': Akira Tatehata, Laura Hoptman, Udo Kultermann and Catherine Taft, *Yayoi Kusama* (2017), p. 21;

**266.** 'He was Vice-President . . .': Tatehata et al, *Yayoi Kusama*, p. 21;

**266.** 'The radical vanguard items . . .': Tatehata et al., *Yayoi Kusama*, p. 21;

**266.** 'In which the action...' *Yayoi Kusama: A Retrospective* (1989) p94;

**273.** 'I always had a flair for clothes . . .': *Louise Nevelson. An Interview with Arnold Glimcher for the Archives of American Art*, 1 January 1973, 33 1/3 RPM LP record;

**273.** 'I think that because of their, not mine, their preconceived ideas . . .': *Nevelson: An Interview with Arnold Glimcher*, 30 January 1972.

## CASUAL

**307.** 'a vivid symbol of what has gone wrong . . .' David Cameron, 1996, http://news.bbc.co.uk/hi/5166498.stm;

**343.** 'the sweetest, kindest...' Gilbert & George, *Our David* (1990).

## Special thanks

Thank you to all the artists, as well as their friends and families, who gave their time and energy to help make *What Artists Wear*. This book started as a piece for the *Financial Times*. Thanks to Jo Ellison for letting me write it, and to William Norwich for first seeing its possibilities as a book. I am forever grateful to Harriet Moore for making the book happen. I hope every writer gets the chance to be edited by an editor like Chloe Currens: insightful, enabling, compassionate, wise.

I am indebted to three writers whose work shows what can be done: Hilton Als, Olivia Laing, Lynne Tillman. Each contributed to this book in their own way, and I thank them. Aileen Corkery believed in the book from the beginning and helped lay its foundations. Sadie Coles gave me excellent food for thought in early conversations. I owe much to Laura and William Burlington, and to Frances and Rodolphe von Hofmannsthal. I thank Veronica Ditting and her studio for all their work on an earlier iteration of the book. Thank you to Adam Cowmeadow, Ruth Drake, Paul Flynn, Amanda Freeman, Polly Hudson, and to Chapter 10 Book Club and the Friends of Arnold Circus.

I would like to thank the staff of the British Library, especially the librarians of Humanities 1, and all whose labour there is unseen.

My parents, Pat and Tony Porter, continue to give me the best insight into being an artist. My sisters Sarah, Sophie and Chloe, and their families, are amazing. Before I met Richard Porter, this book was stuck. Then we met, and all became clear.

## Acknowledgements

Many helped the different aspects of this book come together. If I have missed your name, apologies, and thanks.

Cathal Abberton
Selvi May Akyildiz
Christopher Albert
Mirsini Amidon
Joakim Andreasson
Emma Astner
Charles Atlas
Valentina Bandelloni
Corinne Bannister
Bill Beech
Alex Bennett
Greta Bertram
James Birch
Sophie Bowness
Richard Bruce
Mary-Beth Buesgen
Udo Bugdahn
Rocket Caleshu
Jim Cass
Rana Chan
Sara Chan
Adrienne Chau
Adrian Chew
Niamh Conneely
Jane Crawford
Anna Bush Crews
Peter Currie
Pauline Daly
Emily Davidson
Bridget Donahue
Nico Dregni
Jessamyn Fiore
Hal Fischer
Elena Frohlick
Andreas Gegner
Sam Gordon
Jerry Gorovoy

Simon Gowing
Julie Green
Helen Harrison
Nathaniel Hepburn
Michael Hermann
Jonathan Horrocks
Maya Huong
Tamsin Huxford
Andrew Judd
Stefan Kalmár
Kendall Koppe
Suh Kounim
Catherine Koutsavlis
Jenny Law
Jimi Lee
Lisa Le Feuvre
Kate MacGarry
Cecilia Mackay
Simone Manwarring
Jerry Marshall
Maureen Martin
Jon Mason
Eva Mayhabal Davis
Sarah McCrory
Martin McGeown
Michèle Montagne
Marta de Movellan
John Michael Morein
Moirah Mudd-Kelly
Gregor Muir
Sophie Nurse
Nancy Oakley
Natalie Oleksy-Piekarski
Alex O'Neill
Ales Ortuzar
Maureen Paley
Cristina Palumbo
Lisa Panting
Jeremy Parker
Thomas Persson
James Philips
Marilyn Porlan

Naja Bak Rantorp
Phillida Reid
Norberto L. Riviera
Jacob Robichaux
Tobit Roche
Philip Roe
Sam Roeck
Sara Roffino
Tracey Schuster
Hannes Schroeder-Finckh
Daphne Seybold
Susie Simmons
Francine Snyder
Hedi Sorger
Cosima Spender
Malin Ståhl
Kathy Stephenson
Jason Stern
Sabrina Tamar
Ben Thornborough
Caroline Tisdall
Anthony Tran
Alexandra Truitt
Rob Tufnell
Isabel Venero
Toby Webster
Andrew Wheatley
Mary Whitten
Hannah van den Wijngaard
Amanda Wilkinson
Alex Worcester
Maggie Wright

356

# List of Illustrations & Photo Credits

**1.** Eugène Atget, *Magasin, avenue des Gobelins*, 1925. Gelatin silver printing-out-paper print, 21.8×17.1 cm (8 9/16"×6 3/4"). Museum of Modern Art, New York. Abbott-Levy Collection. Partial gift of Shirley C. Burden. Acc. no.: 1.1969.1379. Photo: © 2021. Digital image, The Museum of Modern Art, New York/Scala, Florence.

**6 (above).** Cave painting, Tassili n'Ajjer, Algeria. Photo: Dimitry Pichugin/Shutterstock.com. **6 (below).** Michelangelo, *La Pietà*, 1498–9. St Peter's Basilica, Vatican City. Photo: Photo-Fires/Shutterstock.com.

**7.** Johannes Vermeer, *Girl with a Pearl Earring*, c.1665. Reproduced by courtesy of Mauritshuis, The Hague.

**8 (left and right).** Sonia Delaunay, *Simultaneous Dress*, patchwork fabric, 1913. Private collection. © Pracusa 2013057.

**13.** Robert Mapplethorpe, *Louise Bourgeois*, 1982. © Robert Mapplethorpe Foundation. Used by permission.

**16.** Louise Bourgeois as a child, 1913. © The Easton Foundation/VAGA at ARS, NY and DACS, London.

**17.** Louise Bourgeois wearing a dress designed by Coco Chanel, aged 13. © The Easton Foundation/VAGA at ARS, NY and DACS, London.

**18.** Louise Bourgeois at a gallery opening, New York, 1960. Photo: Fred W. McDarrah/Getty Images.

**20.** Louise Bourgeois wearing her latex sculpture, *AVENZA* (1968–1969), New York, 1975. Photo: Mark Setteducati. © The Easton Foundation/VAGA at ARS, NY and DACS, London.

**22.** Louise Bourgeois, diary entry, 9 September 1997. © The Easton Foundation/VAGA at ARS, NY and DACS, London.

**24.** Louise Bourgeois wearing a Helmut Lang coat, New York, 2005. Photo: Pouran Esrafily. © The Easton Foundation/VAGA at ARS, NY and DACS, London.

**27.** Gilbert & George, *The Singing Sculpture by Gilbert and George*. Produced and directed by Philip Haas, Sonnabend/Methodact, New York, 1991. Video, 1992. Duration: 20 mins. © Gilbert & George. Courtesy White Cube.

**30 (above and below).** Yves Klein, presentation of *Anthropométries de l'Époque Bleue (Anthropometry of the Blue Period)*, Galerie Internationale d'Art Contemporain, 9 March 1960. © Photo: Harry Shunk and Janos Kender. J. Paul Getty Trust. Getty Research Institute, Los Angeles (2014.R.20). © Artwork: Succession Yves Klein, c/o ADAGP, Paris and DACS, London.

**31.** Yves Klein, presentation of *Anthropométries de l'Époque Bleue (Anthropometry of the Blue Period)*, Galerie Internationale d'Art Contemporain, 9 March 1960. © Photo: Harry Shunk and Janos Kender. J. Paul Getty Trust. Getty Research Institute, Los Angeles (2014.R.20). © Artwork: Succession Yves Klein, c/o ADAGP, Paris and DACS, London.

**32.** Ida Kar, *Alberto Giacometti*, 1954. © National Portrait Gallery, London.

**35.** George Hayter, *The House of Commons*, 1833. © National Portrait Gallery, London.

**36.** Ernst Scheidegger, *Alberto Giacometti in the Doorway*, 1950. Photo: Ernst Scheidegger © 2021 Stiftung Ernst Scheidegger-Archiv, Zurich.

**37.** Life drawing class taught by Charles White at the South Side Community Center in Chicago, photograph, c.1940–41. Holger Cahill papers, 1910–1993. Archives of American Art, Smithsonian Institution, Washington, D.C.

**38.** Kent Twitchell, *Charles White*, 1977. Los Angeles County Museum of Art, gift of Benjamin Horowitz. © Kent Twitchell. Photo: © 2021 Digital Image Museum Associates/LACMA/Art Resource NY/Scala, Florence.

**40.** Georgia O'Keeffe's Emsley Suit, photograph by Gavin Ashworth, 2016. Gift of Juan and Anna Marie Hamilton. © Georgia O'Keeffe Museum. [2000.3.386]. Courtesy of Georgia O'Keeffe Museum.

**41.** Guillermo Kahlo, photograph of Frida Kahlo with her three sisters and a male cousin, Coyoacán, Mexico, 1926. Photo: Granger/TopFoto.

**42.** Frida Kahlo, *Self-Portrait with Cropped Hair*, oil on canvas, 40 × 27.9 cm (15 3/4" × 11"), 1940. Museum of Modern Art (MoMA), New York. Gift of Edgar Kaufmann, Jr. Acc. no. 3.1943. © 2021. Digital image, The Museum of Modern Art, New York/Scala, Florence © Banco de México Diego Rivera Frida Kahlo Museums Trust, Mexico, D.F. / DACS 2021.

**43.** Laurie Anderson, *Big Science*, record sleeve, 1982. © Nonesuch Records.

**45.** Lynn Goldsmith, portrait of Laurie Anderson, 1982. Photo: Lynn Goldsmith/Corbis/Getty Images.

**46.** Peter Hujar, *Thek Working on The Tomb Figure*, 1967. © 1987 The Peter Hujar Archive LLC. Courtesy Pace Gallery, New York and Fraenkel Gallery, San Francisco.

**48.** Gilbert and George, *The Singing Sculpture by Gilbert and George*. Produced and directed by Philip Haas, Sonnabend/Methodact, New York, 1991. Video, 1992. Duration: 20 mins. © Gilbert & George. Courtesy White Cube.

**49.** Gilbert and George, *Life*, multimedia, 422 × 250 cm, 1984, from *Death Hope Life Fea* Tate, London. © Gilbert & George.

**51.** Rita Barros, photograph of Jeff Koons, 1991. Photo: Rita Barros/Archive Photos/Gett Images.

**53.** Andy Warhol, contact sheet with images o Jean-Michel Basquiat, 1982. © 2021 The And Warhol Foundation for the Visual Arts, Inc./ Licensed by DACS/Artimage, London.

**55.** Karen Binns, Jean-Michel Basquiat and Andy Warhol at dinner to celebrate a Basquia opening. Courtesy of Karen Binns.

**57.** Patrick McMullan, photograph of Jean-Michel Basquiat and Francesco Clemente at the Area party for Keith Haring's new store, the POP shop, 1986. Photo: Patrick McMullan Getty Images.

**60.** Jean-Michel Basquiat modelling a double breasted suit at a Comme des Garçons Homm Plus show. Photo: Comme des Garçons

**61.** Jean-Michel Basquiat modelling a zipper jacket at a Comme des Garçons Homme Plus show. Photo: Comme des Garçons

**63.** Gianfranco Gorgoni, *Agnes Martin, Cuba, New Mexico*, 1974. Gelatin silver print. Image: 31.9 × 23.4cm (12 9/16" × 9 3/16"). Sheet: 35.6 × 27.8 cm (14" × 10 15/16"). The J. Paul Getty Museum, Los Angeles. © Estate of Gianfranco Gorgoni.

**65.** Alexander Liberman, photograph of Agnes Martin with level and ladder, 1960. © J. Paul Getty Trust. The Getty Research Institute, Los Angeles (2000.R.19). Artwork featured © Agne Martin/DACS.

**67.** Mildred Tolbert, photograph of Agnes Mar in her studio, Taos, New Mexico, 1953. The Harwood Museum of Art, Taos, New Mexico, courtesy Mildred Tolbert Archive. Artwork featured © Agnes Martin/DACS.

**68.** Mildred Tolbert, photograph of Agnes Martin in her studio, Taos, New Mexico, 1953.

The Harwood Museum of Art, courtesy Mildred Tolbert Archive. Artwork featured © Agnes Martin/DACS.

**69.** Alexander Liberman, photograph of Agnes Martin in her studio, 1960. © J Paul Getty Trust. The Getty Research Institute, Los Angeles. Artwork featured © Agnes Martin/DACS.

**70.** Olivia Laing, photograph of Agnes Martin's overalls on a hanger. Courtesy Olivia Laing.

**73.** Postscript to a letter from Barbara Hepworth to Margaret Gardiner, mid-June 1944. Tate Archive, courtesy Bowness. Photo: © Tate.

**74 (above).** Unknown photographer, photograph of Barbara Hepworth Carving at Chy-an-Kerris, 1948. Courtesy Bowness. **74 (below).** Rosemary Mathews, photograph of Barbara Hepworth in the carving yard at Trewyn, June 1960. Courtesy Bowness.

**75.** Morgan Wells, photograph of Barbara Hepworth at the Morris Singer Foundry with the prototype for *Single Form*, May 1963. Courtesy Bowness.

**76 (above).** Unknown photographer, Barbara Hepworth in a technical jacket in the carving yard at Trewyn, 1960. Courtesy Bowness. **76 (below).** Paul Popper, photograph of Barbara Hepworth in her garden, St Ives, 1957. Photo: Popperfoto/Getty Images.

**77.** Unknown photographer, Barbara Hepworth at Trewyn, 1969. Courtesy Bowness.

**78.** Paul Laib, photograph of Barbara Hepworth in the Mall Studio, London, 1933. De Laszlo Collection of Paul Laib Negatives, Witt Library, The Courtauld Institute of Art, London. Courtesy Bowness.

**79 (above).** Robert Doisneau, photograph of Pablo Picasso, Vallauris, France, c.1952. Photo: Robert Doisneau/Gamma-Rapho/Getty Images. **79 (below).** Tony Evans, photograph of Frank Bowling at work, c.1965. Photo: Tony Evans/Timelapse Library Ltd/Getty Images.

**80.** Geraint Lewis, photograph of Derek Jarman at Prospect Cottage, Dungeness, 1990. © Geraint Lewis.

**82–83.** Photographs taken by the author in Derek Jarman's studio at Prospect Cottage, Dungeness, 2020. Photo: Charlie Porter, with thanks to the Keith Collins Will Trust.

**84.** Unknown photographer, Lucie Rie in her potter's apron, undated. © Estate of Lucie Rie. Image kindly provided by the Craft Study Centre, University for the Creative Arts.

**85.** Stella Snead, photograph of Lucie Rie sun-bathing, 1967. Image kindly provided by the Crafts Study Centre, University for the Creative Arts.

**86.** Susan Peterson, photograph of Shoji Hamada, 1976. Courtesy of Arizona State University Ceramics Research Center, Susan H Peterson Archive.

**87.** Craig Inglis, photograph of El Anatsui working on found wood at the October Gallery, London, 1995. Courtesy of the Artist and October Gallery, London.

**88.** Unknown photographer, Grace Hartigan standing on the roof of an unidentified building, 1951. Grace Hartigan Papers, Special Collections Research Center, Syracuse University Libraries.

**89.** Sarah Lucas, *Divine*, 1991. C-print, 56.5 × 70.5 cm (22 1/4" × 27 3/4"). © Sarah Lucas, courtesy Sadie Coles HQ, London.

**92.** Sarah Lucas, Self-portrait with Fried Eggs, 1996. C-print. Site size: 151 × 103 cm (59 1/2" × 40 1/2"). Frame size: 154.4 × 106.3 × 6 cm (60 3/4" × 41 7/8" × 2 3/8"). © Sarah Lucas, courtesy Sadie Coles HQ, London.

**94.** Sarah Lucas, *Auto-Erotic*, 1997. Not signed or dated. Brown paper jacket, MDF chair. Overall size: 111 × 96 × 51 cm (43 3/4" × 37 3/4" × 20 1/8"). Jacket (laid flat): 70 × 122 × 89cm. Chair: 120 × 69 × 56cm © Sarah Lucas, courtesy Sadie Coles HQ, London.

**95 (above).** Sarah Lucas, *1-123-123-12-12*, 1991. Boots and razor blade and plinth. Each boot: 17 × 10.2 × 27.5 cm. Private Collection © Sarah Lucas, courtesy Sadie Coles HQ, London. **95 (below).** Sarah Lucas, *Bunny Got Snookered*, 1997. Tan tights, stockings, plywood chair, clamp, kapok and wire 101.6 × 90.17 × 63.5 cm (40" × 35 1/2" × 25"). © Sarah Lucas, courtesy Sadie Coles HQ, London.

**96.** Sarah Lucas, *Fighting Fire With Fire*, 1996. B/w photograph. 152.4 × 121.9 cm (60" × 48"). © Sarah Lucas, courtesy Sadie Coles HQ, London.

**101.** Front cover of *L'Uomo Vogue*, June/July 1980, featuring a portrait of Andy Warhol by Gilles Bensimon. Courtesy of *VOGUE ITALIA*, pub. Edizioni Condé Nast, S.p.A. Photograph by Gilles Bensimon/Trunk Archive.

**104.** Andy Warhol meeting Gerald Ford at a White House state dinner, 1975. Courtesy Gerald R. Ford Presidential Library.

**105.** Maria Chabot, *Georgia O'Keeffe Hitching a Ride to Abiquiu with Maurice Grosser*, 1944. Gelatin silver print, 11 1/4" × 7 7/8". Georgia O'Keeffe Museum. Museum Purchase. © Georgia O'Keeffe. [1998.4.1a]. Courtesy of Georgia O'Keeffe Museum.

**106.** Robert Rauschenberg, *Cy + Relics, Rome*, 1952. Gelatin silver print. 15" × 15"; image; sheet 20" × 16" sheet (38.1 × 38.1 cm). © Robert Rauschenberg Foundation/VAGA at ARS, NY and DACS, London.

**107.** Harry Shunk and Janos Kender, photograph of Andy Warhol and Gerard Malanga in a hotel bedroom, Paris, May 8–9, 1965. Photo: Shunk-Kender © J. Paul Getty Trust. Getty Research Institute, Los Angeles (2014.R.20).

**108.** David Gahr, photograph of Andy Warhol at the Factory, 1968. Photo: © Estate of David Gahr/Getty Images.

**109.** Walter Mori, photograph of Andy Warhol at an opening in Ferrara, Italy, 1975. Photo: Mondadori Portfolio/Getty Images.

**111.** Advertisement for Golden Oak Furniture, Inc., featuring Andy Warhol, *c.* 1980s. Private collection.

**112.** Unknown photographer, Keith Haring, Andy Warhol, Jean Michel Basquiat, at the Factory, April 1984. © 2021 The Andy Warhol Foundation for the Visual Arts, Inc./Licensed by DACS/Artimage, London.

**113.** Bruce Talamon, photograph of David Hammons making a body print, 1974. Photo: Bruce W. Talamon. Copyright © 2019. All Rights Reserved.

**114.** David Hammons, *Injustice Case*, 1970. Body print (margarine and powdered pigment) and American flag. Sheet: 63 × 40 1/2" (160.02 × 102.87 cm). Los Angeles County Museum of Art. Museum Acquisition Fund (M.71.7). © David Hammons. Photo: © 2021. Digital Image Museum Associates/LACMA/Art Resource NY/Scala, Florence.

**116.** Gordon Matta-Clark, *Day's End*, photograph, 1975. © Estate of Gordon Matta-Clark/Artists Rights Society (ARS), New York, DACS London.

**117.** Gordon Matta-Clark at work on *Day's End*, photograph, 1975. © Estate of Gordon Matta-Clark/Artists Rights Society (ARS), New York, DACS, London.

**118.** Gordon Matta-Clark working on the house in Englewood, New Jersey, used for *Splitting*, photograph, 1974. © Estate of Gordon Matta-Clark/Artists Rights Society (ARS), New York, DACS, London.

**119.** Gordon Matta-Clark at FOOD, SoHo, photograph, 1971. © Estate of Gordon Matta-Clark/Artists Rights Society (ARS), New York, DACS London.

**120.** Gordon Matta-Clark, *Art Card (WHERE/Drop your pants/Hand your hat/Tie your shoes/Buckle your boots/Arrange Make your face (Face up)/Dropping the other shoe)*, 1970–1971. Black felt-tip pen and graphite, 7.6 × 12.7 cm. Canadian Centre for Architecture. Gift of Esta

of Gordon Matta-Clark. © Estate of Gordon Matta-Clark/Artists Rights Society (ARS), New York, DACS, London.

**121.** Peter Hujar, *David Wojnarowicz with a snake*, photograph, 1981. © 1987 The Peter Hujar Archive LLC. Courtesy Pace Gallery NY and Fraenkel Gallery, San Francisco.

**122.** Nancy Holt at *Sun Tunnels* (1973–76), after the work's completion, Lucin, Utah, 1976. Photograph: Ardele Lister. Collection of Dia Art Foundation, with support of Holt/Smithson Foundation. Art: © Holt/Smithson Foundation and Dia Art Foundation/VAGA at Artists Rights Society (ARS), New York and DACS, London 2021.

**123.** Nancy Holt filming *Sun Tunnels* (1973–1976), Lucin, Utah, 1976. Photograph: Lee Deffebach. © Holt/Smithson Foundation / VAGA at Artists Rights Society (ARS), New York and DACS, London 2021.

**124 (above).** Robert Smithson at *Spiral Jetty*, 1970. Photograph: Gianfranco Gorgoni. Collection of DIA Art Foundation. Art: © Holt/Smithson Foundation and Dia Art Foundation/VAGA at Artists Rights Society (ARS), New York and DACS, London2021. **124 (below).** Jenny Holzer, *PROTECT ME FROM WHAT I WANT*, from *Survival* (1983–85), 1985. Electronic signboard. Photo: John Marchael. © Jenny Holzer. ARS, NY and DACS, London.

**125.** Barbara Yoshida, *Jenny Holzer, 11 June 1991*, photograph, 3.5×6cm. © Barbara Yoshida.

**126.** Dietmar Schneider, *Blinky Palermo, Leverkusen, 1978*. Gelatine Silver Print, 40×30 cm. Photograph: © Dietmar Schneider/VG Bild-Kunst Bonn. Courtesy Galerie Bugdahn, Düsseldorf. Artwork featured: © DACS.

**127 (above, left).** John McCracken at work on *Hopi*, photograph, 1989. © The Estate of John McCracken. Courtesy the Estate of John McCracken and David Zwirner. **127 (above, right).** John McCracken, *Hopi*, 1989. © The

Estate of John McCracken. Courtesy The Estate of John McCracken and David Zwirner. **127 (below).** Melvin Edwards with his sculpture *Double Circles*, 1970. Painted steel. Bethune Tower, 650 Malcolm × Boulevard, Harlem, New York. Courtesy the artist; Alexander Gray Associates, New York and Stephen Friedman Gallery, London.

**128.** Brandon Seekins, photograph of Melvin Edwards, Oklahoma City, 2016. Courtesy: Alexander Gray Associates, New York; Stephen Friedman Gallery, London.

**129.** Tony Evans, photograph of Richard Hamilton seated in front of his screenprint, *Kent State*, 1970. Photo: Tony Evans/Getty Images. Artwork featured: © R. Hamilton. All Rights Reserved, DACS 2021.

**130.** Stephen Gill, *Chris Ofili, London, 1999*. Photograph. Copyright © Stephen Gill. All Rights Reserved.

**131.** Terry van Brunt, photograph of Robert Rauschenberg at Fish House, Captiva, Florida, 1979. Photograph Collection, Robert Rauschenberg Foundation Archives, New York. © Robert Rauschenberg Foundation.

**132.** Peter Hujar, *Self-portrait Jumping I*, 1974. Photograph. © 1987 The Peter Hujar Archive LLC; Courtesy Pace/MacGill Gallery, New York and Fraenkel Gallery, San Francisco.

**133.** Peter Hujar, *Christopher Street Pier #2 (Crossed Legs)*, 1976. Photograph. © 1987 The Peter Hujar Archive, LLC; courtesy Pace/MacGill Gallery, New York and Fraenkel Gallery, San Francisco.

**135.** Nicole Eisenman, *Morning Studio*, 2016. Oil on canvas. 167.6×210.8 cm (66×83 inches). Collection of Susan and Michael Hort, New York, NY. Image courtesy the artist and Anton Kern Gallery, New York.

**136 (left).** Nicole Eisenman, *I'm with Stupid*, 2001. Oil on canvas. 129.5×99 cm (51×39 inches). The Hall Collection. Image courtesy

the artist and Leo Koenig, Inc., New York.
**136 (right).** Nicole Eisenman, *Weeks on the Train*, 2015. Oil on canvas. 208.3 × 165.1 cm (82 × 65 inches). Collection of Rebecca and Marty Eisenberg, New York, NY. Image courtesy the artist and Anton Kern Gallery, New York.

**138 (above).** Nicole Eisenman, *'Tis but a scratch'/'A scratch?! Your arm's off!'/'No, it isn't'*, 2012. Installation view, Studio Voltaire, London. Courtesy of the artist and Studio Voltaire. Photo: Andy Keate. **138 (below).** Nicole Eisenman, *Procession*, 2019. Installation view, 2019 Whitney Biennial, The Whitney Museum of American Art, New York. Image courtesy the artist, Vielmetter Los Angeles, Anton Kern Gallery. Photo: Matt Grubb.

**140–145.** Mary Manning, photographs taken at Nicole Eisenman's studio in Williamsburg, 2019. © Mary Manning.

**149.** Anne Truitt, photographed with two of her works, *Camelot* and *Spanish Main*, at her studio, Washington, D.C., 1964. Photo: © annetruitt.org/ Bridgeman Images.

**153.** Clement Greenberg, *Changer: Anne Truitt, An American Artist*, article in US *Vogue*, May 1968. Photographs by Snowdon. Clement Greenberg/Lord Snowdon, Vogue © Condé Nast.

**154–155.** Anne Truitt's jacket from Sears Roebuck & Co. Private Collection. Photo: Bridgeman Images.

**156.** Installation view of paintings from the *Arundel* series by Anne Truitt during her exhibition *White Paintings* at the Baltimore Museum of Art, December 1974–March 1975. Photo: © annetruitt.org/Bridgeman Images.

**157–162.** Stills from the documentary film *Phyllida*, 2019. Directed by Cosima Spender. Produced by Hauser & Wirth in association with Third Channel and Peacock Pictures.

**162 (below, left).** Elfie Semotan, photograph of Jack Whitten, 2013. © Courtesy the Jack Whitten Estate and Hauser & Wirth. **162 (below, right).** Jack Whitten, photograph of his feet in

sneakers, 2013. © Courtesy the Jack Whitten Estate and Hauser & Wirth.

**163.** John Berens, photograph of Jack Whitten outside his studio in Queens, 2007. © Courtesy the Jack Whitten Estate and Hauser & Wirth.

**164.** Jack Whitten, *Homage to Malcolm*, 1970. Acrylic on canvas. Unique. 265.4 × 301 × 5.4 cm (104 1/2 × 118 1/2 × 2 1/8 inches). Joyner/Giuffrida Collection. © Jack Whitten Estate. Photo: Christopher Burke.

**165.** Jack Whitten, *Black Monolith II, Homage To Ralph Ellison The Invisible Man*, 1994. Acrylic, molasses, copper, salt, coal, ash, chocolate, onion, herbs, rust, eggshell, razor blade on canvas. 147.32 × 132.08 cm (58 × 52 in). Brooklyn Museum, William K. Jacobs, Jr. Fund (2014.65). © Jack Whitten Estate. Photo: John Berens.

**166.** Peter Bellamy, photograph of Jack Whitten, *c.* 1980s. © Courtesy the Jack Whitten Estate and Hauser & Wirth.

**167.** Alvaro Barrington, photograph of Jack Whitten standing in front of his sculpture *Quantum Man (The Sixth Portal)*, 2016, at Hauser & Wirth, 2017. © Courtesy the Jack Whitten Estate and Hauser & Wirth.

**168.** Unknown photographer, Jack Whitten in a T-shirt designed by Bill Whitten, *c.* 1974–1975. © Courtesy the Jack Whitten Estate and Hauser & Wirth.

**169 (above).** Lee Krasner's shoes. Photo courtesy of Pollock-Krasner House and Study Center. **169 (below).** Jackson Pollock's loafers. Photo courtesy of Pollock-Krasner House and Study Center.

**170.** Chantal Joffe's Birkenstock clogs. Photo Chantal Joffe.

**171.** Chantal Joffe, *Standing Self-Portrait*, 201 Oil on board, 201.6 × 90 cm (79 3/8 × 35 3/8 in) © Chantal Joffe. Courtesy the artist and Victo Miro, London/Venice.

**172.** Kaye Donachie's painting dress. Photo by Kaye Donachie.

**173 (left).** Matt Connors' apron. Photo by Matt Connors. **173 (right).** Matt Connors, *Keyboard of Light*, 2019. Oil, acrylic and crayon on canvas, 120×109.9×3.2cm. Courtesy of the artist and The Modern Institute/Toby Webster Ltd., Glasgow. Photo: Patrick Jameson.

**174.** Matt Connors, *Pieta*, 2019. Acrylic and crayon on canvas, 154.9×137.8×3.2 cm. Courtesy of the artist and The Modern Institute/Toby Webster Ltd., Glasgow. Photo: Patrick Jameson.

**175.** Matt Connors, *Repeat Clarice*, 2019. Oil, acrylic and crayon on canvas, 71.1×64.1×2.9 cm. Courtesy of the artist and The Modern Institute/Toby Webster Ltd., Glasgow. Photo: Patrick Jameson.

**176.** Cecil Beaton, photograph of Francis Bacon in his studio, 1960. Photo: © The Cecil Beaton Studio Archive at Sotheby's. Artwork: © The Estate of Francis Bacon. All rights reserved. DACS 2021.

**177.** Michael Holtz, photograph of Francis Bacon in his South Kensington Studio, 1974. Photo: Michael Holtz/Photo12/Alamy. Artwork: © The Estate of Francis Bacon. All rights reserved. DACS 2021.

**178.** Interior of the Francis Bacon Studio, Collection Dublin City Gallery, The Hugh Lane. Photo: Charlie Porter. Artwork: © The Estate of Francis Bacon. All rights reserved. DACS 2021.

**181.** Caroline Tisdall, photograph of Joseph Beuys, 1974. © Caroline Tisdall.

**184.** Caroline Tisdall, photograph of Joseph Beuys, 1973. © Caroline Tisdall.

**186.** Caroline Tisdall, photograph of Joseph Beuys, 1975. © Caroline Tisdall.

**187.** Caroline Tisdall, photograph of Joseph Beuys stirring a cauldron of fat while working on *Tallow*, 1977. © Caroline Tisdall.

**188.** Caroline Tisdall, photograph of Joseph Beuys at the Giant's Causeway, Northern Ireland, 1974. © Caroline Tisdall.

**190.** Joseph Beuys, *Democracy Is Merry (Demokratie ist lustig)*, 1973. Screenprint with ink additions, composition: 75×114.5 cm (29 1/2×45 1/16""); sheet: 75×114.5 cm (29 1/2×45 1/16""). Publisher: Edition Staeck, Heidelberg, Germany. Printer: Gerhard Steidl, Göttingen, Germany. Edition: 80. Museum of Modern Art, New York. Walter Bareiss Fund. Acc. no.: 1443.2001. ©2021. Digital image, The Museum of Modern Art, New York/Scala, Florence. © DACS 2021.

**193.** Lynn Hershman Leeson, *Roberta's Dress*, 1976. Image courtesy the artist and Bridget Donahue, NYC.

**196.** Lynn Hershman Leeson, *Roberta Getting Ready to go to Work*, 1976. Courtesy the artist and Bridget Donahue, NYC. Photographer: Marc Brems Tatti.

**197.** Lynn Hershman Leeson, *Roberta and Irwin Meet for the First Time in Union Square Park*, 1975. Image courtesy the artist and Bridget Donahue, NYC.

**198.** Lynn Hershman Leeson, *Roberta Climbs Steps of Del Coronado Hotel to Meet a Date (San Diego)*, 1976. Image courtesy the artist and Bridget Donahue, NYC.

**199.** Lynn Hershman Leeson, *Roberta Construction Chart #1*, 1975. Courtesy the artist and Bridget Donahue, NYC.

**200.** Lynn Hershman Leeson, *Roberta's Body Language Chart*, 1978. Courtesy the artist and Bridget Donahue, NYC.

**201.** Lynn Hershman Leeson, *Roberta Contemplating Suicide on the Golden Gate Bridge*, 1978. Image courtesy the artist and Bridget Donahue, NYC.

**202.** Lynn Hershman Leeson, *Lynn Turning Into Roberta*, 1978. 16mm film transferred to video

(color, sound) 5:30 minutes. Courtesy the artist and Bridget Donahue, NYC.

**203.** Urara Tsuchiya, *Give Us A Meow*, film by Ben Toms and Urara Tsuchiya, 2019. Courtesy of the artist.

**204.** Cindy Sherman, *Air Shutter Release Fashions* (detail), 1975. 17 black and white photographs, each 7.6 × 5.1 cm (3 × 2 inches). Courtesy the artist, Metro Pictures, New York, and Sprüth Magers.

**205.** Cindy Sherman, *Untitled #92*, 1981. Chromogenic color print, 61 × 121.9 cm (24 × 48 inches). Courtesy the artist, Metro Pictures, New York, and Sprüth Magers.

**206.** Cindy Sherman, *Untitled #474*, 2008. Chromogenic color print, 230.5 × 152.4 cm (90.75 × 60 inches). Courtesy the artist, Metro Pictures, New York, and Sprüth Magers.

**207.** Cindy Sherman, *Untitled #165*, 1986. Chromogenic color print, 90.2 × 60 cm (35 1/2 × 23 5/8 inches). Courtesy the artist, Metro Pictures, New York, and Sprüth Magers.

**209.** Cindy Sherman, *Untitled #418*, 2004. Chromogenic color print, 182.1 × 112.4 cm (71.7 × 44.25 inches). Courtesy the artist, Metro Pictures, New York, and Sprüth Magers.

**210.** Cindy Sherman, *Untitled #122*, 1983. Chromogenic color print, 89.4 × 58.7 cm (35 3/16 × 23 1/8 inches). Courtesy the artist, Metro Pictures, New York, and Sprüth Magers.

**211.** Cindy Sherman, page from her notebook with note 'attack clothes', 1983. Courtesy of the artist, Metro Pictures, New York, and Sprüth Magers.

**212 (above).** Fashion show by Jun Takahashi of Undercover featuring T-shirts with images of Cindy Sherman's work, September 2017. Courtesy Undercover. **212 (below).** Cindy Sherman, *Untitled A*, 1975. Gelatin silver print, 40.6 × 27.9 cm (16 3/8 × 11 1/16 inches). Courtesy the artist, Metro Pictures, New York, and Sprüth Magers.

**214–215.** Geta Brătescu, three details from *Alteritate* (*Alterity*), 2002-2011. Silver gelatin prints, 9 parts. 50 × 50 cm / 19 5/8 × 19 5/8 inches each. © Geta Brătescu. Courtesy the artist, Ivan Gallery, Bucharest and Hauser & Wirth. Photo: Aurora Kiraly.

**216.** Tehching Hsieh, *One Year Performance 1980–1981: Waiting to Punch the Time Clock.* Photograph by Michael Shen. © Tehching Hsieh 1981. Courtesy the artist and Sean Kelly Gallery, New York.

**217 (left).** Tehching Hsieh, *One Year Performance 1980–1981: The First Three Hours of Images in the Year*. Photograph by Tehching Hsieh. © Tehching Hsieh, 1981. Courtesy the artist and Sean Kelly Gallery, New York. **217 (right).** Tehching Hsieh, *One Year Performance 1980–1981: The Last Three Hours of Images in the Year*. Photograph by Tehching Hsieh. © Tehching Hsieh, 1981. Courtesy the artist and Sean Kelly Gallery, New York.

**218.** Ulay / Marina Abramović, *Rest Energy*. Performance for Video. 4 minutes. ROSC' 80, Dublin, 1980. © Ulay/Marina Abramović. Courtesy of the Marina Abramović Archives/ DACS.

**219–220.** Sharon Hayes, images from *In the Near Future*, 2005–2009. Multiple-slide-projection installation. 13 actions, 13 projections. Dimensions variable. Courtesy of the artist and Tanya Leighton, Berlin.

**221.** Senga Nengudi, studio performance with *R.S.V.P.*, 1976. Silver gelatin print, 76.2 × 101.6 cm (30 × 40 inches). Edition of 5, with 1 AP. © 2019 Senga Nengudi.

**222.** Senga Nengudi, *Study for 'Mesh Mirage'*, 1977. Silver gelatin print, 101.6 × 67.3 cm (40 × 26 1/2 inches). Edition of 5, with 1 AP. © 2019 Senga Nengudi.

**223.** Senga Nengudi, *Ceremony for Freeway Fets*, 1978. 11 C-prints. Each photograph, vertical: 45.7 × 30.5 cm (18 × 12 inches). Each photograph, large horizontal: 33 × 45.7 cm

(13×18 inches). Each photograph, small horizontal: 30.5×45.7 cm (12×18 inches). Overall installation: variable. Edition of 5, with 1 AP. © 2019 Senga Nengudi. Photo: Quaku/Roderick Young.

**224.** Richard Tuttle, in collaboration with The Fabric Workshop and Museum, Philadelphia, *Pants* (pictured on the artist), 1979. Pigment on bleached cotton muslin. 72×26 inches (182.9×66 cm). Edition of 5. Collection of The Fabric Workshop and Museum. Photo: Will Brown.

**225.** Richard Tuttle, *Second Green Octagonal*, 1967. Dyed canvas and thread. 167.6 cm × 165.1 cm (66" × 65"). © Richard Tuttle, courtesy Pace Gallery.

**226.** Richard Tuttle, *Pants*, 1979. Silkscreen on bleached cotton. Overall: 66×182.9 cm (26×72 in.). Dorothy and Herbert Vogel Collection, National Gallery of Art, Washington 2007.6.171. © Richard Tuttle, courtesy Pace Gallery.

**229.** Andrea Zittel, *Wagon Station Encampment at A-Z West, Joshua Tree, CA*, 2015. Photo: Lance Brewer. Courtesy Regen Projects, Los Angeles.

**230.** Installation view of uniforms by Andrea Zittel at Regen Projects, Los Angeles, September 16– October 29, 2011. Courtesy Regen Projects, Los Angeles.

**231.** Andrea Zittel, photograph by Sarah Lyon, 2018. Courtesy the artist and Regen Projects, Los Angeles.

**232.** Cao Fei (SL avatar: China Tracy), *RMB City: The Fashions of China Tracy 01*, 2009. Inkjet print, 36×65cm. Courtesy of artist, Vitamin Creative Space and Sprüth Magers.

**233.** Zadie Xa, *Grandmother Mago*, 2019. Performance part of Meetings on Art, 58th Venice Biennale, 2019. Photo: Riccardo Banfi. Courtesy Delfina Foundation and Arts Council England.

**234.** Zadie Xa's pink Versace jacket. Photo: Charlie Porter.

**235.** Zadie Xa's green H&M bomber jacket. Photo: Charlie Porter.

**236.** Zadie Xa, *Child of Magohalmi and the Echos of Creation*, 2019. Yarat Contemporary Art Space, Baku, AZ. Photo: Pat Verbruggen. Courtesy of Yarat Contemporary Art Space.

**237.** Zadie Xa and fellow performers backstage at the Tramway, Glasgow. Photo: Iris Chan.

**239 & 242–243.** Martine Syms, self-portraits, 2019. All photographs courtesy Martine Syms.

**244.** Hal Fischer, *Signifiers for a Male Response*, from the series *Gay Semiotics*, 1977. Gelatin silver print, 46.99 cm×31.59 cm (18 1/2 in.×12 7/16 in.). Courtesy of the artist and Project Native Informant, London.

**245, 247.** Martine Syms, self-portraits, 2019. All photographs courtesy Martine Syms.

**248–249.** Martine Syms, *SHE MAD: Laughing Gas*, 2016*; Made in L.A., 2016: a, the, though, only.* Installation view, Hammer Museum, Los Angeles, 2016. © Martine Syms, courtesy Sadie Coles HQ, London. Photo: Brian Forrest.

**250.** Leigh Bowery, Trojan and Rachel Auburn in a scene from the Charles Atlas film, *Hail the New Puritan*, 1986. © Charles Atlas.

**253.** David Hockney, *Self-portrait*, 1954. Collage on newsprint, 16 1/2×11 3/4"". © David Hockney. Photo: Richard Schmidt. Collection Bradford Museums & Galleries, Bradford.

**258.** Lord Snowdon, portrait of David Hockney in a red cardigan, 1965. Photograph by Snowdon/Trunk Archive.

**259.** Lord Snowdon, portrait of David Hockney in a gold jacket, 1963. Photograph by Snowdon/Trunk Archive.

**261.** Yayoi Kusama, *Suit*, c.1962. Painted textile application on suit, hanger. 101,6×76,2×10,2 cm (40×30×4 in.). Donation 2000 from Kerstin Bonnier and Pontus Bonnier. Moderna Museet, Stockholm MOM/2000/11. © YAYOI KUSAMA.

**262.** KUSAMA Fashion show at her boutique, New York, 1969. Courtesy the artist, Ota Fine Arts and Victoria Miro. © YAYOI KUSAMA.

**263.** KUSAMA Fashion show at her boutique, New York, 1969. Courtesy the artist, Ota Fine Arts and Victoria Miro. © YAYOI KUSAMA.

**264 (above).** KUSAMA's *Silver Squid Dress*, c.1968. Courtesy the artist, Ota Fine Arts and Victoria Miro. © YAYOI KUSAMA. **264 (below).** Sketch of KUSAMA's *Silver Squid Dress*, c.1968. Courtesy the artist, Ota Fine Arts and Victoria Miro. © YAYOI KUSAMA.

**265.** KUSAMA Fashion show at her boutique, New York, 1969. Courtesy the artist, Ota Fine Arts and Victoria Miro. © YAYOI KUSAMA.

**267.** Tabboo! in green velvet suit. Photo courtesy of Tabboo!.

**268.** Tabboo! on stage at Wigstock, 1991. Photo courtesy of Tabboo!.

**270.** Tabboo! in an Alpana Bawa suit at his exhibition opening at Herald St Gallery, London, 2019. Photo: Charlie Porter.

**271.** Detail of shoe worn by Tabboo! at his exhibition opening at Herald St Gallery, London, 2019. Photo: Charlie Porter.

**272.** Louise Nevelson in Ukrainian style dress, 1980. Photo: Nancy R. Schiff/Getty Images.

**274.** Rachel Feinstein's set for Marc Jacob's fashion show, Fall 2012. Photo: Victor Virgile/Gamma-Rapho/Getty Images.

**275.** Rachel Feinstein accompanying Marc Jacobs to the Met Gala, New York, 2012. Photo: Ron Galella/Getty Images.

**276.** Rachel Feinstein, *Cliff House*, 2014. White powder coated aluminium with silkscreen type. 777.24×843.28×375.92 cm (306×332×148 inches). In exhibition at Madison Square Park, New York, May 7 to September 7 2014. Artwork © Rachel Feinstein. Photo: James Ewing.

**278.** Atelier E.B's Ivan tracksuit top and Lendl tracksuit bottoms with Wedgwood print, IOTII collection, 2015. Photo: Rob Smith.

**279.** Atelier E.B, *Faux Shop*, 2018. Mixed media, 450×310×220 cm. Installation view Atelier E.B: Passer-by, Serpentine Sackler Gallery, London, 3 October 2018–6 January 2019. Courtesy the artist and Cabinet, London.

**280.** Emile Holba, photograph of Anthea Hamilton in a paisley dress. © Emile Holba, 2020. All rights reserved.

**281.** Anthea Hamilton, *Karl Lagerfeld Bean Counter*, 2012. Thermoformed acrylic, wood, digital print on paper, buckwheat, Desirée potatoes, metal brackets. 112×190×60 cm. © Anthea Hamilton. Courtesy the artist, Thomas Dane Gallery and Office Baroque, Antwerp. Photo: Pieter Huybrechts.

**282.** Anthea Hamilton, *The Squash*, installation view, Tate Britain, 2018. © Anthea Hamilton. Courtesy the artist and Thomas Dane Gallery. Photo: © Tate.

**283–284.** Anthea Hamilton, *The Squash*, costumes, 2018. © LOEWE. Photo: Laure Bernard.

**285.** Anthea Hamilton, *The New Life*, installation view, *May You Live In Interesting Times*, Biennale di Venezia 58e, 2019. © Anthea Hamilton. Courtesy the artist, Thomas Dane Gallery and kaufmann repetto, Milan. Photo: Andrea Rosetti.

**287.** Prem Sahib, *Rumble*, 2013. Puffer jackets, glass, steel, 120×90×5 cm. Courtesy the artist and Southard Reid, London.

**289.** Prem Sahib, *Basic Man*, 2015. MAC foundation on Zara shirt, aluminium, paint, 85.5×69×5 cm. Courtesy the artist and Southard Reid, London. Courtesy the artist and Southard Reid, London.

**290.** Prem Sahib, Do you care? We do, 2017. Installation View, Prem Sahib: Balconies, Kunstverein in Hamburg, Germany, 2017. Courtesy the artist and Kunstverein in Hamburg. Photo: Fred Dott.

**291 (left).** Robert Pruzan, *Tom and Fans, San Francisco Eagle*, 1985. Image courtesy Tom of Finland Foundation. **291 (right).** TOM OF FINLAND (Touko Laaksonen), *Untitled*, 1980. Graphite on paper. © 1980 Tom of Finland Foundation/Artists Rights Society (ARS), New York/DACS, London2021.

**292 (above).** Alvin Baltrop, *Self-portrait (looking away)*, n.d. (1975-1986). Silver gelatin print, image size: 7.9 × 11.7 cm, paper size: 8.7 × 12.7 cm. Photographs used courtesy of The Alvin Baltrop Trust. © 2010, The Alvin Baltrop Trust and Third Streaming. All rights reserved.
**292 (below).** Alvin Baltrop, *Friends*, 1977. Photograph used courtesy of The Alvin Baltrop Trust. © 2010, The Alvin Baltrop Trust and Third Streaming. All rights reserved.

**295.** Charlotte Prodger, *SaF05*, 2019. Installation view, Scotland + Venice, 58th Venice Biennale. Image courtesy of the artist, Hollybush Gardens, London, Kendall Koppe, Glasgow and Koppe Astner, Glasgow.

**297.** Charlotte Prodger, *Colon Hyphen Asterix*, 2012. Installation view. Image courtesy of the artist, Hollybush Gardens, London and Koppe Astner, Glasgow.

**298.** Charlotte Prodger, *BRIDGIT*, 2016. Installation view, Bergen Kunsthall, Bergen, Norway. Image courtesy of the artist, Hollybush Gardens, London, Kendall Koppe, Glasgow and Koppe Astner, Glasgow.

**299.** Charlotte Prodger, *Passing as a Great Grey Owl*, 2017. Video still. Image courtesy of the artist, Hollybush Gardens, London, Kendall Koppe, Glasgow and Koppe Astner, Glasgow.

**305.** Mark Leckey, *Fiorucci Made Me Hardcore*, 1999. Courtesy the Artist and Cabinet, London.

**308.** Chris Ware, photograph of Duncan Grant in a tracksuit at Charleston, c.1975.

**309.** Chris Ware, photograph of Duncan Grant in a tracksuit holding a copy of Paul Roche's *Enigma Variations And, c.*1975. Artworks

featured © Estate of Duncan Grant. All rights reserved, DACS 2021.

**311.** Sondra Perry, screen still from *Graft and Ash for a Three Monitor Workstation*, 2016. Video, bicycle workstation, 68 × 16 × 42 in (172.72 × 40.64 × 106.68 cm), 9:05 minutes, Edition of 5 plus I AP. Courtesy of the artist and Bridget Donahue, NYC.

**312.** Sondra Perry's New Jersey Devils sweater. Photo: Sondra Perry.

**313–14.** Sondra Perry, screen stills from *IT'S IN THE GAME '18* or *Mirror Gag for Projection and Two Universal Shot Trainers with Nasal Cavity and Pelvis*, 2018. Nam June Paik Award 2018 – International Media Art Prize of the Kunststiftung NRW, Westfälischer Kunstverein, Münster, Germany, November 10, 2018–February 3, 2019. Digital video projection in a room painted Rosco Chroma Key Blue, color, sound (looped), 2 Spalding universal shot trainer sculptures with painted steel, hardware and 3 including an Acer 17"" 4:3 monitor, privacy screen, SD video (looped). Commissioned by the Henie Onstad Kunstsenter, Oslo (HOK) and the Institute of Contemporary Art (ICA), University of Pennsylvania in 2017 for the exhibition Myths of the Marble. Photo: Thorsten Arendt. Courtesy the artist and Bridget Donahue, NYC.

**315.** Mark Leckey, *New Lecture-Performance*, March 5, 2017. Presented at MoMA PS1 as part of VW Sunday Sessions 2016-2017. Photo: Derek Schultz. Courtesy of the Artist and Cabinet, London.

**316–317.** Mark Leckey, *Fiorucci Made Me Hardcore*, 1999. Courtesy the Artist and Cabinet, London.

**318.** Mark Leckey, *Under Under In*, 2019. Courtesy the Artist and Cabinet, London.

**320.** Mark Leckey, *Fiorucci Made Me Hardcore*, 1999. Courtesy the Artist and Cabinet, London.

**321.** Mark Leckey, *Under Under In*, 2019. Courtesy the Artist and Cabinet, London.

**322.** Ryan Trecartin, still from *Item Falls*, 2013. 25:44 min, color, sound, HD video. © Ryan Trecartin. Courtesy of the artist, Sprüth Magers; Regen Projects, Los Angeles.

**323.** Ryan Trecartin, still from *CENTER JENNY*, 2013. 53:15 min, color, sound, HD video. © Ryan Trecartin. Courtesy of the artist, Sprüth Magers; Regen Projects, Los Angeles.

**324.** Lizzie Fitch | Ryan Trecartin, *Whether Line*, 2019. Multimedia installation. Courtesy Fondazione Prada. © Lizzie Fitch | Ryan Trecartin.

**326.** Lizzie Fitch | Ryan Trecartin, *Whether Line*, 2019. Multimedia installation. Courtesy Fondazione Prada. © Lizzie Fitch | Ryan Trecartin.

**327.** Ryan Trecartin, *K-CorealNC.K*, 2009. 33:05 min, color, sound, HD video © Ryan Trecartin. Courtesy of the artist, Sprüth Magers; Regen Projects, Los Angeles.

**328.** Hilary Lloyd, *Car Wash*, 2005. © Hilary Lloyd, Courtesy Galerie Neu, Berlin; Sadie Coles HQ, London; Greene Naftali, New York.

**329.** Hilary Lloyd on a tyre swing at Lismore Castle, 2019. Photo by Charlie Porter.

**330.** Hilary Lloyd, *Princess Julia*, 1997. © Hilary Lloyd, Courtesy Galerie Neu, Berlin; Sadie Coles HQ, London; Greene Naftali, New York.

**331 (above).** Hilary Lloyd, *Car Wash*, 2005. © Hilary Lloyd, Courtesy Galerie Neu, Berlin; Sadie Coles HQ, London; Greene Naftali, New York. **331 (below).** Hilary Lloyd, *Moscow*, 2019. © Hilary Lloyd, Courtesy Galerie Neu, Berlin; Sadie Coles HQ, London; Greene Naftali, New York.

**333.** Mary Manning, *Self-portrait*, 1994. Photograph © Mary Manning.

**334.** Paul Mpagi Sepuya, "*_1010522*". Image courtesy of the artist.

**335.** Paul Mpagi Sepuya, "*_1080411*". Image courtesy of the artist.

**336.** Paul Mpagi Sepuya, "*0X5A1883*". Image courtesy of the artist.

**337.** Marc Hundley, *It's Up To You*, 2019. Xerox print mounted to board. 106.68 × 157.48 cm (42×62 inches). Courtesy of the artist and Canada, New York. Photo: Joe DeNardo.

**338-339.** Marc Hundley, screenprinted t-shirts, 2002-2015. All photographs by Marc Hundley.

**340.** Alvaro Barrington in a T-shirt by Fenty, 2019. Photo: Marcel Erasel.

**341.** Alvaro Barrington in a hibiscus T-shirt at the Notting Hill Carnival, 2019. Photo: Paul Anthony Smith.

**342 (above).** Alvaro Barrington with Sadie Coles at the Notting Hill Carnival, 2019. Photo: Paul Anthony Smith. **342 (below).** Alvaro Barrington in the T-shirt he wore for the Notting Hill Carnival, 2019. Photo: William Scarborough.

**343.** David Robilliard, *Safe Sex*, 1987. Acrylic on canvas, 100 × 150 cm. Collection Van Abbemuseum, Eindhoven, The Netherlands. Photo: Pete Cox. © The Estate of David Robilliard. All rights reserved. DACS.

**344 (above).** David Robilliard at a gallery opening, 1985. Photo: Richard Gilbert. Courtesy of James Birch. **344 (below).** David Robilliard, *Nobody Finds a Dream Man Till They're Asleep*, 1987. Signed and dated. Acrylic on canvas. 170.2 × 177.5 cm (67 × 69 7/8 inches) (AO 0627) Ortuzar Projects, New York. © The Estate of David Robilliard. All rights reserved. DACS.

**345 (above).** David Robilliard at the Colony Club Soho, c.1985. Photo: James Birch. **345 (below).** David Robilliard, *I Asked for Adonis, Not a Doughnut*, 1987. Signed and dated. Acrylic on canvas. 100.3 × 150.2 cm (39 1/2 × 59 1/8 inches). (AO 0625). Ortuzar Projects, New York. © The Estate of David Robilliard. All rights reserved. DACS.

**346.** David Robilliard at the launch of his book, *Swallowing Helmets*, 1987. Photo: Peter Wright, courtesy of James Birch of Birch & Conran. Artwork in the background: David Robilliard, *Life Isn't Good, It's Excellent*, 1987, acrylic on

canvas. © The Estate of David Robilliard. All rights reserved. DACS 2021.

**347.** David Robilliard, *Disposable Boyfriends*, 1987. Signed and dated. Acrylic on canvas. 100.3 × 150.2 cm (39 1/2 × 59 1/8 inches). (AO 0624). Ortuzar Projects, New York. © The Estate of David Robilliard. All rights reserved. DACS.

**348.** Helen Cammock at the Turner Prize opening, Turner Contemporary, Margate, 2019 in front of her work 'Shouting in Whispers (if you won't be touched)', 2017, Screen print on paper, 102 × 72cm, courtesy the artist and Kate MacGarry, London. Photo: Charlie Porter.

**350–351.** Tai Shani, Lawrence Abu Hamdan, Helen Cammock and Oscar Murillo celebrate jointly winning the Turner Prize, Turnery Contemporary, Margate, 2019. Photo: Stuart C. Wilson/Getty Images.